How to Draw
and Paint
Wild Flowers

How to Draw and Paint Wild Flowers

Keith West

Timber Press
Portland, Oregon
in association with
The Royal Botanic Gardens, Kew

Again to Margaret

First published in Great Britain 1993
by The Herbert Press Ltd, 46 Northchurch Road, London N1 4EJ
in association with The Royal Botanic Gardens, Kew

First published in North America in 1993 by
Timber Press, Inc.
9999 S.W. Wilshire, Suite 124
Portland, Oregon 97225, USA

Designed by Pauline Harrison
Set in Linotype Meridien by
Rowland Phototypesetting Ltd, Bury St Edmunds, Suffolk
Printed and bound in Hong Kong
by South China Printing Company (1988) Ltd

I S B N 0-88192-239-0

Contents

Introduction

Wild flowers have a particular charm and interest for me that may in part be due to their association with memories of times spent in wild and beautiful places, as well as to their individual qualities.

Though this book focuses on the portrayal of wild flowers, the techniques described apply to other plants. After all, including the sometimes over-developed creations of plant-breeders, our garden favourites originated as wild flowers selected from around the world.

It is sad that many British wild flowers are now more often seen in gardens than growing wild: the corn cockle and the Welsh poppy are examples.

In drawing and painting plants you are following a wonderful tradition that extends over some 3000 years. Artists of the distant past contemplated the same beauties and rose to the same challenges that we experience today.

Books have long been an outlet for the plant artist, from the earliest simple herbals illustrated by woodcuts to sumptuous productions of the nineteenth century. These lavish books are typified by such works as *Les Liliacées* and *Les Roses*, painted by Pierre-Joseph Redouté; or the huge, 20 by 30 inches, *Orchidaceae of Mexico and Guatemala*, by J. Bateman, illustrated by Miss S. A. Drake and Mrs A. I. Withers.

Before photography, original drawings or paintings intended for reproduction had to be translated by hand into a form capable of being printed. Woodcuts have been mentioned, these were followed by wood-engravings, engravings on various metals, etching processes and lithography. For the volumes above, Redouté's watercolours were reproduced through a method of colour stipple engraving which he invented; whereas the orchids were lithographed by a master of the process, M. Gauci, before each sheet was laboriously hand-coloured using watercolour washes.

A succession of opulent flower books was an expression of an enormous interest in plants fed by a seemingly never-ending flood of novelties from exotic places. Serious scientific investigation flourished, fostered by the insatiable appetites of wealthy patrons for ever more new, curious, and beautiful acquisitions.

The prime years of plant hunting and magnificent publications spanned from the eighteenth century into the early twentieth century. It was mainly the beginning of this period that saw the establishment of many great gardens – a number of which survive today.

With the twentieth century came gradual change: there were fewer prodigiously rich patrons, the flood of new plants for cultivation diminished, and botanical science took a more austere stance, yielding floras employing formal language less often supplemented by colour plates – though there were exceptions.

Today, though the technical means of reproducing fine plant paintings produces results that are close to perfection, costs ensure that a trickle of superb large-scale volumes being published reaches only well-funded institutions and individuals.

Despite the progression outlined above, botanical illustrations are now more widely distributed than ever before. The scientific press requires highly specialized line drawings; this discipline is described in my book, *How to Draw Plants: the techniques of botanical illustration*. Line work is also seen in some popular guides and plant identification books. More often, to attract lay readers, colour plates are included – these are commonly from photographs but reproductions of watercolours are still used. Even so, larger works of the kind seen in eighteenth- and nineteenth-century florilegias and monographs are now painted generally for private commissions or galleries.

The detailed history of plant illustration is fascinating but much too complex to be treated here. Information is confined to the use of pencil, ink, and watercolour and gouache for depicting plants; then twenty wild-flower portraits are created step-by-step. The subjects have been chosen to give variety of colour and interest running through the seasons from early spring to winter. The species selected, or in some cases similar relatives, occur over much of the temperate world.

To portray wild flowers I do sometimes take advantage of common species that naturally spread into the garden. These are potted up so that the growing plant may conveniently be used rather than picked flowers and leaves. Some wild-flower species are grown from seed, both to enhance the garden and to provide models.

In the wild in Britain, rare species must not be picked and it is illegal to dig up *any* plant without permission from the owner of the land. There are various exceptions from these requirements but the sensible general intent is clear.

Should you be a newcomer to working with plants, do not be discouraged if your first efforts fall short of your aspirations. I have tried to make the step-by-step guidance helpful in the use of each medium, and for the portrayal of the wild-flower subjects. Yet this is a demanding enterprise and the best results are achieved only by close observation and skilled application. The process of learning never stops – I find that there are constant challenges even after more than thirty years endeavour. But the results of your work will give harmless pleasure, and each plant portrayed will add to a growing store of happy memories and associations.

General Notes

The following notes apply to work on the wild flowers in general; some of the information is repeated elsewhere in the text.

LIGHT SOURCE All the plates in this book are shaded on the left (except for winter buds), so indicating light coming from the right. As a left-hander I prefer this pattern, with the model placed to the right of the drawing board. This positioning prevents shadow from my working hand falling across the work. Right-handed readers will find it appropriate to place the model to their left and to have the light originating from the upper left.

PENCIL SHARPENING I like to use a scalpel for sharpening pencils. The wood is pared away to maintain a long lead – one in use as I write is 19 mm from the wood margin to the point. This allows an unobstructed view about the tip. To repoint a blunt lead, the pencil is held at an acute angle to a scrap of waste paper while the tip is rubbed and rotated until the point is renewed.

LAYOUT PAPER Less experienced readers may wish to complete many of their preliminary drawings on layout paper and transfer them as described on p. 20. This should be done if you think it likely that the eraser will be in frequent use.

PROTECTIVE SHEET For all of the mediums described, it is advisable to keep a protective piece of paper between your hand and the surface you are using. This will prevent traces of dirt, sweat and body-oils from reaching your work. It is sensible to use an offcut from the paper that you are working on because this will also be especially suited to trying out strokes, colour mixes etc. The piece should not be allowed to become too grubby before it is replaced.

SCALE All wild-flower subjects were portrayed life-size in the drawings and paintings. The original image sizes are given for each.

COMPLEX DISSECTIONS are not dealt with because most readers are unlikely to have easy access to a dissecting microscope. For those interested, the topic is detailed in *How to Draw Plants*.

COLOURS MOST OFTEN USED are permanent yellow, alizarin crimson, and Winsor blue. Their names are constantly repeated in describing progress through the watercolour plates because most of the hues have been mixed from them – with Winsor yellow as an occasional 'cooler' substitute yellow. The other colours in the core list on p. 25 are included because they cannot be matched through mixing – most have been called on, even if rarely.

In colour mixes, I have listed the components in descending order of their proportions. Frequently, the first two pigments are used in close to equal amounts, and the third is expressed as a 'touch', 'hint', 'brush-tip' etc. (there are few concise English expressions for very small amounts). I have not been able to quantify proportions precisely: though the end results may be accurate, one works towards a desired hue by a swift series of intuitive additions and/or dilutions impossible to analyse in practice.

PRESENTATION Having completed a wild-flower drawing or painting you will find that its quality will not be fully realized until it is properly mounted for viewing. It is amazing how a fine mount (matt) and frame enhances all work from the most accomplished to the very modest. Guidance in this area is given in many practical books, or you may prefer to place your originals in the hands of a picture framer.

EXHIBITING Having reached a certain standard – difficult to assess – you may wish to exhibit. There are many galleries that welcome botanical works – though sales do not inevitably follow. Initially, pricing is a problem, looking at how others value their efforts may reveal as great a span in prices as in talent, often with seemingly little connection between the two. Sympathetic gallery owners are worth approaching for realistic advice.

By first reading the relevant text and doing the exercises for each medium that you intend to use, I hope that you will avoid many of the snares and pitfalls that I have struggled with in the past. Then, when going on to work from living plants, do follow the given sequences – they will ease the way without affecting the imprint of your individuality. In gaining experience you will no doubt refine and evolve further ways of your own as part of the never-ending process . . .

Glossary of botanical terms

Where technical words first occur in the text they appear in italics. Definitions are restricted to the text usage, though there may be additional meanings.

Achene A small dry one-seeded indehiscent fruit. Cf. *Capsule, Follicle, Nut.*

Actinomorphic flower A radially symmetrical flower. Syn. *Regular flower. See* fig. 1,*a.* Cf. *Zygomorphic flower.*

Acute Of a pointed apex with straight or slightly convex sides tapering gradually. *See* fig. 5,*a.* Cf. *Obtuse.*

Androecium The male parts of a flower – the stamens collectively. *See* fig. 3. Cf. *Gynoecium, Pistil.*

Angiosperms Plant group in which seeds are borne within a matured ovary (fruit); contrasted with *gymnosperms* in which seeds are not enclosed in an ovary (conifers etc.).

Anther The pollen-bearing part of the stamen. *See* fig. 3.

Appressed Pressed close to or flat against.

Axil The upper angle between a branch(let), leaf or leaf stalk (petiole), flower stalk (peduncle or pedicel), and the stem from which it grows.

Barbed Bearing sharp retrorse lateral and/or terminal projections (barbs).

Berry An indehiscent pulpy fruit, developed from a single pistil containing one to many seeds but no stone. Cf. *Drupe, Pome.*

Bifurcate Forked.

Blade The lamina or expanded portion of a leaf.

Bract A modified leaf, sometimes small to scale-like; usually subtending an inflorescence and/or individual flowers.

Bud An embryonic shoot which may be comprised of developing leaves and/or flowers.

Bulb A storage organ composed of more or less fleshy scales on a short axis. Cf. *Bulbil, Corm, Tuber.*

Bulbil A small bulb produced usually in leaf axils. Cf. *Bulb, Corm, Tuber.*

Caducous Falling at an early stage.

Calyx The outer floral whorl – the sepals collectively. *See* fig. 3.

Capitulum A headlike inflorescence of usually sessile aggregated flowers. Pl. *Capitula. See* fig. 2.

Capsule A dehiscent dry fruit developed from two or more carpels. Cf. *Achene, Follicle, Nut.*

Cleistogamic flower A small closed self-fertilized flower, usually on or under the ground.

Coma A tuft of hairs, as on the seeds of the rosebay willow-herb.

Compound Composed of two to many like parts, as in a compound leaf. *See* fig. 4.

Cone A reproductive structure comprised of sporophylls or ovule-bearing scales grouped on a central axis.

Corm A storage organ consisting of a short, thickened, upright underground stem. Cf. *Bulb, Bulbil, Tuber.*

Corolla The inner whorl of floral envelopes (the petals collectively). *See* fig. 3.

Dehiscence The process of opening of a fruit, anther, or other structure.

Dicotyledon A plant with an embryo possessing two seed leaves (cotyledons). Cf. *Monocotyledon.*

Dioecious Of a taxon in which the male (staminate) and female (pistillate) flowers are borne on different individual plants. Contrasted with the *monoecious* state in which male and female flowers occur on the same plant.

Disc floret One of the florets comprising the central portions of flowerheads (capitula). *See* fig. 2. Cf. *Ray floret, Capitulum.*

Double serrate With coarse serrations, themselves bearing small teeth.

Drupe A stone fruit: the seed enclosed in a hard shell set in a fleshy surround. Cf. *Berry, Pome.*

Eglandular hairs Hairs lacking glands. Cf. *Glandular hairs.*

Epiphyte A non-parasitic perching plant.

Entire With a continuous margin that is not toothed, indented, or cut. *See* fig. 6,*a.*

Exserted Projecting, as the style or stamens beyond the corolla. *See* knapweed.

Filament The stalk of the stamen. *See* fig. 3.

Fimbriate Fringed. *See* knapweed.

Floral envelopes Sterile appendages of the flower – the perianth (corolla and calyx together). *See* fig. 3.

Floral tube Structure formed by the fusion of the basal parts of sepals, petals and stamens in some flowers.

Floret Individual flower of a capitulum; individual flower of an inflorescence. *See* fig. 2. Cf. *Disc floret, Ray floret.*

Follicle A dry dehiscent fruit opening along one side, derived from a single pistil. Cf. *Achene, Capsule, Nut.*

Glabrous Without hairs.

Glandular hairs Secreting hairs. Cf. *Eglandular hairs.*

Gynoecium The female part(s) of a flower – the pistil or pistils collectively. *See* fig. 3. Cf. *Androecium, Stamens.*

Herbaceous Non-woody.

Husk The outer covering of some fruits – as in *Juglans,* walnut, and *Aesculus,* horse chestnut.

Imperfect flower A flower lacking either stamens or pistils. Cf. *Perfect flower.*

Inflorescence A flower cluster.

Involucre One or more whorls of bracts, often calyx-like, immediately beneath an aggregation of flowers. *See* knapweed.

Irregular flower A flower divisible into matching halves along one plane only. Syn. *Zygomorphic flower. See* fig. 1,*b.* Cf. *Regular flower, Actinomorphic flower.*

Lamina The expanded portion of a leaf.

Leaf scar Mark left on site from which a leaf has fallen.

Lenticel A small spongy opening in a stem or other plant part allowing an interchange of gases.

Ligule A strap-shaped structure, as in the ray florets of a capitulum. *See* fig. 2.

Lobed With recognizable but not separated divisions of a leaf or petal etc. *See* fig. 4,*b.*

Monocotyledon A plant with an embryo possessing one seed leaf (cotyledon). Cf. *Dicotyledon.*

Morphology The study of forms.

Motile Capable of movement.

Node A point on a stem where one or more leaves are attached.

Nut A hard, dry, indehiscent, one-seeded fruit. Cf. *Achene, Capsule, Follicle.*

Obtuse Of a blunt apex. *See* fig. 5,*i.* Cf. *Acute.*

Ovary The ovule-bearing part of a pistil: on maturity an ovary becomes a fruit. *See* fig. 3.

Ovule The structure in seed plants containing the female gametophyte with egg cell: on maturity an ovule becomes a seed. *See* fig. 3.

Pedicel The stalk of an individual flower in a compound inflorescence.

Peduncle The stalk of a solitary flower; the main stalk of a compound inflorescence.

Perfect flower A flower having both stamens and pistils. *See* fig. 3. Cf. *Imperfect flower, Pistillate flower, Staminate flower.*

Persistent Remaining attached. Cf. *Caducous.*

Petiole Stalk of a leaf.

Petiolule Stalk of a leaflet.

Phyllary A bract, especially of the inflorescences of members of the family Asteraceae (Compositae). *See* knapweed.

Pistil A unit of the gynoecium comprised of ovary, style (where present) and stigma. Some authors use carpel as a synonym. *See* fig. 3. Cf. *Stamen.*

Pistillate Having pistils but no functional stamens. Cf. *Staminate.*

Pome A simple fleshy fruit found only in one subfamily of the Rosaceae – apples, pears, etc. Cf. *Berry, Drupe.*

Ray floret Outer floret of a composite flower, with a strap-like extension of the corolla. *See* fig. 2. Cf. *Disc floret.*

Regular flower A regular flower is radially symmetrical. Syn. *Actinomorphic. See* fig. 1,*a.*

Retrorse Directed back or down.

Revolute With a margin rolled towards the underside. *See* fig. 6,*b.*

Rugose Wrinkled. *See* primrose.

Scabrous Rough to the touch. *See* hop.

Serrate Of a margin toothed like a saw. *See* fig. 6,*f.*

Sepal One separate part of a calyx. *See* fig. 3.

Sessile Stalkless: of an organ attached directly by the base.

Sinuate Wavy, as in leaf or petal margins, where movement is in and out in the same plane as the surface of the organ. *See* fig. 6,*c.* Cf. *Undulate.*

Spadix A spike inflorescence, usually subtended by a spathe as in Araceae. *See* lords and ladies.

Spathe A bract more or less surrounding or subtending a spadix. *See* lords and ladies.

Stamen The pollen-bearing organ of a seed plant. *See* fig. 3.

Staminate flower Having stamens but lacking pistils. Cf. *Pistillate.*

Stellate Star shaped: of hairs with radiating branches.

Stem The main above-ground axis of a plant. Used loosely in the text to include other stalks.

Stigma The part of the pistil receptive to pollen. *See* fig. 3.

Stipule An appendage, usually paired, sometimes present at the base of a petiole. *See* dog rose.

Storage organs Structures modified to store food. Cf. *Bulb, Bulbil, Corm, Tuber.*

Striated With parallel linear markings. *See* horse chestnut.

Style More or less elongated tissue connecting the ovary and stigma. *See* fig. 3.

Taxonomy Classification. Hence, taxon – any taxonomic unit, regardless of its place in a hierarchy.

Tomentose Densely woolly.

Trichome Outgrowths from the epidermis such as hairs, bristles, prickles and scales.

Trifoliolate Having a leaf or leaves or three leaflets. *See* wood sorrel.

Tuber A much enlarged fleshy underground stem – as a potato. Cf. *Bulb, Bulbil, Corm.*

Undulate Wavy, as in leaf or petal margins, where movement is up and down at right angles to the surface of the organ. *See* fig. 6,*d.* Cf. *Sinuate.*

Valve The units into which a capsule splits on dehiscence. *See* rosebay willowherb.

Venation The arrangement of veins.

Vesture Covering, as of hairs or other trichomes.

Zygomorphic flower A flower divisible into matching halves along one plane only. Syn. *Irregular flower. See* fig. 1,*b.* Cf. *Actinomorphic flower.*

1 BASIC EQUIPMENT

Equipment needed specifically for each medium is detailed in chapter 3. Basic items used throughout are listed below.

WORK SPACE A separate room or quiet private area will assist you to concentrate. Preferably you should have enough space to stand back to see your work from another viewpoint. Failing this, use a mirror to double the apparent viewing distance; the reversed image is often helpful in revealing weaknesses.

LIGHTING Natural light without exposure to direct sunlight is the rarely met ideal. Place yourself close by the best light source, usually a window. To avoid shadows across your work, have the light fall from your left if you are right-handed; for the left-handed the light should come from your right.

Artificial light is usually necessary for at least part of the day. If you use standard bulbs be aware that they distort colours by a yellow-red bias. This heightens yellows and reds while dulling blues. Balanced fluorescent systems shed an almost natural light which is pleasant to work under; while an economic but successful alternative is the blue-tinted 'daylight' bulb now widely available.

WORK SURFACE An entirely adequate work surface may be made from an off-cut of 5 mm plywood measuring about 65 × 50 cm. This is sloped against books or bricks etc. on a table and the angle is changed by moving the board to and fro.

Table-top drawing boards with movable struts are a more convenient possibility. The next (big) step is a drawing stand with legs supporting a board moving freely from the horizontal through all degrees of slope to the vertical. This easy versatility is useful but not vital. Models range from the simplest type to the extremes of elaboration you can see in graphic arts suppliers' catalogues.

SEAT Comfort is essential: you should be able to sit for long periods without being conscious of your chair. If you have to stretch to work near the top of the drawing board you may need an adjustable seat.

Drawing stands require draftsmens' chairs or stools because the work surface is usually held too high to reach satisfactorily from an ordinary chair.

CRAFT KNIFE Though I use a scalpel for most light cutting, a sturdy craft knife is more suitable for heavier papers. It will also, with persistence, cut boards, though these are best trimmed by heavy-duty studio cutters.

Paper cutting quickly blunts blades and usually spares are included with craft knives. Even so, I like to extend their lives by the use of a whetstone. Some types feature safer retractable blades.

STRAIGHT EDGE A straight edge is a reliably true rule for use as a cutting guide. A plain steel ruler will serve, preferably engraved with both a millimetre/centimetre scale and one in inches and fractions. For this basic type a 300 mm/12 inch length is sensible since without a non-slip backing the larger sizes may move in use.

A metre-length rule with a rubber non-slip back, though costly, is both safer and more practical. Such rules are bevelled along the cutting edge and they usually carry a mm/cm scale. The generous length is appreciated when you handle large sheets.

CUTTING MAT For years I used scraps of cardboard, plywood, formica etc. as protective backings upon which to cut paper. Such discarded pieces work well enough, but unless you are everwatchful a blade may be easily and disastrously diverted into old tracks.

A cutting mat, made just for this purpose, is so superior that it is definitely recommended. The material used has the peculiar property of allowing the blade to enter the surface while the cut edges meld together behind to leave an almost invisible trace. Mats are very long-lasting though wear does eventually show in often-used portions.

LAYOUT PAPER For the mediums described in chapter 3, I normally first sketch a skeleton framework directly on the surface chosen for the finished work before starting in earnest. If a complex composition is planned (p. 20), I then do the initial drawing on layout paper. This is a thin paper purchased in pads, with an agreeable surface tolerating considerable erasure – elements may be drawn and redrawn until the effect pleases. The design is then taped into the intended position, graphite tracing down paper

(below) is inserted under the layout paper, and the drawing is transferred with a pricker (below). The process is described in detail on p. 20.

If your hand lacks confidence you might make a practice of refining your drawing first on layout paper in this way. Erasure should always be kept to the minimum for the finished version to lower the risk of smears or damage to the paper.

GRAPHITE TRACING DOWN PAPER Though this may be bought, I make my own to control the density of the traced-through line. A piece of layout or other thin paper about A4 size is convenient. Middle grade pencils, HB, F or H, are used to cover the sheet working almost to the edges. Several layers are needed to ensure an even density. The primed paper is then burnished over carefully with rag or tissues to remove loose graphite – this step renders marks less likely to be transferred inadvertently by finger pressure. The intensity of the traced-through line may be adjusted: further burnishing will be needed should the line be too dark, and more graphite may be added if the line is too light. Creating your own graphite paper takes only a few minutes but this result should last for months. After long use the paper inevitably cockles and it should then be scrapped.

PRICKER This tool, a needle-like rod set in a holder, is used to trace a fine line through layout paper onto the final surface (p. 20). A pricker may be bought or you may make your own. I have one fashioned from an old compass point inserted securely into a red-barked maple twig.

HAND-LENS By using an 8 to 10 diameter lens, details of plant construction are clarified and beauties revealed. The lens should be held close to your eye and the subject approached or raised until it is brought into sharp focus.

DIVIDERS AND RULER Though a ruler serves to take measurements from a plant subject, I prefer dividers because the points are easier to manoeuvre.

SCALPEL After using various tools for sharpening pencils and for other light cutting, I have returned to a scalpel. Mine is an antique model with an integral blade – the edge is renewed with a fine-grained stone.

Of course there are many other suitable lightweight instruments that you may

prefer. Some feature blades that are both disposable and retractable.

I do not care for the office-type mechanical or electrical sharpeners as these yield leads that are, for me, too short. Scalpels with replaceable blades are best for dissections since only the keenest edges are appropriate for parting delicate plant tissues.

FEATHER A pinion from a large bird, such as a goose, cannot be bettered as a device for swishing away erasure crumbs. A visit to a suitable lake or waterway during the summer moult should secure you a supply to last for years.

PLANT CONTAINERS AND 'OASIS' Jars, vases and bottles are all useful depending upon the sizes and shapes of the plant subjects.

Florists 'oasis' provides an excellent steady base when placed in a saucer of water. The yielding substance will accept many stems before needing replacement.

TAPES Special drafting tapes are helpful, particularly for temporarily holding layout paper in place (p. 20), as well as for other minor uses. This lightly adhesive tape may be lifted without damaging the paper surface.

'Magic' tape has like properties as well as being virtually invisible when smoothed down – useful in photocopying. Masking tape will do, but after use it must be removed with greater care, especially from fragile grounds.

VASCULUM A vasculum is a handheld metal container designed to carry specimens collected in the field. Plastic bags are now more widely used for this purpose. For smallish delicate subjects I use a plastic box lined with damp paper towelling. It is doubtless pretentious to call such an object a vasculum – yet it serves just as well, and I find it pleasing to keep this traditional link.

Professional workers will probably already possess the basic equipment described above, and more besides. If you are a beginner the list may seem daunting. Even so, you will find that several items are likely to be already to hand, some are easily made, and others may be adapted.

This short inventory represents the equipment that you should aim to have in order to work comfortably, yet you can manage with very few essentials. The same is true for each medium – if you have a tight budget, you may still do fine work with a minimum of simple tools.

2 DRAWING PLANT STRUCTURES

A pencil line-drawing is necessary for all representational plant portrayal, whether it is used as a preliminary step before finishing in another medium or intended to stand on its own.

In making a drawing you are in a position to contemplate the intricacies and beauties of pure plant form at one remove from their associated colour and tone. This is part of the 'why' of the work as outlined in the Introduction. The present chapter is concerned with 'how'. The fundamental basis of drawing is discussed briefly. Then, after describing choosing and siting the plant model, and the general sequence of work, a brief survey is given of common plant structures together with tips on drawing them.

HOW DO WE DRAW? Eidetic imagery is the means by which the transfer of information is achieved. I use myriads of swift glances at the subject – each time carrying for a few seconds a mental picture that I attempt to capture in line on the paper.

Usually forms are first represented by a lightly sketched generalized line, which is then refined and detailed. So the mental image may be broadly focussed – as when establishing the midrib and broad outline of a leaf (fig. 8, *e,f*). Or it may be tightly focussed on a narrow section of minute detail.

The initial generalization is vital. If you plunge straight into detail it is all too easy to drift away from the main path. Once the outline is determined, the detail is added piece by piece. The amount drawn each time depends upon the complexity of the structure. To take a leaf margin as an example, should it carry small irregularly spaced and sized teeth, I find that my mental focus contracts to take in only a centimetre or less at a time. The process does not seem disjointed because my eyes flick back and forth from the original to the paper and each mental image necessarily continuously overlaps.

After so long portraying plants, I cannot say that my capacity for accurately memorizing fine detail has enlarged perceptibly – though I do find it easier to record the eidetic image through a gradually improved facility in using a pencil. I have no idea whether such innate capab-

ilities are fixed or whether they might somehow be enhanced.

In mentioning my imperfect skill, I should emphasize that I am referring to a fine degree of accuracy. A whole plant – and more or less anything else – may be completed from memory in loose form, but the transference of detail remains a challenge.

Fortunately, pattern is a crutch to ease the way. Regular arrangements such as spirals are sometimes present – once these are grasped it becomes feasible to carry in the mind larger amounts of information than if there are only disparate elements.

CHOOSING AND SITING THE MODEL I spend a great deal of time selecting material. If the plant is not well known to me, I first try to read up about it – many species have interesting features that are not readily apparent. Usually with wild flowers I will know where particular plants are to be found – this from years of weekend wandering. All of the plants shown are relatively common so their collection was in the main straightforward. Depending upon their nature I carry specimens in either plastic bags or a *vasculum*.

As plants frequently wilt after picking, I find that whenever feasible it is best to allow them to recover overnight in a cool room with their *stems* deep in water. Such a period also often allows fresh flowers to open – sometimes these are of better form than those that have been exposed to winds and other rigours.

In preparing to draw, the plant model – sitting in a jar or 'oasis' – is placed to the left or right of the work surface depending upon which hand you favour. For reference, several other specimens are normally kept in jars close by.

The *inflorescence*, or other focus of interest, is raised or lowered to be at eyelevel. Books of various thicknesses are the easiest means of adjustment – these are protected from water spills etc. by a piece of card.

The model is slowly turned full circle again and again to ensure that the best position is selected. The aim is to reveal the special characteristics of the plant while making judgements about the

eventual composition – including the possible introduction of further elements. At this phase I sit as if drawing so that from my working viewpoint I can pick out parts of the plant that are in alignment – for instance, where the tip of a leaf to the rear of the plant intersects a stem at the front at the point where a bud emerges. For precision such fixed references are chosen with one eye closed. As the drawing progresses these markers are checked now and then to ensure that everything is recorded from the one position.

Occasionally you will find a plant that is unusually motile – as when an inflorescence tracks the path of the sun. Such movements add difficulty to the work, but generally there will be time to record a given stage.

DRAWING SEQUENCE Drawings develop in logical steps. Assuming that the plant model is in place, and paper has been selected appropriate to the image size and to the finishing medium (*see* chapter 3), the sequence is as follows:
(a) Lightly pencil in margins. Unless the image is to be much larger or much smaller than the average, I like to have margins of between 20 and 30 mm at the top and sides, and rather more at the bottom.

If the drawing is to consist of a single component – perhaps a stem with flowers – the width of the work is simply that of the plant model, with the margins added to this dimension. The length will usually be a little more flexible, depending upon how much stem you wish to include. These measurements are transferred from the model using dividers or ruler. Should several components be planned, I estimate the likely width, taking care to leave enough space for the above margin widths to be maintained.

The blank surround should not be breached – works are spoiled by allowing the drawing to press to the sheet edge and so appear cramped. Once the plant is established, the faintly indicated margins are erased unless, as in the great bindweed (p. 35) etc., they are an integral part of the design.
(b) Keeping the protective sheet under your hand, sketch in the main compo-

nents. Typically, from the model already placed, the central axis might be shown with a single line, then dividers or a ruler would be used to transfer key dimensions as described on p. 20. Working down from the top margin these would show the positions of features such as the depth and width of the inflorescence and the points from which branches emerged etc. If more material is likely to be added to round out the composition, it is often helpful to rough in a few lines to serve as loose guides for later placement. The initial skeletal framework should be kept very light to allow its easy erasure as fining-up progresses.

(c) The drawing is developed working between the marked key points. Simple structures, such as stems etc., may be drawn directly by following the lightly sketched axes. Complex structures, as mentioned earlier, are more easily managed by first drawing a generalized outline, and then filling in the detail.

After the main component of the drawing is completed – usually a stem bearing flowers – supplementary elements may be introduced. These might be further stems with flowers, or perhaps fruits. Enlarged details are frequently more conveniently entered last (often after the rest of the work has been completed in watercolour or another medium) but space should be set aside at an early stage.

(d) As you finish the drawing, stand back to examine it for a short time. Flaws may be spotted and corrected at this point – quite small changes frequently have a large effect. A usefully fresh image is achieved through looking at the work reversed in a mirror. The quality of the completed piece depends upon this foundation. A fine drawing may stand alone but weakness cannot be hidden; conversely, a strong beginning will flatter inept tone and colour to some degree.

PLANT STRUCTURES Common structures are surveyed below with an emphasis upon drawing them rather than their botanical significance. Technical terms are kept to a minimum: a glossary appears on pp. 9–10. The text concentrates mostly on the structures that you will meet in the wild flowers portrayed. (A wider treatment is given in *How to Draw Plants*). Readers interested in plant *morphology* and its terminology will find many general botanical texts which cover the subject.

FLOWERS A diagram of an *angiosperm* flower is shown in fig. 3. It seems surpris-

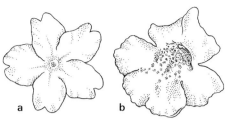

1. *a*, actinomorphic flower, primrose; *b*, zygomorphic flower, monkey flower

ing that from these few basic components comes an inexhaustible diversity of beautiful forms.

A wealth of technical terms is associated with this abundance, but for the botanical artist just beginning it is helpful to recognize just two main categories of flowers: these are *regular*, or *actinomorphic* – radially symmetrical (fig. 1,*a*); and *irregular*, or *zygomorphic* flowers – divisible into matching halves along one plane only (fig. 1,*b*). A few groups have flowers that are not divisible into like parts (some authors have confined the term 'irregular' to this form – here I retain the less restrictive use).

Regular flowers are usually straightforward to draw. The radial symmetry means that most measurements may easily be taken starting from the centre. The primrose (fig. 1,*a*) serves as an example: the central point is first established on the sheet; the radius of the flower is determined and the broad ellipse described by the petal apices is entered; the lobes are fined-up and the central throat detailed. Other regular flowers have more visible sexual parts, but for the most part they may be drawn in much the same way.

Irregular flowers, such as the monkey flower (fig. 1,*b*), are testing in that their

elements are more difficult to keep in proportion and balance. The irregular form clearly shows bilateral symmetry when viewed from the front – in this position measurements are not hard to take and the readily appreciated pattern eases drawing. Unfortunately, three-quarters, or more or less side views are usual alignments and these present problems since symmetry and pattern become less apparent. Measurement then tends to be awkward, especially as blooms are often held at an oblique angle; judgement and skill are needed.

Notes are given for drawing individual wild flowers in their associated text.

A cluster of flowers on a stem is an inflorescence, and there are many inflorescence types. Each is named, and characterized by a particular arrangement of flowers on the axis and in relation to each other. Inflorescences consisting of numerous flowers are demanding to draw, and only two obvious ones are included: the rosebay willow-herb and the honeysuckle. A common cryptic multi-flowered inflorescence type is confusing in having the superficial appearance of a single flower. This is the *capitulum* (fig. 2), which is especially associated with the huge family Asteraceae (Compositae, composites). The form is represented in this book by the knapweed, Asteraceae, and the field scabious, Dipsacaceae. Each capitulum consists of a tight aggregation of usually *sessile* (stalkless) flowers. These are typically of two kinds: *disc florets* at the centre of the flower head, and *ray florets* at the periphery. As the diagram suggests, the florets may be markedly distinct, as seen in daisies and dandelions; or apparently less differentiated, as in the knapweed.

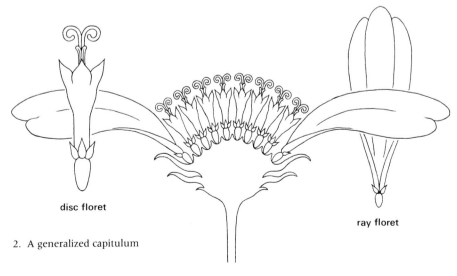

disc floret

ray floret

2. A generalized capitulum

The key to drawing a daisy-type capitulum is to appreciate that the form is composed essentially of two main ellipses. One is described by the outer edges of the ray florets, and the other is from the rim of the disc florets. The depth of these ellipses depends upon their relation to your eyelevel and the angle at which the capitulum is held on the stem.

Of course, apart from the simple ellipses, there are subtleties to consider – the petals (strictly, *ligules* of the ray florets) may be raised or lowered in relation to the central disc, and they may be contorted in various ways. Larger capitula may show a distinct spiral arrangement of the disc florets, especially evident when they are in bud. Such spirals are also present in smaller flower heads – as in the common daisy – though a hand-lens may be needed to pick them out.

Care should be taken properly to place the capitulum on its supporting stem (*peduncle*) by tracing the axis through to the centre of the head.

SEX EXPRESSION In considering the sexual parts of flowers a few terms are necessary, and in the main these are given in fig. 3.

The diagram shows the male, pollen-bearing organs, the *stamens* – collectively, the *androecium*, 'house of man'. They are depicted surrounding the female, *ovule*-containing organ, the *pistil* (single here, but frequently multiple) – the *gynoecium*, 'house of woman'.

Flowers with both pistils and stamens are termed *perfect*. Sometimes either pistils or stamens are lacking and the flower is then *imperfect* and *staminate* or *pistillate*.

From these clear-cut arrangements there are many variations. Reproductive systems are diverse and fascinating – different strategems may be found within a species or even within a population (*see* primrose).

As stamens and pistils have not been shown in detail on the plates, their forms are not discussed here. Yet they are well worth scrutiny with the hand-lens because their interest is usually only appreciated through magnification. During years of peering down a dissecting microscope I have revelled in the sheer elegance and beauty revealed.

Care should be taken to place correctly the sexual parts in relation to the surrounding *floral envelopes* (that is, the inner whorl, the petals – collectively the *corolla*; and the outer whorl, the *sepals* –

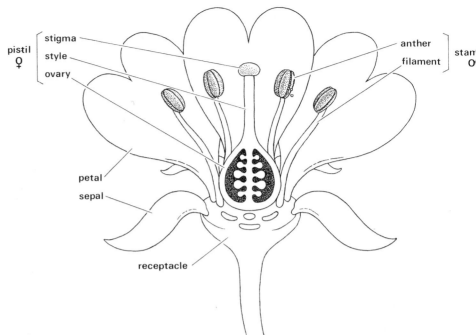

3. Flower parts

collectively the *calyx*). The relative position of the *ovary*, the potential fruit, is especially important.

FRUITS During the late autumn and winter months, wild flowers themselves are not much in evidence, but their fruits are often so eye-catching that they may well be featured on their own or included as details. You will see that the painting of the dog rose is paired with one showing its fruits, the glowing red hips. For numerous species with attractive fruits, matched paintings may be considered. Another approach, if you have enough patience, is to keep a work stretched on the board so that a fruiting stage may be added in season.

Just as for flowers, a large terminology specifically applies to fruits. In drawing fruits it is not vital to know the appropriate technical description, but it is satisfying to know at least the broad type and this may easily be looked up. The following are familiar kinds: dry – *achenes, capsules, nuts, follicles* etc.; wet – *drupe, pome, berry*, and so on.

Ripening hops are the only fruits in these pages to show a distinct spiral formation, but it is worth pointing out that spirals are to be seen in the structure of many fruits – especially compound ones such as blackberries. Earlier, under flowers, I noted spirals in the disposition of disc florets. Perhaps it should be stressed that spirals occur in many plant structures: sometimes clearly, as in pine cones; masked as in the involucral bracts

of the knapweed; or quite hidden in elaborate petal arrangements.

SEEDS Few seeds have been shown on the plates. Most are small and the hand-lens is needed to examine them. Horse chestnuts, conkers, are an exception. The seeds are strictly not nuts, though the term is commonly applied and I have followed this loose usage in the text to alternate with 'conkers'. The markings on the shiny coat are reminiscent of fine wood grain. Unfortunately, this fades on exposure and in any case is too subtle to capture at life-size.

Seeds are sometimes reproduced enlarged in black-and-white illustrations for scientific journals. Forms and surface details are often exquisite and they make excellent and unusual subjects for paintings – though for this purpose a dissecting microscope is almost imperative.

STEMS Throughout the descriptive text associated with the plates, I have generally used 'stem' as an unambiguous overall term. Properly, the stem is the main axis of a plant. The 'stems' or stalks of particular organs have their own nomenclature: leaves have petioles; single flowers in a cluster are borne on pedicels; and flower clusters or solitary flowers are supported on peduncles, etc.

Stems (again in the broad sense above) are normally drawn using two more or less parallel lines. As discussed elsewhere (p. 19), after one line is established it serves as a guide for the other. Such lines

describe the simple cylindrical form typical in many plants. But other shapes are not uncommon – for example, the stem of the monkey flower has a distinct angularity. Such characters, sometimes diagnostic, are always worth including.

Stems may be woody or *herbaceous* – often both phases will be present at the same time, and an effort should be made to capture the texture of each. Apart from the modelling noted above, stems often bear a variety of markings, these include: pigmentation; *leaf scars*; and *lenticels* (tiny orifices indicating the sites of gas exchange), as well as the *trichomes* discussed on p. 17.

STORAGE ORGANS AND ROOTS Increasing environmental pressure on wild plants has led to their protection by legislation. Digging them up for portrayal with roots included was a frequent practice in the past, but today this is no longer appropriate. Exceptions might be made for specimens grown from seed in the garden, though even for these I am inclined not to show the underground parts unless they have features of special interest such as *tubers*, *bulbs* and *corms*.

The plates in this book do not include *storage organs* or roots and so they are not detailed here (for the specialized purposes of scientific botanical illustration they are included in *How to Draw Plants*).

LEAVES Leaves are adapted to perform their functions in an incredible range of habitats. Shape, texture, *venation*, *vesture* etc., may all be relevant to the success of the individual as well as being characteristic of a particular *taxon*. As for other plant organs, there is a daunting vocabulary applicable to leaf features. It is fortunate that only a few terms are needed in describing how to draw them.

1. *Outlines* Leaf shapes are confusing in their multiplicity. In trying to comprehend this diversity, it is helpful to understand that, in spite of elaboration, there are a small number of basic underlying forms (fig. 4). Also, leaves consist of merely three main morphological components: *petiole* – the stalk, this may be absent and the leaf is then sessile; *lamina* – the *blade* or expanded portion; *stipule* – usually paired, often minute or absent, the stipules are basal appendages of the petioles (*see* the dog rose).

As might be expected, complex leaf outlines are challenging to draw. Yet even the most simple forms should be treated with respect because on analysis they reveal surprising refinements that are frequently stable enough to be used in identification. Merely by altering the position or angle of the widest part, the appearance of the leaf is radically changed (fig. 5, *a-d*). Similarly, small amendments to the outline of the leaf base (*e-g*) or the apex (*h-j*) have a striking effect.

2. *Margins* After looking at leaf outlines we now focus on the nature of their margins. These may be loosely categorized in order of complexity as shown in fig. 6, *a-g*. The diagram is not comprehensive, only basic forms are included.

A profusely toothed and deeply dissected margin may obscure a relatively simple overall form; as I noted earlier (p. 12), the method of drawing is first to generalize the outline before filling in detail, as shown in fig. 7. The dashed line represents this lightly drawn 'averaged' outline. Indicating the positions of the major lateral veins is also helpful in achieving accuracy.

3. *Surfaces* Various modes of venation and modelling are found in leaves and these very much influence the appearance of the plant.

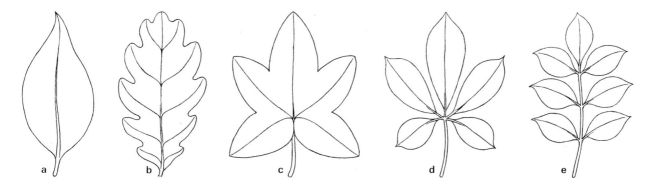

4. Common leaf forms: *a*, simple; *b*, lobed; *c*, palmate; *d*, palmately compound; *e*, pinnately compound

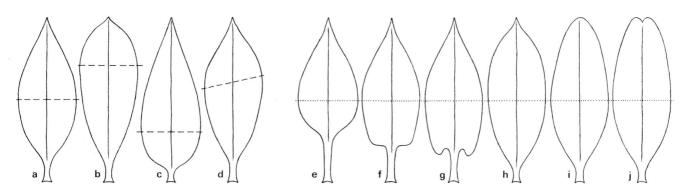

5. Changes to leaf outline

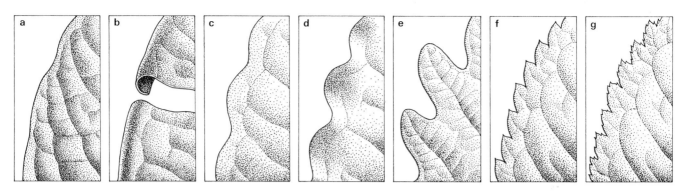

6. Basic margin types: *a*, entire; *b*, revolute; *c* sinuate; *d*, undulate; *e*, lobed; *f*, serrate; *g*, double serrate

There are two major patterns of venation: the parallel veins of *monocotyledonous* species (represented here only by the snake's head fritillary); and the netted venation of *dicotyledonous* species. The venation patterns of dicot leaves are especially diverse.

Always try to comprehend the particular formation before drawing. Midribs of leaves are straightforward, but lateral veins are more complex: they may be few or many, originate from the base of the leaf, or from along the midrib, and be either opposite or alternate. In some species the lateral veins may approach the margins and then curve away, in others, lateral veins may be followed to the tips of *serrations*.

It is a matter of judgement as to how much of the network is shown. The aim should be to capture the essential character of the leaf. There is a temptation in deciphering obscurely defined patterns to make them rather more distinct than in life – avoid this. Also, even though every tiny trace may be sharply visible, overworking the surface by attempting to show all will be unconvincing as well as tedious.

Surface modelling is affected by venation. Many species have smooth leaves, others show varying degrees of rucking between the veins – though sometimes this is largely confined to areas between the main lateral veins, minor veins may also be involved. The primrose's *rugose* leaves represent an extreme example of the latter condition.

Leaf textures may also be mentioned here. Surfaces vary from shiny to matt. These qualities may be due to inherent characteristics of the epidermis, which in turn may be modified by the presence and density of trichomes (treated separately below).

4. *Posture and arrangement* The habit, or general aspect of a plant is much affected by the angles at which the various structures are held. Stems, branches, inflorescences and leaves are all carried at certain angles: their posture.

Most species portrayed here have leaves that maintain a more or less stable posture – though this may be influenced by the time of day, water etc. Others show greater degrees of motility: the wood sorrel is an extreme example – the varied postures of this species' leaves are characteristic.

Most leaves are angled slightly downwards in relation to the stem and these are best drawn working from the top towards the bottom of the sheet. Occasionally, you will draw plants in which the leaves are virtually erect and overlapping – for these it is easier to move from the base upwards.

The ways in which the leaves are positioned on the stems are significant. Common arrangements are opposite, alternate, whorled, or spiralled. Within these categories there are other technically named possibilities. There also may be combinations on a plant –

willow-herbs have opposite leaves on much of the stem, but as the inflorescence is approached they usually alternate.

5. *Leaves in perspective* Leaves viewed from above present the easiest configuration to draw – but this is rarely the position in working from life (the blackberry *compound* leaf on p. 97 is one example). I try to orientate specimens so that many of the leaves are placed below eyelevel to expose as much of their surface as is feasible. A side view is preferred because this limits distortion through foreshortening (fig. 8,*a*). Most stems will have a few leaves that more or less face forward to give a three-quarters view, *b,c*. The full-frontal siting, *d*, looks contrived and is best avoided.

In all instances the line of the midrib is first established, *e*; the generalized outline is drawn, *f*; then the veins are entered together with the margin details, *g*.

Foreshortening tests objectivity. Strive to see foreshortened structures (all organs) just as they appear – not as you know them to be. Your mind may insist

7. Stages in drawing a complex margin

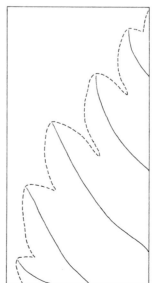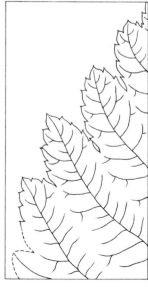

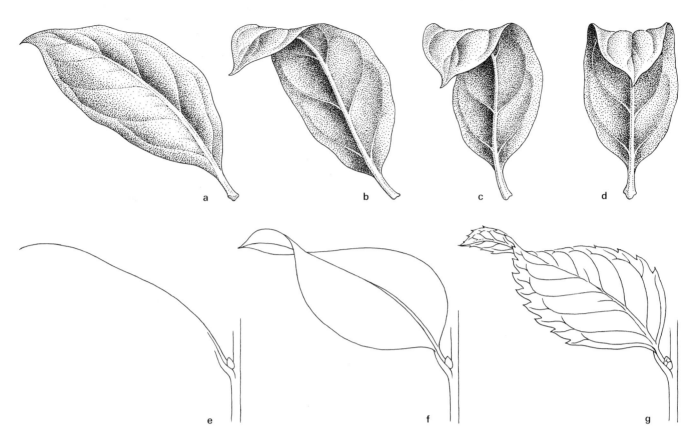

8. *a–d*, leaves in perspective; *e–g*, steps in drawing a leaf

that what you see is not far from the real length, rather than the much reduced version that you should record. To demonstrate degrees of reduction, pluck a leaf, hold it on the paper showing its full length and measure this off on the sheet; then manoeuvre the leaf to turn it towards you through various orientations, marking down the foreshortened dimensions.

It is convenient to consider the drawing plane as bissecting the axis of the plant model. On this plane leaves etc. may be measured directly with dividers or ruler. Structures falling behind the plane or in front (as in leaves slanting forwards) should accordingly be slightly reduced or enlarged. I usually measure only a few key points on the drawing plane, and place other elements in relation to these by eye.

BUDS *Buds* of flowers and leaves show features that are species characteristic.

Many of the wild-flower plates show flower buds, because I like where possible to show several phases – from bud to full bloom and sometimes senescence. The buds are usually covered by the enfolding sepals of the calyx which may be either *persistent* or *caducous*. If flowers are to open early in spring they are often pro-

tected by an insulating layer of hairs on the calyx (as in the primrose) or there may be other strategems. Where you can, try to show the unfurling corollas because the different modes are interesting.

Leaf buds appear less often in the plates since leaves are often fully opened at the same time as the flowers – an exception is the late season honeysuckle in which small tight buds for next year's leaves are seen in the leaf *axils*. Perennial species' buds overwinter by various means; many are protected under overlapping scales which are often arranged in spirals.

Leaf buds have not been featured as separate subjects here (except for winter buds) because it has been difficult to fit them in at the appropriate time. I do suggest as topics the leaf buds of species such as the sycamore, ash, and horse chestnut. Those of the sycamore in particular, when engorged and beginning to burst, are elegant in line and in their subtly modulated colours.

TRICHOMES Trichomes are outgrowths from the epidermis, such as hairs, bristles, prickles and scales. In the main they are structures best examined by using a hand-lens or dissecting microscope. They are categorized using botanical terms as to their structure, size and density. Com-

monly they are found on leaves, stems, petioles and calyces; occasionally they are also present elsewhere. Plants bearing no trichomes are *glabrous*.

Where trichomes are present they are often characteristic of a particular taxon and so should be recorded. Should hairs be dense, there may have to be a certain compromise – if you try to enter each one the effect will be quite unreal. Generally it is proper to show them where they are most visible along the margins of stems, leaves etc., and perhaps to indicate a few in Chinese white where they show up against darker surfaces. If the finishing medium is ink, hairs may also be judiciously entered to a certain density on leaf blades etc., again striving for an overall impression. Some species are densely woolly or *tomentose* – these are best portrayed using gouache.

Though it may be necessary to stylize density, the length, posture and character of trichomes should be rendered as accurately as you can. Taking hairs as examples, they may be erect, *appressed, bifurcate* to *stellate, glandular* or *eglandular* and so on. Not uncommonly, two layers of hairs may be present, but as with the field scabious, it is often not practicable to show this arrangement at life-scale.

3 MEDIUMS

PENCIL

Perhaps the most obvious use of pencil is for linework, and line (pp. 19–20) is a necessary preliminary in botanical water-colours. Works in pencil line alone may also be effective – different line widths and intensities being used to suggest light, shade, and emphasis.

Areas of tone and tonal gradation may be realized by using either hatching (pp. 20–21) or continuous tone (pp. 21–2). Hatching is appropriate when rapid completion is a factor and where the finest level of detail is not required. For the sharpest detail and the subtlest transition from light to shade, the technique of continuous tone, though time-consuming, is ideal. The techniques of line and continuous tone tend to be used discretely. Hatched work is usually bounded by line visible to a greater or lesser degree.

EQUIPMENT
Requirements specifically for work in pencil are detailed below. Refer to chapter 1 for descriptions of basic items needed for use with all the mediums featured, and p. 8 for general tips.

PENCILS Most quality brands of graphite pencil have a range of some twenty levels of hardness, moving from the softer darker leads, 9B to 2B and B; followed by HB, F, and H, the middle grades; then 2H to 9H, the harder lighter leads. Artists' quality grades should always be used.

For the work described in this chapter the softer pencils are unsuitable; though they produce excellent darks, these are easily smudged. Fine lines from these grades are only possible through constant sharpening. Harder, lighter leads yield fine lines sustained over prolonged use, but these are too light in tone for our purposes. Normally I prefer to use pencils from about the middle of the range: depending upon the paper ground, HB or F pencils are the usual choices. The most intense black is not attainable with these grades and occasionally an area of tone may be deepened by blending in touches of B or 2B.

EXTENDERS I like a pencil to be long, resting lightly in the hollow between the thumb and first finger. Well before sharpening has shortened the shaft into a stub, the pencil is inserted into an extender. This allows use up to the last few centimetres of lead. Pencil extenders used to be commercially available though I have not seen one for a decade or so. The empty barrel of a fattish pen is easily converted to be a satisfactory substitute.

PAPER In making a drawing the characteristcs of the paper are equally as important as the quality of the pencil: hardness, texture, thickness, colour, and durability are all considerations.

Hardness and texture (tooth) are largely linked in the search for the perfect paper – this might be described as having a slightly elastic hard surface withstanding eraser use, with a very fine, almost invisible texture or tooth. The slightest tooth will anchor graphite particles to give a homogeneous tone of considerable depth. But if the tooth is too coarse its formation will be thrown into obtrusive relief by the differential retention of pigment.

At the other extreme, a slick-surfaced hard paper records only a light grey tone no matter how persistently the pencil is applied. Soft papers are also unsuitable, leaving aside textural qualities, in that the pencil point makes grooves and quickly disturbs fibres. Again, a soft surface rapidly breaks down under erasure.

The thickness of drawing paper is not critical, though a flimsy paper may feel of lesser quality than a thicker one of like performance.

Paper colour is simply a matter of preference. I like a slightly off-white ivory or cream ground rather than a harsh white.

Rag-based paper ensures permanence; wood-based paper may discolour quite rapidly on exposure to light.

ERASERS Today there are many excellent erasers, though I have not found one that works well on all grounds. I keep a couple to hand spanning all needs: one is for everyday use, and the other is a plastic eraser of smooth consistency which is useful for cutting out white lines (p. 22), though it smears on some hard surfaces.

Soiling from the pencil lead is always found around the part of the eraser in use. As the grip on the eraser is changed, the dirtied portion may easily make an impressed smudge which is difficult to remove. To avoid this nuisance, the eraser edge should be kept clean by rubbing on scrap paper – a virtually automatic action.

FIXATIVES Fixative sprays are intended to form a protective film over works that might otherwise smudge or lift. Pencil drawings may be finished in this way – though there can be no guarantee against eventual discoloration. I prefer to avoid them: in using mainly HB and F pencils the risk of smudging or transferring graphite is diminished, though where B or 2B pencils add depth to blacks a more careful handling is called for. Drawings framed behind glass are safe from the above problems if they are to be filed, the ideal is that each should be faced with tissue paper and placed in a folder without scope for lateral movement and free from heavy pressure. Provided drawings are handled gently and stored sensibly they should come to little harm.

TECHNIQUES
In this section, pencil line, hatching, and continuous tone are described and illustrated. Exercises show effects achieved in practice, in each instance a leaf is used to make comparisons easy.

If drawings are made entirely by using movements of the fingers or wrist, clenching and cramp ensues and your work will reflect these restrictive motions. For best results the whole arm is involved in movement, with strokes originating from the shoulder – though some actions, as when making short parallel lines, use the elbow as a pivot.

Allow the pencil to rest lightly in your hand at an angle of about 30 to 40 degrees to the paper surface. The fingers serve only to keep the shaft in place without themselves moving independently. Then, with your forearm placed on a protective sheet and the tip of your little

finger used as a support, you are ready to start.

LINE To explore the possibilities of pure line in pencil I suggest that you make a tryout doodle similar to fig. 9 (reproduced at actual size). For this an HB pencil was used on cartridge paper.

Though I term fig. 9 a doodle, it is also a considered drawing done to illustrate the qualities of pencil line as they might be applied in working on plants – for this reason the forms are all loosely plant based. An imaginary concept was used because if you draw something similar you will be able to concentrate on the line without being distracted by constantly having to refer back to a plant model for dimensions etc. (The next exercise will provide this additional component.)

The pencil line should be clean-edged and unwavering – unless drawn otherwise for a specific purpose. If you are blessed with an enviable natural facility you will be able dextrously to place long lines using single strokes following complex shapes. I suspect that this ability is very rare, and most of us are only able to draw with precision through a series of shortish strokes with the beginnings and

ends blended imperceptibly. Preliminary lines are sketched with the faintest pressure. An eraser is then used gently to dab out unwanted marks before the correct line is strengthened. This sequence was followed in making all the outlines of the larger forms in fig. 9. It is common practice in establishing outlines throughout.

Simple smaller elements within a finished outline may be drawn with more confidence using only one or two strokes. In the exercise the minute circular markings at the bottom left were done in this way without taxing skill, though had they been derived from an actual plant organ it probably would have first been necessary to sketch in lightly some of the key elements as guides before completing the rest of the pattern.

Much of fig. 9 consists of roughly parallel lines. These are not difficult to draw provided that you first complete an initial marker line to be followed when drawing the next, which in turn serves in the same way. In being left-handed I keep the line that I am following above and/or to the right. If you are right-handed you will be more comfortable keeping this line above and/or to the left. Where lines twist about – as in the 'feelers' at the top left – you

will need to turn the sheet as you work.

For some drawings, as in the leaf of fig. 10, a developed tonal structure is not required, but fig. 9 provides a useful chance to see how an effect of light and shade may be shown through line alone. This is achieved in four ways: by variations in pressure on the lead along a line; by building up the thickness of a line in parts once it is established – as at the bottom right and elsewhere; by varying line spacing, and by using the eraser – see the lighter parts of the larger form on the right as well as those of the 'grass blades' and the highlights at the bottom left.

Remember to keep drawing from the shoulder (or elbow where necessary). This becomes an unconscious process so that eventually there seems to be a direct link between your mind and the pencil tip without intervening mechanisms. Should you have difficulty in reaching this condition, you might consider that the process is equally valid in handwriting – your letters may be comfortably written 'straight from the shoulder' while gaining useful practice.

For a first exercise using a living subject, a leaf was taken from a plant of alkanet, *Pentaglottis sempervirens* (fig. 10);

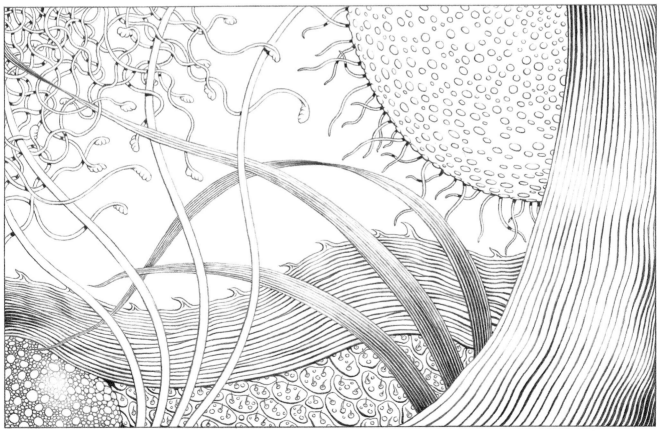

9. Pencil line doodle

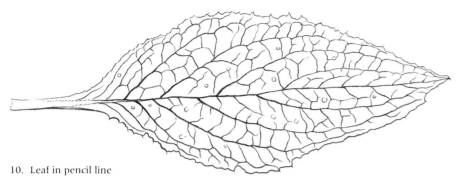

10. Leaf in pencil line

this being one of the few species available early in the spring with broad leaves interestingly veined and textured. Any similar leaf may be chosen.

An initial outline drawing was made on layout paper to be later transferred (see below) for three versions: to illustrate line alone, line with hatching, and continuous tone.

To have the leaf close by for easy scrutiny I placed it on dampened tissue paper in the lid of a plastic container – this was taped to the sloped surface of my drawing stand.

Before drawing I spent a few minutes examining the leaf to absorb its distinctive features. A hand-lens was used to explore such minute details as the vesture of small hairs, together with fine bristles – each of which was seated on a raised light-coloured base. Though these intricacies were too small to be represented in the final drawings, had this not been simply an exercise I would probably have included an enlarged portion to show them.

The first line drawn on the layout paper represented the midrib of the leaf as measured using dividers. The length was marked in and then the slightly fluctuating line, broadening out to the petiole, was sketched faintly to be fined-up as the drawing progressed.

Again using dividers, the widest point above the midrib was marked taking care to place it correctly in relation to the leaf apex and base. The same was done for the broadest point below the midrib. The leaf outline was then roughed in lightly.

Then the points of origin of the major veins on the upper part of the leaf were measured off along the midrib. These marked positions allowed like points for the lower area to be entered by eye before all the main veins were indicated. The first was the vein nearest the apex on the upper part which was followed from where it branched from the midrib until the end was obscured close by the leaf tip.

The remaining veins of the upper half were then placed, each in relation to the one before. The same sequence was used for the veins below the midrib line.

The minor veins, creating a network, were put in while adjusting and fining-up the lines of the main veins. The process was again started from the main vein nearest the apex on the upper left. During this stage the whitish bases to the bristles were suggested where they occurred in the reticulation.

The completed outline was then ready for transfer. I decided to use cartridge paper for both the line drawing and the hatched leaf. The leaf to be completed in continuous tone required the smoother surface of Ivorex board.

A piece of cartridge paper about A4 size was big enough to accommodate the first two drawings, and this was fixed to the working surface using small tabs of 'Magic' tape. The layout paper, with the outline, was taped into position over the cartridge paper using two pieces of tape along the upper edge. This allowed the graphite tracing-down paper to be freely slipped between the sheets.

A pricker was used to trace the outline through using the same sequence as when making the drawing. While carrying out this process I lifted the upper two sheets after a few strokes to check that the transferred line was distinct.

Once the first outline was transferred, the operation was repeated after the image on the layout paper was appropriately moved down. The whole sequence was followed through again on the Ivorex board.

Little more work was necessary to complete the pure line version of the alkanet leaf. An eraser used with a gentle dabbing motion left the traced through outline very faint, but still enough to follow with an HB pencil. Again the same sequence for lining in was used as in doing the original drawing (which itself would have been sufficient to keep as an

example had it not been submitted three times to the incisive pricker).

The HB lead was kept sharp and by varying pressure an attempt was made to suggest different intensities of tone. Along the major veins more emphasis was given by slightly widening the lines. As mentioned earlier (p. 12), this technique of pure line is fundamentally the same as that used as a preliminary step for all the mediums demonstrated in this book. The only essential addition for a line drawing intended to stand as a finished work is that the line itself should be made to carry information about light and shade by variations in its strength.

HATCHING consists of short parallel lines. Each one is made by placing the pencil point firmly on the paper and then making a stroke while gradually lifting the lead from the surface so the line tapers off. The bases of the wedges form shadowed areas where fade towards the light. The movement uses the elbow as a pivot – each stroke is made rapidly with a flicking motion. Tone may be deepened by returning to darker areas using the same strokes. I prefer this solution to that of cross-hatching (shown in ink, fig. 14) which can look too mechanical for an organic subject.

The technique is not to be compared with continuous tone as a means of depicting detail, but it is highly appropriate when the subject is large, when time is limited, or where the paper surface is of indifferent quality.

Hatching is a traditional method of shading. If you examine an old-master drawing you will find that the hatched strokes are usually orientated more or less in one direction depending upon which hand the artist favoured. For instance, Leonardo da Vinci, typically for the left-handed, used strokes running predominantly from top left to bottom right.

In a serious study having all the hatching sloped in the same direction gives a pleasing consistency of appearance. But for quick note taking, consistency is barely relevant.

Apart from the leaf below, I have not featured pencil hatching in any of the chosen plant subjects – this should not deter you from shading in this way wherever a broad treatment is needed.

The transferred outline of the alkanet leaf intended for hatching was lined in using an HB pencil, much as described earlier. The differences were that no

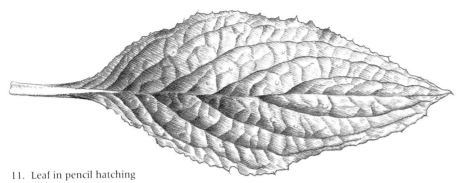

11. Leaf in pencil hatching

emphasis was given anywhere, and the minor veins were not lined in because sufficient weight would later be provided by the hatching.

As a left-hander I started the hatching around the top left margin of the leaf (fig. 11). For the purpose of the illustration I wanted to keep the individual strokes distinct so for these an H pencil was used in preference to the softer HB.

Almost all the strokes originate from the leaf margin or along one of the major or minor veins. In a few places hatched lines are not bounded – such free-standing strokes are seen below the mid-rib on the right. These were made with a brushing motion in contrast to the flicked strokes.

Completion of the drawing was straightforward – the hatching was carried over all the shaded areas of the leaf. The broader bases of the wedge-shaped lines supplied darker emphases. The light patches of the bristle-bases were left blank.

Back strokes were used at some points along the lower margins. This was because, in taking the hatching to the edge, the rapid motion of the flick stroke would certainly have broken across the line – a reverse action avoided this.

The leaf was again worked over adding a touch more pressure to define the areas in deeper shadow. I still felt that yet more contrast was needed to finish the exercise and so an HB was used to give more depth here and there.

CONTINUOUS TONE By this pencil technique the finest detail may be represented. The results can be striking, but the process is best reserved for smaller subjects since it calls for considerable patience.

Continuous tone is more exacting than either line or hatching in requiring a hard smooth paper surface. For figs. 12, 13, for the wood sorrel, and for the greater bindweed, an HB pencil was used on Ivorex board.

As well as the necessity of being able to draw with some ability, this technique requires the mastery of an additional skill – the capacity to make an even unblemished gradation in tone.

To demonstrate the process I again made a composition from imagination (fig. 12), reproduced here at the same size as the original. After the rectangle was ruled, two faint lines were drawn to indicate the positions of the central depression and the white vein to the right. My intention was to make a design which progressively became more complex. I suggest that you try a similar layout. The pencil is held as noted on p. 18, though for continuous tone a shallower angle to the paper is preferred – between 20 and 30 degrees.

The even gradation of tone from black to white on the left of fig. 12 illustrates the basis of the process which was used throughout the work. One movement was completed continuously – an ellipse, around 5 mm across (less where appropriate) kept shallow so that the centre was filled by the lower stroke. Without being lifted, the lead was applied both across the paper and also downwards to create an even area of light-grey tone. Before you start your version of fig. 12, try out the stroke on a protective sheet. You will find that if you revolve the pencil slightly as you work, the tip will become polished and in this form it will deposit less graphite. This is not a disadvantage because a buffed tip gives a more even first coat.

The bulk of the shape at the left was first established without attempting a gradation of tone towards the outer edge – this was left as a ragged margin until the bottom border was reached. I then returned to the top and blended out the ragged portion in a smooth gradation to white. This was done by continuing with the basic elliptical movement while applying less and less pressure until at the outer edge the lead was lifted. The gradation was not easy to achieve successfully and light touches of the eraser were needed at the zone of transition to white. (Resist blending graphite by rubbing with a finger, if done to any extent it leaves a greasy slickness). The same tone was applied to the central diagonal, trailing off the edges as described above.

12. Pencil continuous tone doodle

Next, the channel of the vein on the right was lightly pencilled and each small side vein was indicated by a single line. The outlines of the prickles and the 'blisters' were also faintly shown.

The tone was then carried to the right, skirting the prickles and leaving highlights on the 'blisters'. The pencil was halted just short of the lines of the minor veins so that each was left as a white trace.

At this point it had become plain that a counter was needed to balance the weight of detail on the right. I thought that a depression on the bland expanse to the left would help. Though the effect was not intentional, the concavity looked somewhat navel-like and this appearance was retained to hint at an intriguing metamorphosis.

The first phase, of lightish grey, was completed by fading out the tone to white or ending it cleanly at the margins and veins etc. The second and final phase was to bring the darker areas to a greater depth of tone. The pencil was sharpened frequently since a newly trimmed lead deposits more graphite than one that has been polished by use. Several coats were added moving backwards and forwards to keep the development even until completion.

Continuous tone is slow in use and this gives one time to plan ahead. So it is that erasure is usually not necessary for anything other than minor slips or for intended white lines. In *How to Draw Plants* I detailed the use of a plastic eraser to lift out white lines from a mid-grey tone. One end of an eraser is first sliced with a scalpel into a chisel-shape; unfortunately, in use the sharp edge erodes quickly and it has to be constantly re-cut. This is irritating, and because erasers are quickly used up I now reserve this technique for otherwise insoluble problems: for the portrayal of crisscrossing grass blades and like complexities.

To demonstrate the use of continuous tone on a plant subject, the third version of the alkanet leaf (fig. 13) was completed. The outline of the leaf as transferred onto Ivorex board was too dark, so I dabbed it with an eraser until just a trace remained.

Then, using the basic elliptical stroke with a buffed HB lead (as detailed above), a light-grey tone was taken from the apex of the leaf to the base. The upper half was done first, followed by the part below the midrib. By using extra pressure the tone was deepened in meeting each vein since

13. Leaf in pencil continuous tone

otherwise these features would have been obscured.

From this stage the process was simple yet subtle in application. I continued to add tone, gradually building depth, until the needed level was reached in the darkest shadows. The light patches of the bristle bases were left more evident than in either the line or the hatched treatments.

Two continuous tone drawings of wildflowers are demonstrated: the wood sorrel, *Oxalis acetosella*, and great bindweed, *Calystegia sylvatica*.

INK

Black ink is the traditional medium of the professional illustrator for works intended for publication in monographs, floras, scientific journals etc. The production of such ascetic drawings is detailed in my earlier book, *How to Draw Plants*. In this present volume ink is explored for the realistic portrayal of wild flowers. Though traditional methods are shown, the work is not restricted to the semi-diagrammatic treatment used for scientific purposes.

The technique used is that of line combined with hatching and stippling (pp. 23–5). It is possible to use hatching or stippling on their own, but normally a defining outline is helpful.

Hatching in ink seems less suitable than hatching in pencil when working on plants. The strokes appear harsher and less organic in feeling than pencil strokes which tend to blend softly. For this reason ink hatching is treated only briefly below.

The strength of black ink lies in its intensity and this characteristic is to be exploited. The same strength is also a weakness in that no matter how light your touch, the slightest mark is an uncompromising jet. Therefore a tonal transition in shading from near-white to white is only possible at a fairly coarse

level through stippling (fig. 14). (Reducing the size of the original in reproduction will lessen the apparent crudeness, though there will then also be a loss of other qualities.) In contrast, variations in tone in darker areas are much easier to make both by hatching or by stippling (fig. 15). In Chinese brush painting or pen and wash, ink may be diluted to modify tone, but these techniques are not covered here.

EQUIPMENT

Requirements specifically for work in ink are detailed below. Refer to chapter 1 for descriptions of basic items needed for use with all the mediums featured, and p. 8 for general tips.

PENS Today there are so many pens to choose from – ones with fibre, ceramic, or plastic tips. The major manufacturers all produce reliable instruments using light-fast waterproof inks. I use a three pen walleted set with tips of 0.1, 0.3, and 0.5 mm. Other sized tips expand the range but I have not found them necessary. Though these pens are disposable and not expensive, they last a satisfyingly long time.

In comparison with the nibbed pen, its modern equivalent is a joy to use: it never blots, the ink flows freely on demand and minute variations in pressure on the tip are sensitively reflected in the line width. Lines may be started or trailed off with the finest of traces and solid areas are easily blocked·in. As the pigment dries almost on contact you may closely space parallel lines without making unsightly blobs should they touch.

PAPER The many commercial uses for line work ensure a supply of rag-based papers and boards. The difference between the two is confusing: stouter papers of a certain thickness or weight are termed 'board', yet the same epithet also applies to papers mounted on card.

Several grades of surface are offered

ranging from the very smooth to an abraded finish. A smooth ground allows the pen the greatest fluency of movement, favouring rapid decisive strokes. An abraded surface has the slightest tooth which minutely drags at the pen tip; in fractionally slowing the stroke a more considered deliberate approach is encouraged. The difference is not excessive and you might wish to experiment with both surfaces.

Crisp clean-edged lines are obtained from all good quality papers and boards. Cheaper or inappropriate ones may yield lines that bleed.

In choosing surfaces for work in line consider that occasionally it may be necessary to erase. A hard-surfaced paper will generally accept judicious rubbing out.

Many like to use a brilliant white ground, but as for pencil I prefer a less severe off-white finish.

PENCILS Surfaces for work in ink are usually harder and less resilient than those intended for pencil or watercolour. Consequently, pencils used in preliminary drawing prior to inking should also be hard – lead grades from 2H to 4H are suitable. Softer leads do not maintain a point and are inclined to smear on erasure.

Bear in mind that paper responds markedly to changes in humidity. Dry weather dessicates and hardens the paper to give an ideal surface, but on wet days paper absorbs moisture and the pencil point may score unless you compensate with lighter pressure (or a softer lead) – such marks are permanent. Any remaining pencil lines are erased after inking.

ERASERS An ordinary pencil eraser is used on the preliminary pencil drawing but a more abrasive type is needed to erase ink. In recent years there have been advances in formulation and effective new erasers cause minimal damage if used with restraint.

Removing ink is a nuisance and is best avoided. Yet there are inevitably times when erasure is necessary. For best results use the ink eraser quite gently with a circular motion. With patience all traces of ink should be removed, the crumbs brushed away with a feather, and the clean surface renewed with a smooth pebble or other burnisher.

Minute slips, such as lines that run over borders etc., may be corrected with a scalpel. The method is to cut around the offending portion by merely piercing the surface. The edge of the patch is then lifted with the scalpel point before the whole is rolled away like a carpet. The cleared surface is not burnished because inevitably ink particles will break from the side of the corrected portion to be impressed into the paper.

It is possible to cover errors in waterproof ink with white pigment. I prefer not to do this since such corrections always remain obtrusively visible.

TECHNIQUES

The plastic-tipped pen of today is held in the same way as a pencil and the observations on p. 18 are equally applicable.

A trial sketch (fig. 15) will allow you to explore the characteristics of ink. The illustration is reproduced at the same size as the original.

For the reason given before (p. 19), an imaginative drawing was again used, this time to show the strokes and shading suited to portraying plants in ink. A secondary aim was to make a dramatic and interesting counterpoint of light and shade as the practice exercise should also be enjoyable to do. I suggest that you try a drawing of your own, also using shapes derived from plants.

Before starting, you will notice that in fig. 15 different means of shading are used depending upon the kinds of structures involved. These dots and lines are magnified in fig. 14, *a-g*, to show how each is contrived. Hatching strokes, *f,g*, are included, though, as mentioned, I rarely use them when working with plants. This is a personal bias and the techniques of hatching in ink, made in the same way as in pencil (p. 20), should also be one of your skills.

A working sequence for fig. 15 is described below to help you in making your own version.

1. As the drawing was to be more complex than that used for pencil line, I first made a rough in HB pencil on layout paper. Many changes are necessary in evolving such a composition, and had a rough not been drawn, the preliminary pencil work would have been done on the ground for the finished work, with the risk that frequent erasures would mar the surface.

2. The design was then transferred to 290 gsm Ivorex board by the process described on p. 20. After a drawing is transferred in this way, I often reduce the graphite lines by dabbing with an eraser while replacing them with a fine line from a sharp 2H pencil. This time the graphite transfer paper had reached just the right state after some weeks of use, so that the transferred line was of a quality which needed little fining-up.

3. I next ruled the border and outlined all the component forms using a 0.1 plastic-tipped drawing pen – this was used throughout the exercise. At this stage I began using the protective sheet.

4. The background was intended to throw the plant shapes into prominence so it was inked first using the modified stipple of fig. 14,*a*. This form of stipple is especially useful when fairly large areas are to be covered, since it allows a rhythmic movement to hasten the work (even so, stipple shading of any kind requires patience). The more or less 'S' shaped broken forms yielded an even tone which could have been kept lighter or darker by changing the spacing of the elements. This stipple is not suitable for use in shading minute structures because the component 'S' shapes then appear too conspicuous.

I held the background tone quite light with the intention of making later adjustments. In doing an ink drawing it is sensible to have shading light to start with; it may be intensified as the tonal balance evolves. In a complicated composition options are best kept open in this way until the progress of the work makes final commitment inevitable. If an area is initially too dark, correction is difficult to make.

Nevertheless, where you are confident of the intensity of the shading needed, it should be applied in one smooth operation. This is largely for your own satisfaction – such areas almost always have a better appearance than those that have been later darkened, though to anyone other than the artist the difference is likely to be invisible.

The background tone was later extensively worked over (see below) and the only original stipple is seen at the top, just left of centre.

5. The fruit shape at the upper right was then stippled using the short straight strokes of *b*. This type of shading is more successful on lighter areas, and though from the beginning I had intended that this zone should be dark, it did seem appropriate to start with it being lighter than the background. This allowed the possibility that had the composition developed differently the fruit shape might have become a light-toned feature embraced by dark sepals. (Perhaps for most works the final tonal structure is obvious

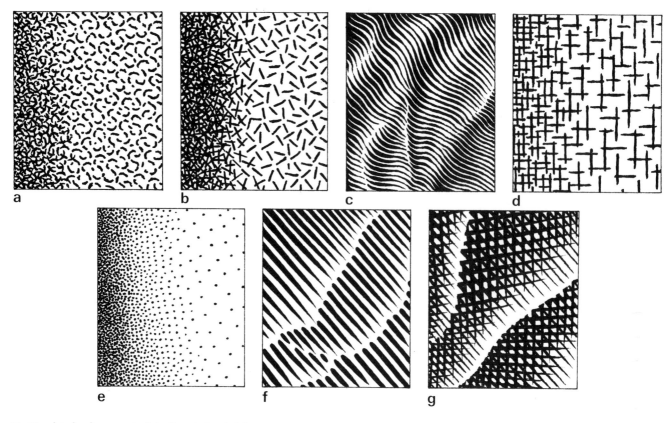

14. Simulated enlargement of shading strokes in ink

15. Ink doodle

from an early stage. With others, such as the present composition, several possibilities remain open for some time.)

Similar strokes, though much shorter, were used on the anthers at the bottom left as well as for the sepals of the flower at the top left.

6. For the rose-type stems I wanted to suggest a woody texture. Lines followed the contours as shown in *c*.

7. The *style* and *filaments* of the bottom left flower required a faint suggestion of cellular structure. The strokes of *d* were used, slightly curved where they were below eyelevel.

8. The dots of *e* were used for all the remaining forms. I find that dots are best reserved for light-toned areas such as the petals shown here. This is one form of stipple which should be put on in finished density where feasible. If you try later to squeeze in more dots it is hard to avoid a certain blotchiness.

9. At this point all the preliminary work had been done and the exacting but most pleasing final phase began.

The plate still lacked contrast and it was clear that the background needed deepening first to initiate a shifting in tonal balance. The modified stipple, *a*, used before, was applied until the background came close to the finished form. Patches of near black suggested vegetation as well as providing emphasis.

It had become obvious that the fruit at the top right would look best in glossy black. This was achieved again using stipple *b*.

10. A few touches adding extra weight brought the plate to its final state. One regret is that a feature not worked out in the rough, the soft-focus background vegetation, consists of shapes that should have been larger.

A fully developed drawing of a wild flower in ink, the wood anemone, *Anemone nemorosa*, is demonstrated on pp. 37–9.

WATERCOLOUR AND GOUACHE

As mentioned in the Introduction, watercolour has been used for some 3000 years to portray plants. Though today most botanical artists use what are generally called 'transparent' colours – more accurately they are translucent – many early examples are in the opaque form known as 'gouache' or 'body-colour'.

For clarity I shall reserve 'watercolour' for the translucent form and 'gouache' for opaque colours. Gouache and the types of subject for which this medium is best suited are treated separately (p. 31).

I confess to a leaning towards watercolour rather than gouache: translucent layers are applied, each modifying the others yet allowing the white of the paper to glow through. Watercolours may have a freshness and immediacy not attainable with gouache, though the latter medium has its own attractions.

The terms 'gouache' and 'body-colour' refer to the same type of opaque pigments, but they are frequently used differently when describing pictures. A work wholly in opaque colours is usually though not invariably known as a 'gouache'; one mainly in translucent colours may be noted as having 'touches of body-colour'. Such opaque 'touches' are sometimes the only sensible means of showing minute light-coloured features against darker grounds – as hairs and spines, or pollen on anthers etc.

While one subject may best be painted in gouache and another wholly in translucent colours or with touches of body-colour, you should avoid making a painting that is a patchwork of the two modes. The differences in surface will be obvious and ill-matched; though curiously, this effect is often lessened in reproduction.

EQUIPMENT

Requirements specifically for work in watercolour are detailed below. Refer to chapter 1 for descriptions of basic items needed for use with all the mediums featured, and p. 8 for general tips.

WATERCOLOUR PAINTS come in tubes or pans. I find tubes inconvenient and wasteful and I much prefer pans – though strangely, this is a minority choice. (The small containers commonly sold are 'half-pans', but as the full sizes are now rarely seen I shall continue to refer simply to 'pans'.)

Please buy 'artists' quality' colours, inferior grades are not appropriate. Fine colours are expensive, though in compensation only a few are essential. Readers of my earlier books may be aware that the pigments named there have differed somewhat over the years, but whatever the colours may be, the aim remains of achieving the most balanced spectrum with the fewest elements. Here is my present core of 10 hues: Winsor yellow, and the slightly warmer permanent yellow, cadmium orange, Winsor red, alizarin crimson, permanent rose, permanent magenta, violet, French ultramarine, Winsor blue. I could just manage without cadmium orange, permanent magenta, violet, and even French ultramarine (once my main blue) – the loss would be felt but would not be obvious in the work. For me Winsor blue has to a large extent replaced French ultramarine. I do not recall using the latter hue while working on the wild flowers in this book – yet it is retained, since the exact colour is impossible to mix. No colours other than the foregoing were used for the paintings described.

There are no greens listed. Through years of trial I have found that purchased greens have distinct deficiencies. Greens mixed from the palette above are preferred – the mixtures are detailed in the text where they are used. Also, I keep no manufactured blacks, these have a dulling effect not seen in an intense version of the shadow mixture (using several coats) described on p. 31. I do keep one tube, this is of Chinese white, used for white hairs and mixing gouache or body-colour.

The above colours are more or less permanent and they mix well together. In making further acquisitions you may occasionally find that a pigment behaves well on its own, but on mixing with others the results will be streaked or too unstable to allow a second coat without damage. Unfortunately, such undesirable qualities will only be found through use.

Pans may be bought individually and I would urge that you make a selection based on my list rather than take a manufacturer's set which will contain colours never needed.

Paint boxes may also be bought separately, though they are surprisingly expensive. The box lids are designed for use as palettes but they are usually insufficient in capacity and where wash mixtures are adjacent it is all too easy for one to contaminate another – *see* PALETTES, p. 26. Criteria for a paint box are that pans should be held firmly, that there will be space for new colours according to your inclination, and that it should be easy to clean.

BRUSHES must be of the first quality for you to achieve your best. Sable brushes are without equal, and of these Kolinsky sables are the finest – they carry pigment well, they maintain a point, and they last. Brushes of other natural hairs or of synthetic fibre are barely comparable.

Sable brushes are also costly, but only two sizes are necessary for the plant paintings described in these pages: brushes of grades 0 or 1 for tiny detail and a brush of grade 3 or 4 for the bulk of work. Rather than risk better brush tips, I reserve a slightly worn 3 or 4 brush for blending, a process that involves gentle rubbing.

If you are on a very tight budget it is possible to manage adequately with a single 3 or 4 sized brush.

Store brushes with their points intact and clear of contact. If they are unlikely to be used for several months, they should be placed in a sealed tube with a mothball.

PAPER may be bought in large sheets. A single sheet cut as required will yield enough paper for several paintings. In purchasing paper by the sheet you will be able to try several kinds more easily than if you buy pads.

Watercolour papers come with different surfaces: 'HP' is hot-pressed to a smooth finish; 'NOT' means not hot-pressed; and 'Rough' is heavily textured. For botanical watercolours I find 'rough' papers too coarse, 'HP' too smooth, and 'NOT' papers just about right.

Papers are referred to in terms of their weight per ream, in 'lb' or 'gsm'. Weight is important, papers of 140 lb and above do not need to be stretched before use to prevent cockling, but they tend to be more markedly textured or toothed than lighter weights of the same category.

I normally use Arches 90 lb (190 gsm) paper, stretched with the back of the sheet uppermost, because this side – in common with other papers – presents a fractionally finer tooth. I have mentioned the manufacturer's name because in a number of respects, difficult to define concisely, Arches papers suit my hand better than others currently available that I have tried. Even so, minutely less tooth would be an improvement.

Whichever papers you choose, make sure that they are rag-based for the reasons given earlier (p. 18).

Watercolour boards present an alternative. These consist of papers mounted on stable backings. Rough, NOT and HP surfaces are offered, and some companies also produce abraded boards. More expensive than sheet paper, boards are difficult to trim without a cumbersome heavy-duty cutter.

Though some papers and boards are finished in brilliant white, there are many in the faintly off-white that I prefer.

PALETTES should hold plenty of pigment and be easy to clean after use. Porcelain ones which may be stacked and kept dust-free are ideal.

WATER JAR This should be of colourless glass so that you may see when to change the water. It should also be wide-mouthed for ready access and squat for stability.

GUMMED BROWN PAPER STRIP is used in stretching paper. Small rolls offered by art or craft outlets are far less economical than the larger ones used by picture framers. Though they may be harder to find, the larger rolls, 5 cm wide by about 17 cm diameter, last for many months of constant use.

LIGHTWEIGHT BOARD A rectangle of 5 mm thick plywood cut to about 65 × 50 cm makes a suitable support for stretched paper. In use it may be placed on top of the usual drawing board or stand, or it may be tilted to a working angle on a table by books or other means.

PENCILS I find 2H pencils are normally the most appropriate grade for the fairly hard surface and tooth of watercolour papers and boards.

ERASERS Most good quality erasers are acceptable for use on watercolour paper, though the caution on p. 18 should be observed.

RAG OR PAPER TOWELLING is used for absorbing excess water from the brush after it is cleaned in the water jar. I use lint-free cotton rag which is suspended for convenience from a corner of the drawing stand.

TECHNIQUES

Watercolour techniques are very simple. They consist of wash, gradated wash, and dry-brush. You will also need to know how to blend edges and how to make corrections. Though these skills are straightforward to acquire, much of the pleasure and challenge in using watercolours lies in continually refining their application.

Before starting with watercolour in basic exercises, a method of stretching paper is shown. Heavier sheets (140 lb and above) do not need this treatment. Even if you intend to use heavier papers I still urge you to experiment with lighter grades. This will allow you to experience the special nature of a drum-taut surface.

STRETCHING If lighter-weight papers are not stretched prior to use they are prone to distortion by unsightly and permanent cockling. I work almost invariably on stretched paper because I appreciate the agreeable surface presented.

The process as described below may appear tedious, but from the time of soaking the paper, the steps are completed in a minute or so.

In preparation trim your paper to fit on the lightweight board. Leave room for the four gummed strips which should be cut to size as shown in fig. 16.

By the side of a bath or sink, place a small towel and a face-cloth folded into a pad and well-moistened. Run enough water to be sure of covering the paper. The gummed strips should be lined up on a firm surface in easy reach.

1. Submerge the sheet for about 30 seconds.
2. Take up the paper by one corner and shake it gently to assist drainage.
3. Change your grip to hold two corners (not diagonals). Trail the bottom edge more or less into position on the board. Pull the sheet into final adjustment as it is laid down.
4. Place the towel over the paper to absorb free water. Use very gentle vertical pressure without lateral rubbing which would be damaging. Remove the towel after a few seconds.
5. Moisten a gummed strip with one or two strokes of the face-cloth pad. Hold the strip at each end to place it in position. Rapidly do the same with the remaining strips.

16. Stretched paper on a drawing board

6. Use your fingers in smoothing strokes to squeeze out any air bubbles appearing in the strips. Be careful to avoid touching the damp watercolour sheet.

At this stage the paper may cockle markedly; this will disappear well before drying is complete.

Stretching paper should lie flat so that the drying process will be even. If paper is dried unevenly, by tilting or by using a heater, it may well split or pull away from the strip.

Though qualified by temperature and humidity, it is necessary to allow several hours for drying to be complete. I prefer to schedule stretching so that paper dries thoroughly overnight. On even a slightly damp surface, pencil points will score and erasers smudge or tear.

The stretched sheet remains in place until the painting is completed. It should then be removed without cutting into the underlying board. A scalpel is held at a shallow angle to the surface and the blade is inserted through the gummed strip at the outer edge of the paper. The tip of the blade should extend just under the margin of the sheet. Retaining the angle of the scalpel, the margin is followed until the paper is freed. Its edging of gummed strip is then trimmed away on the cutting board or other suitable support.

Once a sheet is stretched and dry you will be ready to try the exercises below. (Should you be too impatient to wait until drying is complete, either choose a heavier grade of paper or accept some cockling of a light one.)

Before starting you will need to draw a number of rectangles (fig. 18). Fifteen should be the minimum, though more will allow further practice and experiment. A convenient size for each is about 8 × 5 cm – drawn ruled or freehand. Though rectangles are convenient for demonstration in this book format, the boundaries are simply aids in acquiring brush control and you may well prefer other shapes.

While at work, keep the protective sheet under your hand.

WASH This technique is used on largish areas where it is possible to apply an even coat of pigment without interruption.

Slope the drawing board to an angle of around 30 degrees. This ensures that the wash will move freely down the sheet while remaining under control. Have paper towelling or rag close by.

Mix pigment with water in a palette to

a b

about the density shown in fig. 17,a. The yellows and cadmium orange are rather light toned for a rich depth in the later stages, but any other colours are suitable. Use a grade 3 brush and mix ample wash.
1. Place the brush in the wash, then pass the loaded hairs lightly over the palette rim to shed any excess that might drip. Practice will confirm a safe amount.
2. Hold the brush at a shallow angle to leave a broad trace. Put the tip to a top corner of a rectangle and then take it to the opposite corner with a slowish smooth stroke (fig. 17,a).
3. The first stroke should have deposited enough wash for a small surplus to have collected at the base of the band of colour. If your brush-load was a little light, or if the paper was very absorbent, it may be necessary to recharge for the return stroke b. The retention of a surplus at the base of the wash in progress is essential for the creation of an even unblemished surface.
4. Continue strokes to and fro while moving down the rectangle. Do not lift the brush from the paper until the full gutter shows a slight depletion – again, practice will soon allow you to assess this point.
5. On reaching the bottom of the rectangle, stop a millimetre or less from the line. Wash out your brush and quickly squeeze it semi-dry on the paper towelling or rag. Then complete the final stroke along the edge of the bottom line, absorbing the pigment reservoir as you finish.

Ideally, on completion the panel should be even and streak-free. The wash should also neatly fill the area without straying over the edges. Do not be discouraged with your first few attempts if you fail to meet this standard.

Different papers vary in their absorptive qualities. If the wash in the first rectangle looks patchy, you might try

pre-moistening the next panel. To do this simply put on a wash of clean water exactly as you did before with pigment. Wait a minute or so until the area becomes damp rather than wet. Then apply a pigment wash, but this time allow the formation of only the smallest reservoir. On damp paper, paint in an overfull gutter more easily breaks free to run down out of control. Should this happen, squeeze out your brush and use it rapidly to pick up the runnel, then continue as before – but with a lighter brush-load.

This pre-treatment is also often helpful in working on delicately coloured or shaded structures such as petals (e.g. monkey flower). In such instances moistening small areas in turn gives better control to the process of blending in the blurring edges (fig. 18,k).

Add the wash mixture to five or six rectangles in all while attempting to make each successive one better than the last. Once the panels are dry, add a second layer to all but the first in the row. Then give a third coat to the last three panels; a fourth to the remaining two; and a fifth coat to the final rectangle. Remember to allow a few minutes for each coat to dry. The completed row will then demonstrate the effect of progressive layering up to a full intensity of pigment. Unless your first wash was extremely light, you will find that adding further coats to the last panel does not deepen the hue. Also, with all papers there is a level beyond which no more pigment will be accepted. Once this is reached, attempts at additions will only break up the paint surface.

I must emphasize that preceding coats should be dry before another layer is added. Attempts to apply wet pigment to damp pigment are generally unsuccessful – unevenness and streaking result. This is especially so when several layers have previously been laid down – if the upper

one remains damp then the movement of the brush tends to disrupt the paint film.

GRADATED WASH A gradated wash progresses from a darker to a lighter mode (fig. 18, *f-j*). This is opposite to usual watercolour practice in which one works from a lesser to a greater depth of tone. The technique is useful for largish areas such as smooth leaf blades or size-able petals where a gradual tonal transition is needed. Most of the wild flowers painted for this book were composed of elements that were too small to require this treatment. Lords and ladies (p. 59) could have been an exception, but even in this instance the forms were broken down into smaller components that were handled by other means. Nevertheless this simple skill is worth acquiring because you may at some time work on larger plants such as many tropical species, which virtually demand the use of gradated washes. (For example, the bird of paradise, *Strelitzia reginae*; its leaves would be difficult to manage other than through this technique.)

Before starting, ensure that you have plenty of wash mixed, and also that there is clean water in the water-jar.

1. Load the brush as for the previous exercise.

2. Lay down a wash until about half of the rectangle is covered. Then dip the brush-tip into the water for an instant. This will slightly dilute the pigment on the brush, and as the next stroke is made the gathered pigment in the gutter will also be thinned.

3. Add further water with each stroke or with alternate strokes.

4. By the time that you reach the bottom of the panel there should be only clear water on your brush and the lower area will then be either colourless or faintly pigmented.

Obviously, the swiftness of the gradation depends upon the amount of water added and the frequency of each dilution – so by this means the rate of change may be controlled. A completely smooth transition takes some practice and I suggest that you complete the panels as shown in the figure.

For *h* and *i* the board is turned, and for *j* it should be held diagonally. When the panels are dry you may like to try adding a second layer of gradated wash to intensify the tone of the upper portion of a rectangle, as in *g*.

To retain freshness and directness in your work it is preferable to complete as much as possible by means of washes. In the demonstrated sequences of painting wild flowers there is almost invariably a first green coat to establish the lightest underlying colour. This is usually carried throughout all vegetative parts and applied in wash form. Often, because of the small areas involved, the wash strokes have to be modified because the narrow bounds of such organs as stems etc. constrain the ideal back and forth movement. This does not matter – the essential objective is to keep the wash flowing. (Occasionally, through misjudgement in painting a convoluted area, a portion of the wash may dry to form a hard unsightly edge. This may be amended as described on p. 30).

A second green coat, to show the basic leaf colour, may also be applied as a true wash. But quite often the necessity of making complicated manipulations – as when leaving tiny traces open for the underlying green to show through as veins – means that the pigment has to be applied with a lightly charged brush for more accurate control. This semi-wash is used when working on small discrete areas with the edges frequently blended or blurred as described below:

BLENDED EDGES Few parts of a plant's surface are seen as flat colour – most areas tend softly to blend into lighter zones. While large sections may be completed using gradated washes, more often you will be faced with very small areas which have to be blended in with their surrounds, as shown in fig. 18,*k*.

The blending technique is used too often to keep mentioning in the notes on the paintings. Its effects may most easily be seen in the shading stage; it may also be used in the first green coat when skirting highlights; and through much of each subsequent phase.

Blending is simple in principle, but a little tricky in application. Carry wet pigment to just short of the zone that you wish to blend into. Then use a brush moistened with clean water gently to stroke and blur the edges. The pigment advances into the area dampened by the water, where it is partly diluted and partly absorbed by the brush. For all but the tiniest areas so treated you will need to wash out the brush several times. Success comes by gauging precisely the right amount of water on the brush – too much and the water will spread disastrously into the pigmented area; too little and the

brush water will not provide dilution, instead the brush will pick up and then deposit pigment to give a mottled fringe.

Unfortunately the process has to be carried through with the greatest speed. Once pigment begins to dry, attempts at blending result in a blotchy mess. I find that time is lost in taking excess water from the brush by using a rag which hangs ready to one side. To avoid this lag I pass the brush between my lips applying slight pressure to leave the appropriate amount of moisture on the hairs. This practice should preferably not be used as it is scarcely hygienic – though only one pigment on my present list, cadmium orange, is toxic.

At various stages of a painting, when blending is constantly done, I keep one brush in my working hand and the blending brush ready in the other. While blending, the brushes are swapped from hand to hand.

The blending brush that I use is a worn number 4 which has otherwise been retired.

A final point: if you are about to work on an area not previously painted – blank paper – a smoother result may be achieved by pre-moistening.

Try blending edges on one or more of your panels, as illustrated in fig. 18,*k*.

DRY-BRUSH Apart from the wash technique (including gradated washes) dry-brush is the only other method of applying watercolour used for the paintings described here. The term is a slight misnomer in that the brush is never truly dry, always moist.

The main use of this technique is to add intensity of hue and tone throughout small sections of a larger area – as demonstrated in fig. 18,*l* and *m*. It is also often applied for fine details. Dry-brush has been used on at least part of every wild flower painting reproduced here, and its effect is clearly seen in many works: e.g. on the largest leaf in the finished hops painting on p. 96.

A virtue of the dry-brush method is that its use allows pigment to be added in a controlled precise way without the necessity for speed demanded when laying down a wash. A slight disadvantage is that a dry-brushed area is never as smooth and fresh looking as a washed one. For this reason, though I find the technique essential, I try to do as much of the preliminary work as is feasible in washes.

Though a faintly mottled or textured

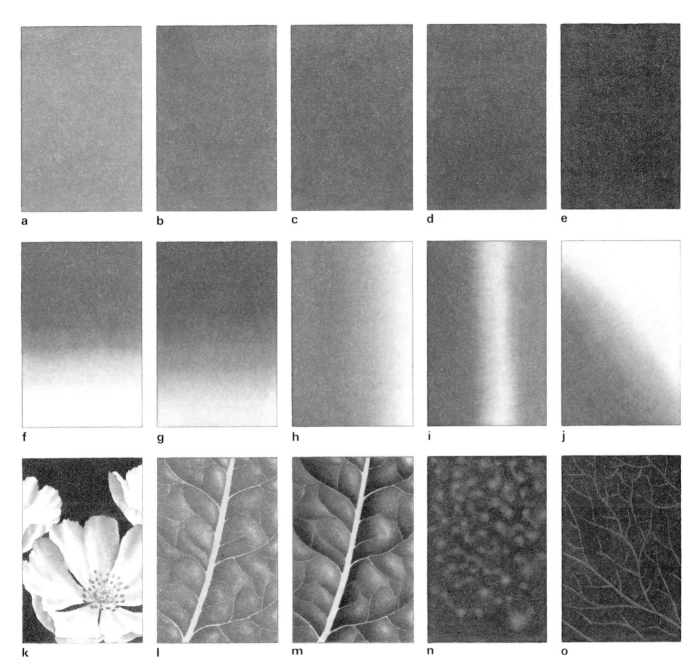

18. Watercolour exercises

appearance is inevitable when dry-brush is applied to light-toned areas as in *l*, this tends to be masked as the tone deepens, *m*.

For the dry-brush exercise demonstrated in *l* and *m*, first draw a leaf-surface section in one of the rectangles (the example shown is magnified for clarity). Normally, before turning to dry-brush, such a leaf would already have been shaded, a first green coat would have been applied; and a second green coat would also be in place – probably put on in a semi-wash as described above. For the present trial (after the initial wash) the leaf should be completed by dry-

brush to give plenty of scope for practice. To do this, mix ample lightish-toned wash, then continue as follows:

1. Apply the wash as an underlayer and allow it to dry thoroughly.
2. Take up some of the wash mixture on the brush, then shed surplus liquid by dragging the hairs with a little pressure over the palette lip. Repeat this motion several times until a very small trace of wash remains on the brush. One or two strokes on the protective sheet should show whether a suitable state has been reached. This lightly moist phase will soon be recognized after you have dry-brushed a few sections on the panel.

3. Using short strokes (*c.* 1–3 mm) with the brush-tip, apply the pigment moving from the light towards areas destined to be dark. The first strokes for each section should be put on with the gentlest touch, depositing a minimum of pigment to blend imperceptibly with the lighter area above. Succeeding strokes may be added using a little more pressure. You will find that the brush needs recharging with some frequency (by the method described).
4. After all parts to be dry-brushed have received one layer, return again and again with separate layers until the required density is achieved throughout.

29

Apply pigment to each part, one layer at a time in sequence – from the top to the bottom of the panel or from one side to the other. You should then find that the pigment is dry for the start of each new layer. Occasionally, especially in the later phases when several layers are present, it may be necessary to wait a short time for the paper to dry thoroughly.

In carrying out this trial you will appreciate that dry-brush may be used to achieve subtle modulations in tone as well as providing fine detail. Properly reserved for the later stages of painting it often provides last touches to bring a work to a satisfying conclusion.

CORRECTIONS AND AMEND-MENTS Large errors in watercolour are time-consuming and tedious to correct. Fortunately, for the kind of paintings described here, sequences are planned ahead and the need for major corrections should hardly ever occur. Should an accident, spilled pigment etc., necessitate the removal of a sizeable area, I would suggest that in many instances it is better to repeat the work. Several colours stain, and these are never entirely erased; other hues may be taken out after much effort, but then the surface of the paper may be marred.

Should you be obliged to take out a considerable block of colour, the following steps give a relatively effective result:
1. Adjust your board so that it is horizontal; a sloped plane allows pigment to spread downwards.
2. Flood the offending area with water using a clean brush. The water must extend just beyond the margins of the error.
3. Allow the water to sink in for a few seconds to help in loosening surface particles.

Then take a worn brush, preferably but not necessarily of a larger size than usual, and gently rub over the area. Try to work over each part evenly including the edges. Wash and squeeze out the brush before using it to absorb the pigment-laden water.
4. Flood the area again and repeat the process making sure that the inevitable spread of diluted pigment is not allowed to begin to dry in an aureole surrounding the error.
5. After two or three attacks the paper surface may begin to show signs of damage, with little balls of fibre breaking away. Ideally you should stop before this happens and only minimal practice is needed before you become aware that

this point is about to be reached. Around this phase use clean water to sop up any trace of pigment extending outside the area, and then allow the sheet to dry thoroughly.
6. Repeat the process until you feel satisfied that all the colour has been erased – or more likely, that little or no more pigment is being taken up and the surface is becoming furred.

Do not be tempted to use Chinese white to cover any stubborn stain – it will be glaringly obvious. Provided that the paper surface is reasonably intact, the best strategy is to hide remaining traces by the insertion of fresh material – foliage etc. This will probably have to be dry-brushed since the scrubbed area is unlikely to take a wash evenly. You may be suitably daunted by the foregoing to ensure that no careless blunders are made.

On the other hand, minute corrections are necessary in every work. The most frequent need is where a wash strays just over its pencilled bounds. Such small flaws are usually only a millimetre or two in length and they are easily dealt with by a modification of the above process:
1. Use a number 3 or 4 grade brush to dampen the error without extending into the main wash. Allow the moisture to seep in and then use the brush-tip to dislodge particles.

2. Wash the brush and squeeze it out before absorbing any freed pigment.

3. Repeat several times until the flaw is removed. If complete erasure proves impossible, it is usually feasible to lighten these blemishes until they are almost undetectable.

Much the same procedure may be needed for the blending in of a hard edge left by a prematurely dried wash. Often the course of a wash has to be split, sometimes several times, as when painting a deeply lobed leaf. In concentrating on keeping channels running out to the lobe tips, you may find that one has dried before the margin is reached. A harsh ragged line will be left at the edge. If this happens to be in a part that will later be brought to a deep tone, the treatment is easy. Soften the line by the means described above, but take care not to damage the surface – successive washes or dry-brushing will then hide the blemish.

Should the flaw occur in a light-toned area, it may be necessary to introduce a vein or other feature roughly to follow

just inside the offending line. As such dried edges are generally irregularly shaped, you will probably need to erase some extrusions over the line. The wash may then be carried to completion.

Quite often a fairly large area of wash may be put in to match the tone and hue required but for a few raised patches with low-key highlights. With experience, I normally skirt such spots, blending in the wet edges while moving the wash on. This is tricky as there is a risk of the wash drying unless it is kept moving. If you are a beginner, it is better to complete the wash in an even coat and allow it to dry. Then at a considered pace you may use the brush, as for small corrections, to lift out pigment and to blur edges. The results of this method are shown in fig. 18,*n*.

Virtually the same technique as that used for removing small errors is applicable to making minor amendments. The most frequent use is in strengthening the traces of minor veins – for this the brush-tip is pressed into a chisel-edge to aid in cutting out lines, as illustrated in fig. 18,*o*.

COLOUR AND COLOUR MIX-ING The use of colour is a sensuous pleasure. I still derive satisfaction from laying down an even wash in a fine clear hue. By all means experiment with many colours and delight in their interplay, but as mentioned earlier only a few colours are truly vital. A full paint box is not necessarily a mark of a skilled artist.

I find it helpful to keep my core colours in logical order, as in the list on p. 25. These are followed by a subsidiary ranking of pigments less often used – many being earlier purchases for one reason or another less in favour.

A useful reference is provided by making a colour chart. Draw a number of squares or rectangles on a stretched sheet. Have enough forms for the core colours plus plenty for later acquisitions. Then use washes to paint in your colours using the same order as they sit in the paint box. Two or three layers will give a rich intensity. Add the colour name to each panel. This sheet will aid in the selection of colours and also assist you in imagining the effects of mixes. My chart is mounted on thick cardboard and sleeved in plastic. Kept in sight near my watercolours, it is constantly useful.

You have probably seen books devoted to the intricacies of colour mixing in theory and practice. Please do not feel that the subject is too complex to absorb without serious study. At the level of

practical everyday use surely few things are as simple as mixing colours. You will almost certainly already know the basics: yellow plus red makes orange, red plus blue gives purple, and green is derived from blue plus yellow, etc. Even the most subtle tints are rarely the product of more than three component pigments. With a little experience you will find that colour analysis becomes an unconscious action as you work. Faced with, for example, a particular leaf green, you will automatically mix yellow with blue to an appropriate balance and then modify the mixture with a touch of red if necessary.

When you move on to painting wild flowers, do be sure to mix enough of each colour used. It is always worthwhile to keep mixtures in palettes throughout a work – labelling using tabs of tape prevents confusion.

Though mixing colour should for the most part be straightforward, Nature sometimes presents hues that cannot be captured by paint. A certain intensity and brilliance is seen only in living plant tissues. You may be able to reflect accurately the quiet tint of a primrose flower, but the blazing richness of a poppy translucent in a raking light (see *Painting Plant Portraits*) is beyond the capacity of manufactured pigments.

Presenting a light-toned flower on a white ground also lessens its impact. To counter this, a highly effective device is to paint in a dark background. I have done so on occasion when it seemed vital, but over use could appear meretricious.

Pale-coloured or white flowers do benefit by being placed in front of foliage to heighten contrast. This may sometimes be done quite naturally, the primrose is again an example, but you should avoid obvious distortion.

Careful use of shading on pale petals will lift them sufficiently from the paper – but never make the shadows too dark. If you err, let the flowers be slight rather than leaden.

A neutral shadow colour may be mixed from Winsor blue and alizarin crimson, plus a little permanent yellow. Other blues, reds, and yellows may be used, but after long trial I think that this mixture is the most pleasing. The balance is of course flexible – warm shadows need a hint more alizarin crimsom, and cool ones extra Winsor blue. This shadow mix was used for all the wild-flower paintings.

Shading is the means by which a three-dimensional quality is introduced. The pattern of light and shade, *chiaroscuro*, helps to suggest reality. For the wild flowers, the initial shadow coat established the tonal structure of the work and then served as a guide for subsequent development. (It is for this reason that I have long reversed the practice of earlier years when the shading was added last.)

If you use the above mixture in several coats, a vibrant black is obtained. I prefer to use this rather than manufacturers' lamp or ivory blacks which appear dull by comparison.

True black, even in fruits, is not common – where a very deep tone is present you will often find that it may be accurately represented by an adjustment in the composition of the shadow mix. Such a black might lean towards intense purple, blue, or sepia.

It is sometimes necessary to modify colours already in place. Occasionally a hue will have been marginally misjudged; alternatively, a later alteration may have been planned (as for the hop leaf-undersides). The course to be followed is the same in both instances. First paint a few patches of the original colour on the protective sheet. When these have dried, try on one or two a fairly dilute wash of the hue that you assess might create the wanted change. This additional coat might be derived from several components or more simply, from one or two pigments. Allow the modifying colour to stand before judging the result – watercolours lighten on drying. If necessary, make adjustments by further trials on the protective sheet. Depending upon the nature of the area to be altered, the pigment may be added as a wash, semi-wash, or by dry-brush.

Translucence in leaves is often suggested by a modifying coat of yellow or yellow-green on lighter areas. This effect should be employed with restraint – too much translucent foliage might mislead as to the general colour of the leaves, as well as border on the garish.

PRELIMINARY DRAWING In chapter 2 hints were given for drawing specific plant organs. Here, in referring to drawing prior to using watercolour, it is possible to be general and brief.

Strive for excellence in your preliminary drawing. If the foundation is weak, the same will be true of the finished piece, no matter how skilled the colourist. Drawing such complex organisms as plants can hardly be expected to be easy – I have never found it so.

You are blessed if you possess a considerable innate drawing ability. But do not despair if your first efforts are not as you would wish – it is feasible to make great advances through practice.

Lines should be accurately placed and applied with thought. Keep the pencil trace thin, light, and without superfluity. Little or none should remain visible at the completion of the painting.

With dividers and ruler measure the total length and width of the plant material that you intend to draw (see also p. 12). Then in cutting a sheet of watercolour paper for stretching, allow space for a sensible margin around the proposed image. Often I find it necessary to stretch paper before specimens are collected – the size of the sheet then has to be based on past experience.

Do use material that you have collected yourself rather than merely copying my examples. With your own specimens you will still be able to follow the instructional notes while creating a painting that is entirely your own. If your time is limited, it is perfectly appropriate to confine yourself to working on a small portion of a plant. You might then choose such subjects as the fruiting head shown on the lords and ladies plate, or a single inflorescence such as that of the upper stem of the monkey flower, or even a single leaf – as the blackberry. Large paintings rushed through under pressure are likely to be far less satisfying to the artist or pleasing to the recipient than carefully considered small works.

My aim has been to detail watercolour procedures that have worked for me. But just as my own techniques and preferences have evolved, so no doubt will your own as your abilities grow.

GOUACHE

Though all plants may be portrayed in gouache there are some with features that make them specially suitable for work in this medium. The ivy, pp. 120–27, is one such species. Others are plants with glaucous leaves or which are otherwise predominantly pastel-coloured; those with a waxy bloom; and species with felted hairs. The opacity of gouache may also be exploited by painting light-toned subjects over a darker background; white or pale flowers may be effectively displayed in this way.

Gouache is kind to the learner: errors may be painted out and second thoughts

expressed. By contrast, translucent watercolour is unforgiving – mistakes are not easily corrected and certain disciplines are vital. Gouache is altogether easier to handle. The pigments are applied throughout in small strokes that are easier to control than the underlying washes of watercolour: in starting a wash you are committed to complete the area speedily or you risk unsightly complications; with gouache there is no intrinsic need to hurry.

Gouache paints are presented in tubes or pots. In this instance tubes are preferable as it is too easy to sully pot colours accidentally with an already loaded brush. Pot colours have a creamy consistency which renders contaminating stains hard to remove.

Suppliers provide colours variously described as 'gouache', 'designers' gouache', 'designers' colours' and similar combinations.

Though the numbers of hues approach those of watercolour, the few that you will need are the same as those listed for watercolour on p. 25. Annoyingly, the names for like colours vary from the one medium to the other so you will find it helpful to compare manufacturers' colour charts.

Do make sure that you have a large tube of Chinese white because this is used to mix with the colours for reduction (lightening). Chinese white is itself lightfast and it does not affect the durability of colours in mixes – a weakness of some other whites.

If you would like to experiment before deciding whether to buy gouache, you may make a satisfactory version yourself. Translucent watercolour is mixed with Chinese white to give opacity as each hue is needed. This is a simple process (below), and after making your own gouache you may not feel that you need to buy.

Papers and boards for watercolour may also be used for gouache, though because this medium is less demanding, cheaper supports could be considered as well. These should be rag-based or acid-free for permanency. Lightfast coloured papers and cards make alternative readymade backgrounds for pale-toned subjects.

Other than the basic items listed in chapter 1, the rest of the materials for gouache are the same as those for watercolour, with the addition of a softer pencil, B or 2B, to show up on tinted grounds.

TECHNIQUES

Gouache being easier to use than translucent watercolour, I suggest that, after the exercise described below, you should turn straight to the plant subject in gouache, ivy, pp. 120–27. Leaves of this species are available throughout the year, flowering extends through autumn into winter.

In using gouache, either the form mixed yourself or the commercial product, there are a few points to bear in mind:

Pigment is mixed to a thin creamy consistency, and applied in short strokes – washes are not appropriate.

Chinese white is always the first pigment placed in the palette. Colours are added to this base until the wanted hue is reached. It is much more difficult to arrive at a wanted colour by adding white to a mixture.

Gouache dries faintly lighter than it appears when wet. This has to be considered especially when applying light colour over dark, as the contrast may otherwise be greater than what was wanted.

As gouache is essentially opaque, it is sensible to add shadows to your work at a late stage (as opposed to the treatment described in this book for translucent watercolour).

I usually prefer to keep highlights for the very last touches that bring a painting to life. For the ivy plate, the availability of natural light imposed a different sequence.

For a simple exercise to gain the feel of the medium, try the following steps:

1. First squeeze rather less than 10 mm of Chinese white into a palette. Blend in Winsor blue and alizarin crimson until a mid-tone is reached (warm or cool according to the proportions of each colour used). In adding pigments use enough water to maintain a thin creamy consistency. Too much dilution will lead to patchiness and more coats will then be required. Too little water will leave the paint thick and difficult to use for fine detail.

Paint an area with the mixture, using short vertical strokes. Any scrap of fairly stout paper may be used, though for later reference you may prefer a similar rectangle to those suggested for the exercises with translucent watercolours (pp. 27–8). For a single small-scale trial you will not need to stretch the paper.

2. Allow the coat to dry (apply a second layer if the white of the paper still shows through). Then add another coat to half the area to demonstrate the difference in tone between wet and dry gouache. Notice that as the paint dries the tone becomes virtually even throughout – though a boundary between the two zones may be just detectable depending upon the opacity of your mix.

3. The next step is to make a smooth gradation to a deeper tone at the bottom of the area. In another palette, take some of the above mixture and add more Winsor blue and alizarin crimson. While deepening the tone, try to maintain much the same colour as above.

Load the brush, then drag the hairs over the palette edge to leave pigment at the dry-brush level (pp. 28–30). Starting about a third of the way up the painted area, apply the colour using small dabs in an open stipple. As you move downwards, gradually merge the strokes into a continuous even coat. Do not be disconcerted by the harsh contrast of the wet colour over the first coat as this diminishes on drying. Depending upon the depth of tone of the new pigment when dry, the gradation will need more or less adjustment. This is achieved by taking some of the first mix and dry-brushing it thinly into the transition zone.

4. The final part of the exercise is to make an even transition from the midtone to a lighter tone in the top third of the area. Squeeze out about 10 mm of Chinese white into a clean palette and then mix in some of the original mid-tone with a little water.

Turn the sheet so that once again you can work downwards. Then add the light tone in just the same manner as the dark tone was applied. As before, adjust the transition after the pigment has dried. Gentle touches with a clean moist brush will also assist the blending process.

The end result of the exercise is an area divided into three gradually merging zones: a light tone at the top, then a midtone followed by a deeper tone at the base. On completion you will have experienced the few necessary techniques for working on a wild flower in gouache.

4 THE WILD FLOWERS

1 WOOD SORREL
Oxalis acetosella, Family Oxalidaceae

The vernacular name, 'sorrel', links this plant to the sour docks or sorrels, *Rumex* species, though it is not botanically related. As in these plants, the wood sorrel foliage has a sharp taste through the presence of binoxalate of potash. Both generic and specific names refer to this property.

The leaflets are intriguingly sensitive, they fold in wet weather, at night, and oddly, also in direct sunlight.

In observing the flowers from spring to spring, it seems that they vary considerably in size according to seasonal conditions. Again, some plants carry flowers in which the petal venation is almost colourless; others show veins ranging from pale pink to intense purple. Hidden *cleistogamic* flowers are also produced.

PAPER: Ivorex board.
PENCIL: HB.
IMAGE AREA: 110 × 80 mm.

1. DRAWING AND BACKGROUND TONE [A]
Flowers and leaves were collected from banks in an oakwood and kept overnight in water.

The following morning I found that though the flowers were open, most of the leaves remained folded. This did not much matter because I intended to begin by working on the flowers.

To start, I scribbled a rough on a scrap of paper to determine an appropriate image size for the effect that I wanted to convey – that of a dense patch of wood sorrel in bloom.

After measuring and ruling in a rectangle on Ivorex board, the upper flower was drawn starting with the upper petal. The sexual parts were then indicated though they were too small to show clearly. After the petals were outlined, the pale and delicate veins were entered. Next came the opening flower and then the flower at the bottom right. Then a tightish bud was drawn.

It was interesting to see that the relative positions of the reddish *bracts* on the stems altered according to the flowers' development. Before the flower opened, the bracts were close to the bud. The peduncle above the bracts then lengthened considerably as the flower matured.

I then drew several of the smaller leaves which were open – starting with one on the bottom right. I had not been

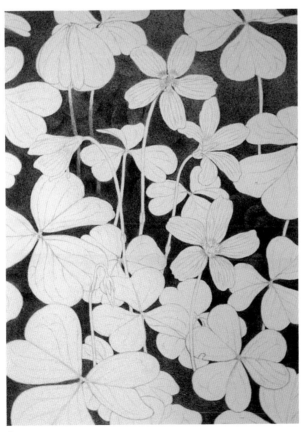

A

aware of the *motility* of the *trifoliolate* leaves; each time they were touched to move them into a more favourable position, the leaflets would partially collapse. As most of the leaves remained closed, I went back to the wood to gather some which were fully extended. The leaf mosaic was then completed.

To throw the flowers and leaves into sharp relief, background tone was added using the elliptical strokes described on p. 21. Several coats were needed before the required depth was reached.

2. FINISHING TOUCHES [B]

The leaves were then shaded and I added a suggestion of more leaves in the background by further darkening some sections and by lifting out tone in other parts by dabbing with an eraser.

Just a hint of shading was given to the flowers (this may not be visible in reproduction).

A final adjustment was made to the overall balance by intensifying tone in a few places.

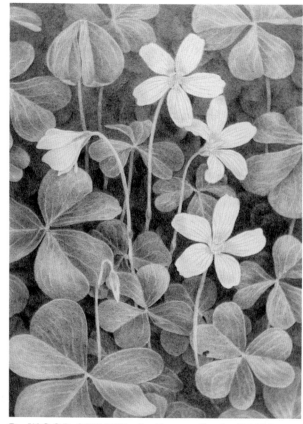

B. WOOD SORREL, *Oxalis acetosella*, April 1992.

34

2 GREAT BINDWEED

Calystegia sylvatica, Family Convolvulaceae

A characteristic flower of hedges and wastelands in summer, the great bindweed is an introduction often found alongside the similar native, *C. sepium*, with which it hybridizes.

 Calystegia species, together with others of the closely related genus *Convolvulus*, are regarded as nuisances by farmers and gardeners though they yield splendid subjects for plant artists. Several species in both genera display coloured flowers; the present subject, with its white blooms and elegant contours, was chosen as being ideal for portrayal in pencilled continuous tone.

PAPER: Ivorex board.
PENCIL: HB.
IMAGE AREA: 220 × 165 mm.

1. DRAWING AND BACKGROUND TONE [A]

Sections of twining stems with flowers and buds were collected from a local hedgerow. Some time was spent in untangling the stalks to put them in water.

 After ruling in a border to the above dimensions, I lightly roughed in a skeletal layout. Then the top flower was outlined, followed by the one below, the leaf at the bottom left and the calyx enfolding the ovary at the bottom centre.

 Background tone was added by working over the area several times using elliptical strokes. The process demands patience, though it can on occasion be soothing in requiring little thought but much concentration.

2. SHADING OF LEAVES [B]

I worked over leaves by the method described on p. 22. The margins of some leaves carried a deep red pigmentation, this had to be sacrificed in order to maintain necessary contrast with the background. About this time, a large and perfect flower opened too late to include – a common occurrence in working with plants.

3. FINISHING TOUCHES [C]

Light shading was applied to the flowers using a feather touch.

 Finally, contrast was adjusted here and there.

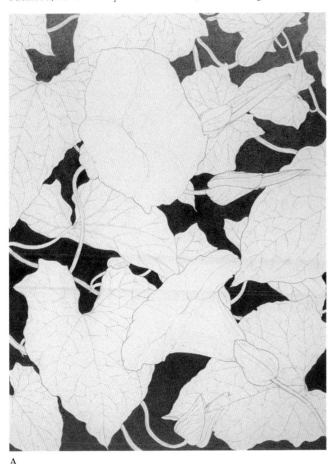

A

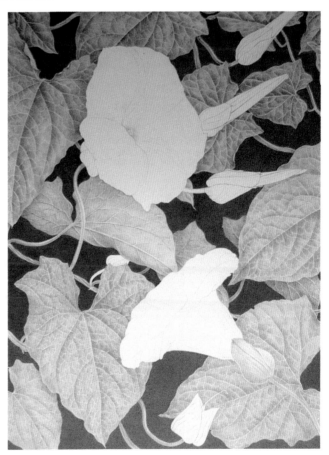

B

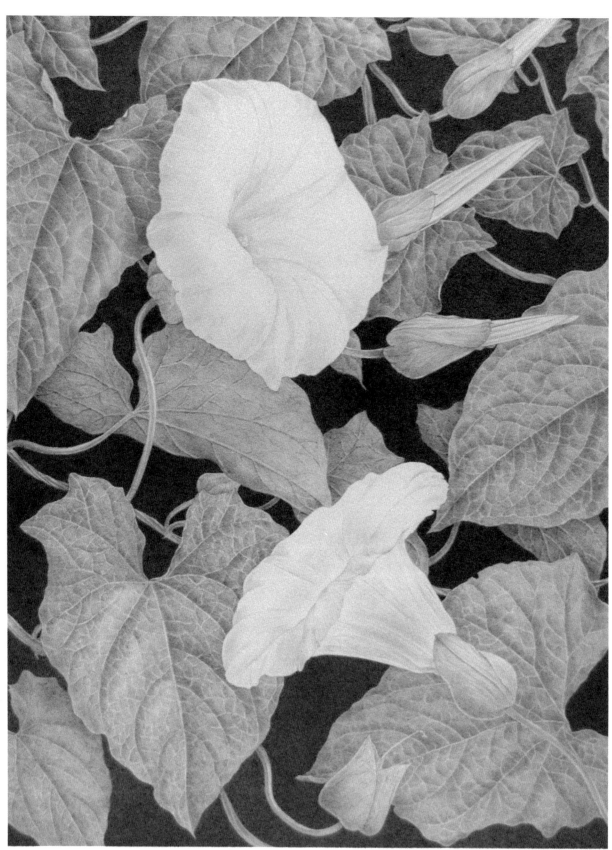

C. GREAT BINDWEED, *Calystegia sylvatica*, July 1992.

3 WOOD ANEMONE
Anemone nemorosa, Family Ranunculaceae

The wood anemone is a modest member of a genus that includes colourful species such as the flamboyant *Anemone coronaria*, or the little blue windflower, *A. blanda* (shown in *Painting Plant Portraits*). Though these and other species in the genus are inviting to the botanical artist, there is a special charm about the wood anemone. It blooms quite early in the spring and the starry white flowers are watched for as markers of winter's end.

The plants portrayed were collected on the steep banks of a country lane. The afternoon was sunny and soft in contrast to a succession of bleak cold days. While at the spot I also gathered ivy, moss, bark and a few of last season's oak leaves for background material.

PAPER: Ivorex board 290 gsm. PENCIL: H. PEN: Pilot DR, 0.1. IMAGE AREA: 210 × 130 mm.

1. INITIAL DRAWING AND COMPLETED COMPOSITION [A]
Several stems were placed in 'oasis' to settle overnight. In the morning, drawing was begun on layout paper so that I could first evolve the composition in some detail before moving to the Ivorex board. I started with the pistils of the central flower. The petals came next, followed by the *anthers* – the hair-thin filaments were omitted at this stage. The stem of the flower was then drawn with the trifoliolate leaf in the front. I went on to complete the other leaves and the main stem before introducing two more flowers.

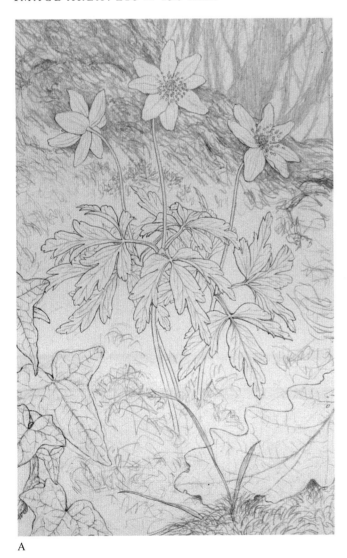

A

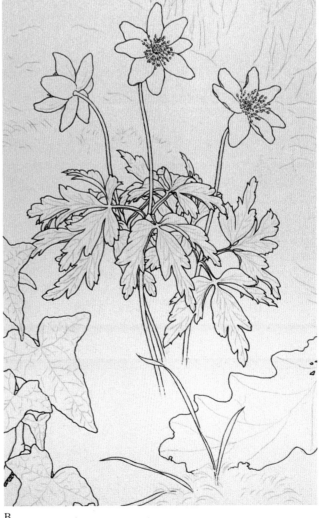

B

Elements of the background were then drawn in gradually to build a balanced design.

2. TRANSFERRED DRAWING [B]

The initial drawing on layout paper was transferred to Ivorex board using graphite tracing-down paper. The major forms were then inked in.

3. BACKGROUND [C]

The background was then inked in order to show the flowers in contrast. Various strokes and stipples (pp. 23–5) were used to imitate the various textures. In suggesting the *Dicranum* moss at the bottom right, I held a ruler along the margin to stop the pen tip from straying over the edge as swift strokes were made.

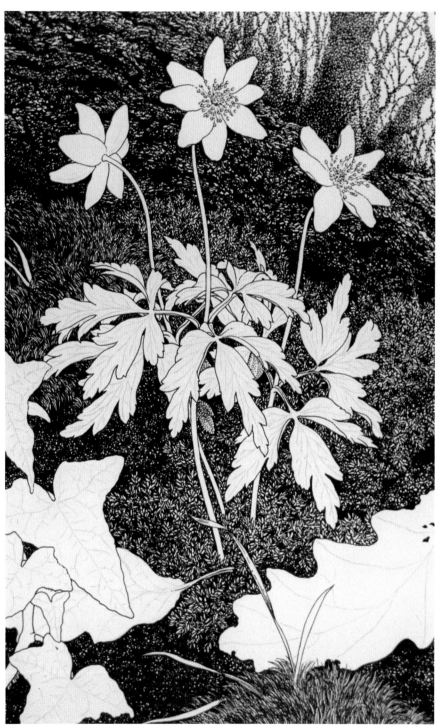

C

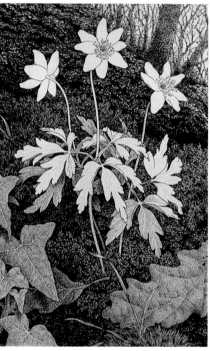

D

4. FURTHER INKING [D]

A dot stipple was used for some of the anemone leaves with a shading of very short strokes on the oak leaves. I was frustrated by the inability of ink to capture the beautiful markings on the ivy leaves.

5. FINISHING TOUCHES [E]

The remaining anemone leaves were completed with a light dot stipple. The petals were left with only the faintest shading to preserve their impact. Lastly, the plate was judiciously worked over to add further depth to the background.

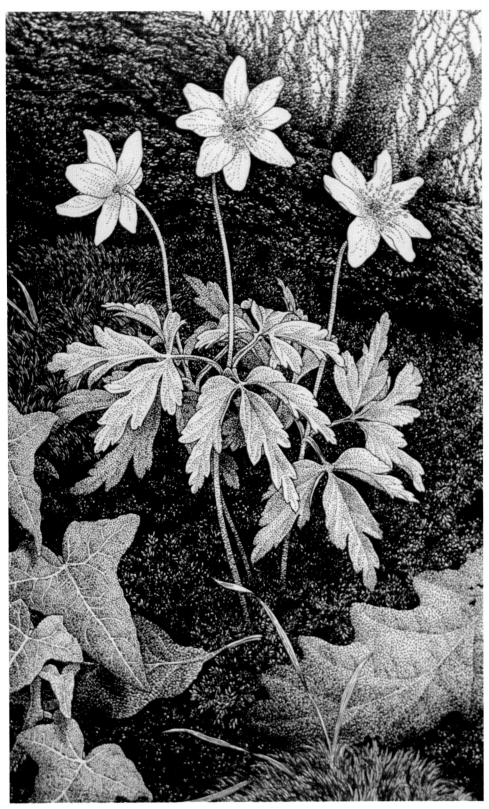

E. WOOD ANEMONE, *Anemone nemorosa*, April 1992.

4 LESSER CELANDINE

Ranunculus ficaria, Family Ranunculaceae

Though the celandine is abundant, it is nonetheless welcome because it is one of the first species to flower in the spring. The first flowers are usually small and held close to the ground. With improving weather the plants become more open, lush, and larger flowered. The specimen featured is of the latter form. As with other *Ranunculus* species, the petals vary in number and size.

This species does produce viable seed, but in addition it also reproduces by means of *bulbils* formed in the upper leaf axils.

Flowers close and are inconspicuous in wet or dull weather. On bright days they can be spectacular when massed. This is reflected in a Celtic name for the sun, '*grian*', which is also used to describe this plant.

The epithet 'lesser' distinguishes the plant from the greater celandine, though the two species are not related and they are markedly different in appearance.

PAPER: stretched Arches 90 lb NOT.
IMAGE AREA: 211 × 149 mm.

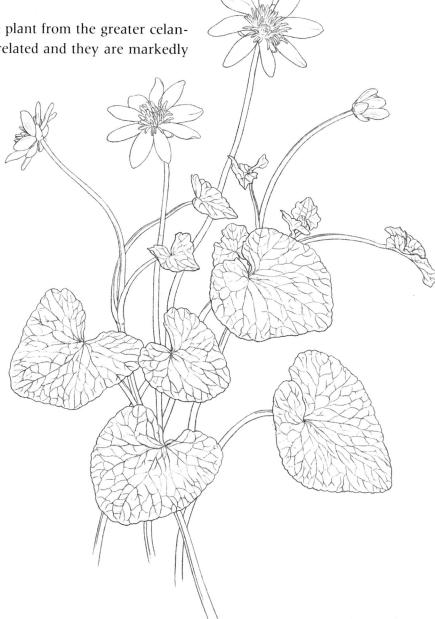

1. DRAWING [A]
Specimens were collected from the verges of a local lane and placed in water overnight.

The flower on the right was drawn first. I started with the central pistils before moving to the surrounding petals and the stem.

For the flower in the centre I began with the stamens which at this phase obscured the pistils. It was necessary to move fast since the flowers opened quickly in my warm room and the petals soon reflexed.

The outline of the leaf at mid-right was roughed in and the venation drawn while the margins were fined up.

The left leaf was followed by the opening flower above, with its subtending leaves.

Next came the lower leaf at the centre bottom and a smallish central leaf with one lobe carried over part of the leaf on the left.

The upper bud at the upper right preceded its small stem leaves and tight bud.

The drawing was completed with the leaf at the bottom right.

A

2. SHADING [B]

Next morning I found that in the warmth of my room the flowers had opened in spite of the skies outside being dull.

The shadow mix (p. 31) was used first on the stems, then diluted on the petals before being applied at the original strength to the leaves.

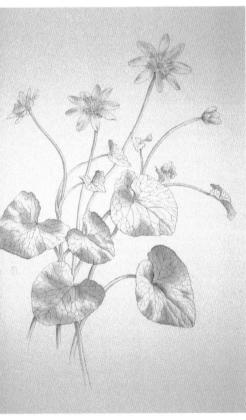

B

3. FIRST GREEN COAT AND HIGHLIGHT BLUE [C]

The first green coat, used for all the vegetative parts, was mixed from Winsor yellow and Winsor blue, plus a little alizarin crimson. Highlights were skirted and the margins blended during progress.

A weak wash of Winsor blue was used for highlights on stems and leaves.

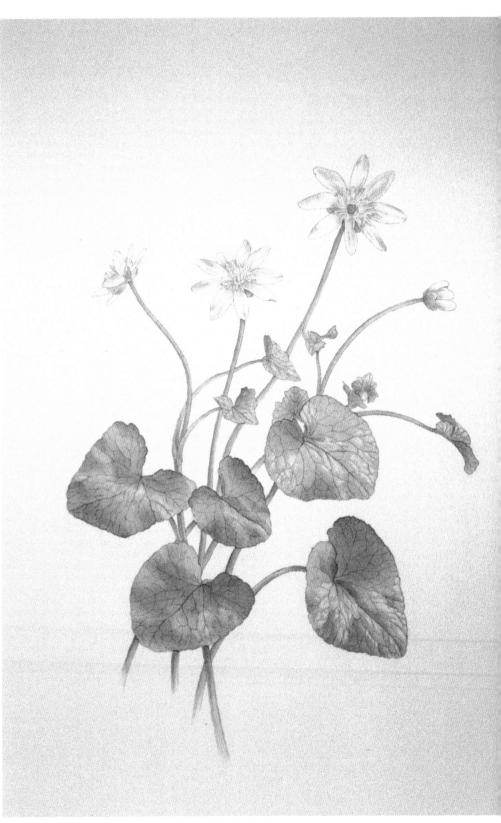

C

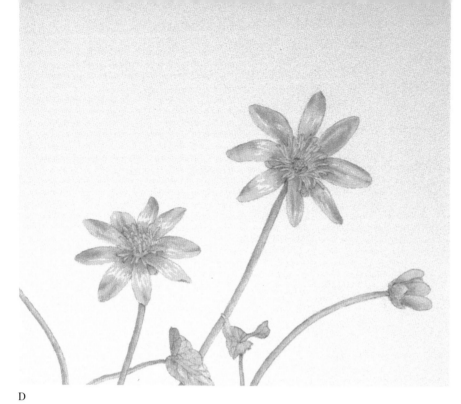

D

4. FIRST FLOWER COAT [D]

The petals were painted with dilute permanent yellow.

Small patches were left blank to represent the brilliant highlights which give the flowers their characteristic varnished appearance.

5. FURTHER FLOWER COLOURS: SECOND GREEN COAT [E]

To some of the first green mixture I added more Winsor blue and a hint of alizarin crimson to make a greenish underlayer for the darker backs of the petals of the opening flowers to the left and right. Over this layer a dilute purple was dry-brushed from a blend of Winsor blue and alizarin crimson.

Two more coats of the original yellow were used to bring the petal hue to full intensity.

The stamen colour was made from the above yellow plus a touch of cadmium orange.

Then a more intense green was mixed by enriching the first wash with additional Winsor blue, Winsor yellow and a little alizarin crimson. This was used on all the leaves.

6. FINISHING TOUCHES [F]

The same green as above was dry-brushed onto the leaves to emphasize the incised veins. It was also used in darker green areas, taking care to leave minute gaps for the veins.

For the deep purple of the tiny flower bud on the right I used an intense mix of alizarin crimson, Winsor blue, and a dot of permanent yellow.

In reviewing the almost completed work I thought that the bottom leaf on the left looked rather flat, so more shadow mix was added to the right lobe to show its curved contour.

A brush load of the green wash was mixed with the petal colour to give a lime green. This strengthened the hue of the stems, and suggested trans-lucence where dry-brushed onto appropriate parts of the leaves.

E

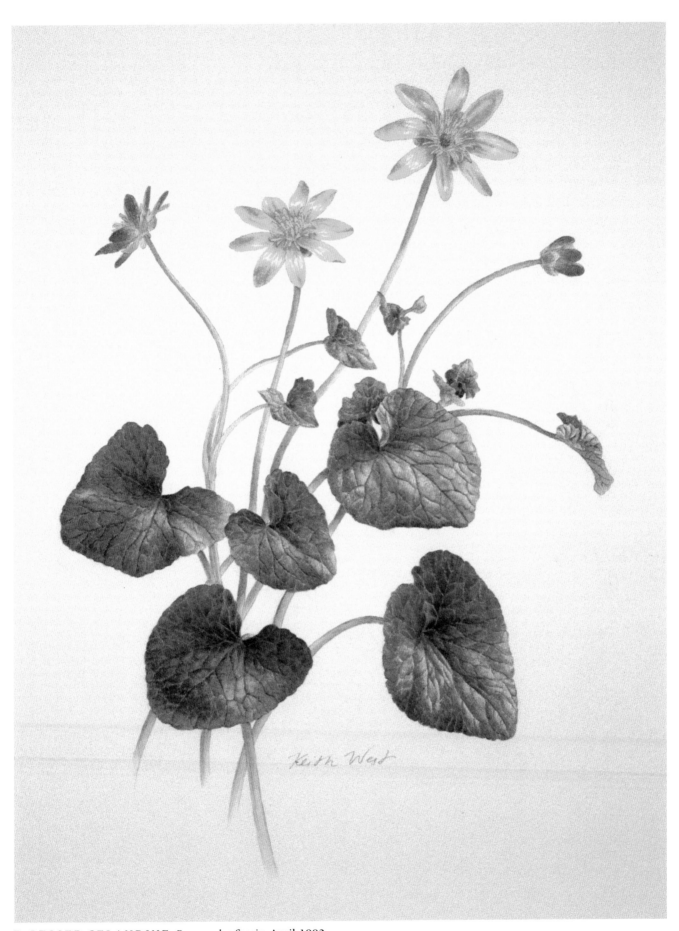

F. LESSER CELANDINE, *Ranunculus ficaria*, April 1992.

5 SNAKE'S HEAD FRITILLARY
Fritillaria meleagris, Family Liliaceae

This curious flower is native to only a few areas of England, though it is now found in gardens across the country. The 'snake's head' part of the common name refers to the appearance of the flower bud – unfortunately for the present painting I missed this stage by a day or so. The term 'fritillary', also used for a group of butterflies, is derived from the Latin, *fritillus*, a dice-box. As these flowers and the butterflies have chequered markings, I imagine that at some time dice-boxes were typically decorated in this way. The several other vernacular names for the plant all refer to this feature. Some specimens show extraordinarily regular checkerboard-like squares.

PAPER: stretched Arches 90 lb NOT. IMAGE AREA: 207 × 165 mm.

NB The first stage of painting a wild flower is the drawing. This has already been demonstrated for the lesser celandine. For the snake's head fritillary and subsequent subjects the step-by-step illustrations begin with the stage after the initial drawing.

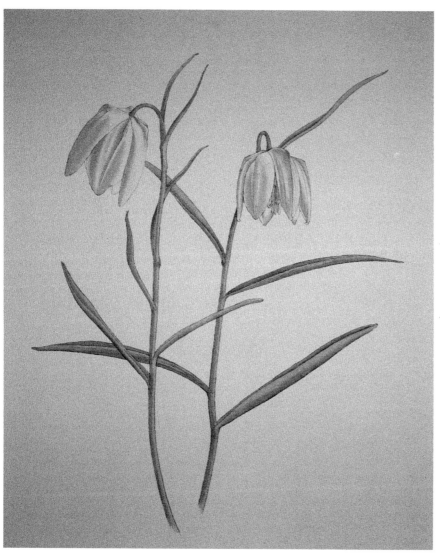

A

1. DRAWING, SHADING AND FIRST GREEN COAT [A]
As I had fritillaries growing in the garden it was easy to pot up three plants and allow them to settle over-night.

The flower on the left was drawn first. I worked from the point of insertion of the peduncle, outlining the central petal before the petals to right and left. The stem and leaves were completed before the same procedure was adopted for the plant on the right. The chequered patterning was left for the time being.

Perhaps distracted, I slipped from my usual sequence by applying a first green coat – from Winsor blue and permanent yellow – before adding shading with the shadow mix.

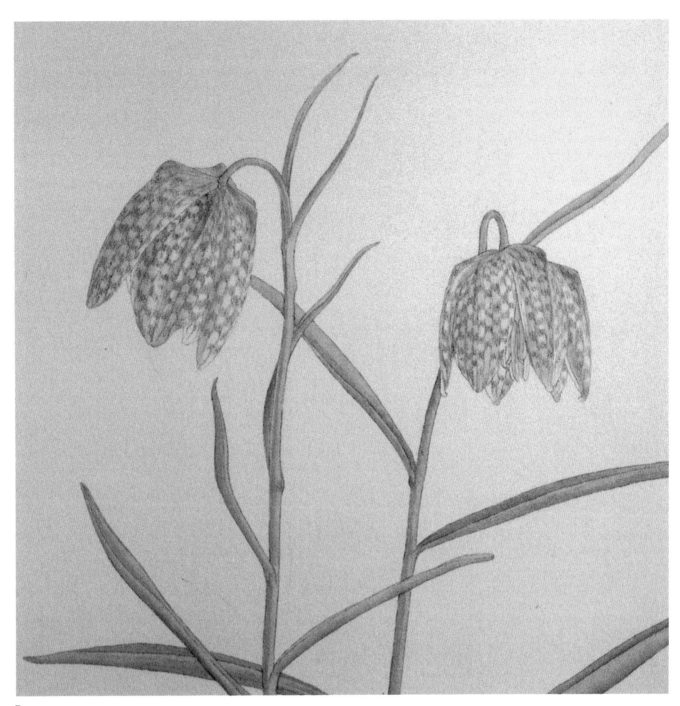

B

2. FLOWER PATTERNING AND HIGHLIGHTS [B,C]

The checkerboard pattern on the petals was then drawn in with pencil.

Dilute Winsor blue was used to show the sky reflected from the slightly waxy bloom on the flowers.

C

D

3. FLOWER AND STEM COLOURS [D,E]

A first coat of colour on the flowers was mixed from alizarin crimson and Winsor blue. Some of this wash was transferred to another palette and mixed with more Winsor blue before being used on the stems.

More of the flower hue was added to the lower stems and to the upper peduncle of the flower on the right.

The first green coat was used on portions of the style and stigma of the right flower. The anthers were coloured with dilute Winsor yellow.

E

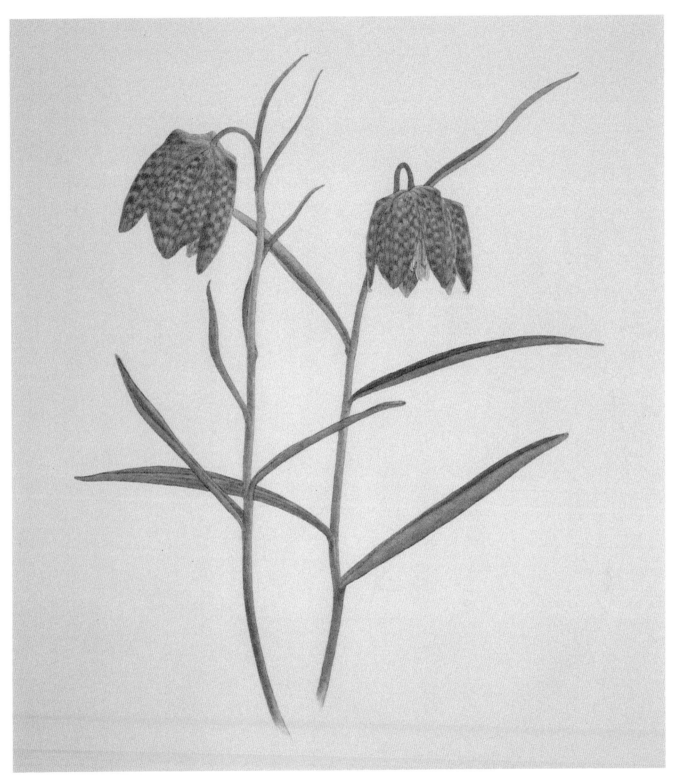

F

4. SECOND GREEN COAT ETC. [F]

Some of the first green coat was brightened with Winsor yellow to suggest translucence on parts of the leaves.

A second green coat used on the leaves was mixed from Winsor yellow, Winsor blue and a little alizarin crimson.

The margins of the leaves were edged in pale reddish lines, these were shown with a mix of Winsor blue and alizarin crimson.

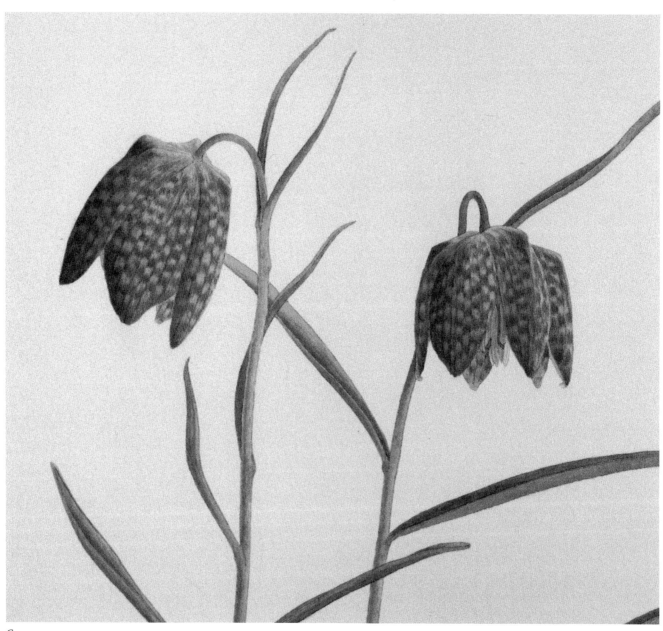

G

5. FINISHING TOUCHES [G,H]

The pattern on the petals was deepened
by dry-brushing in another coat of the
flower colour. I felt that by this addition
the shading of the flowers had been
submerged to leave them looking
flattish. The modelling was restored by
again using the shadow mix.

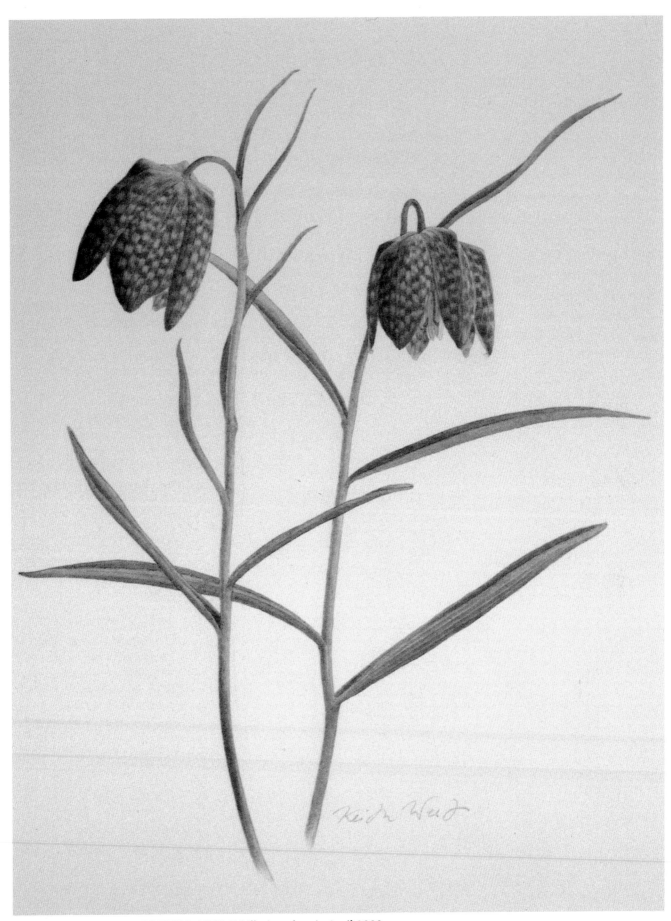

H. SNAKE'S HEAD FRITILLARY, *Fritillaria meleagris*, April 1992.

6 PRIMROSE
Primula vulgaris, Family Primulaceae

Pale primroses appear almost insignificant compared with the rich colours of other primulas. Yet this light yellow is wonderfully evocative of spring, when the flowers brighten the borders of woods and the banks of country lanes.

There are two kinds of flowers: 'pin-eyed' and 'thrum-eyed'. Each plant bears either one kind of flower or the other; they never appear together. Pin-eyes have the anthers below the *stigma*, which sits like a pin-head at the top of the floral tube. In the thrum-eyed flowers the anthers are at the mouth of the floral tube with the stigma below them. These different arrangements enhance the chances of cross-fertilization and hence genetic variability. Such mechanisms are not uncommon but this expression in the primrose is especially visible.

A few primroses are sometimes seen in sheltered spots flowering as early as January, though the full flush comes in April and May. This early arrival is recognized in the name, 'primrose', which comes from the Latin, *prima rosa* – the first rose.

PAPER: stretched Arches 90 lb NOT. IMAGE AREA: 235 × 186 mm.

1. DRAWING AND SHADING [A]

I picked thrum-eyed flowers, buds and leaves at all stages of development from the banks of a lane running through oak woodland.

A composition of a flowering clump was lightly indicated in skeletal form as a very rough guide.

I started with a flower at more or less the centre of the sheet. Another was then drawn to the left and slightly behind the first; other flowers and buds were then established.

As I worked I found that though the flowers held up well in water, the leaves seemed fresher if kept in the vasculum to be brought out and positioned as needed in 'oasis'.

With each leaf I lightly sketched in the midrib and then generalized the outline. The main veins were then positioned followed by the minor veins – this sequence was time-consuming but a necessary preliminary in capturing the texture. The outline was then fined-up.

The shadow mix was first used on the leaves, initially defining the midribs, then shading along the lateral veins before moving out to the surfaces between the minor veins. Cast shadows on the leaves were also shown.

In order to keep the correct tonal balance I decided to leave the flower shading until after the first green coat, when an assessment of the needed depth would be easier.

A few touches of dilute Winsor blue were brushed onto the leaves to show the positions of low-key highlights.

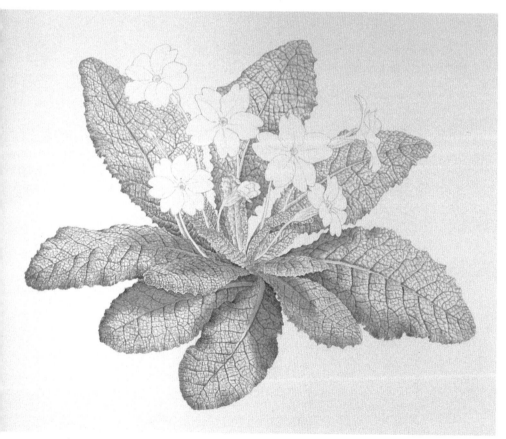

A

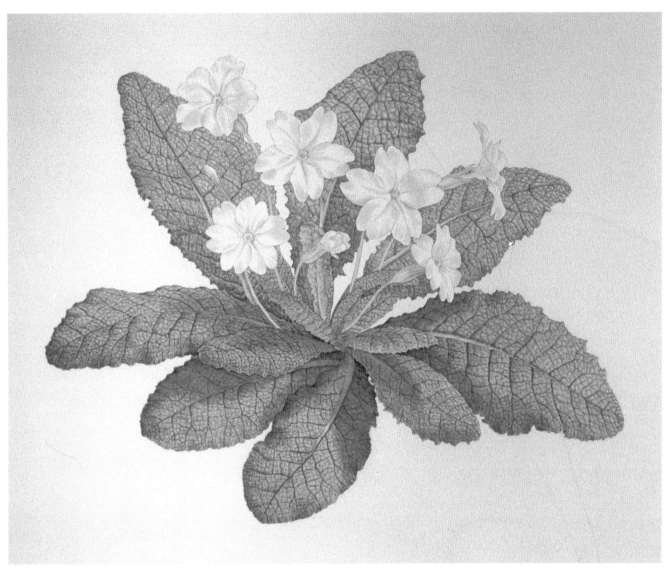

B

2. FIRST GREEN COAT AND FLOWER SHADING [B]

A first green coat was made from permanent yellow and Winsor blue. This was carried over all the vegetative parts. The flowers were then shaded with very light tone from further diluted shadow mix.

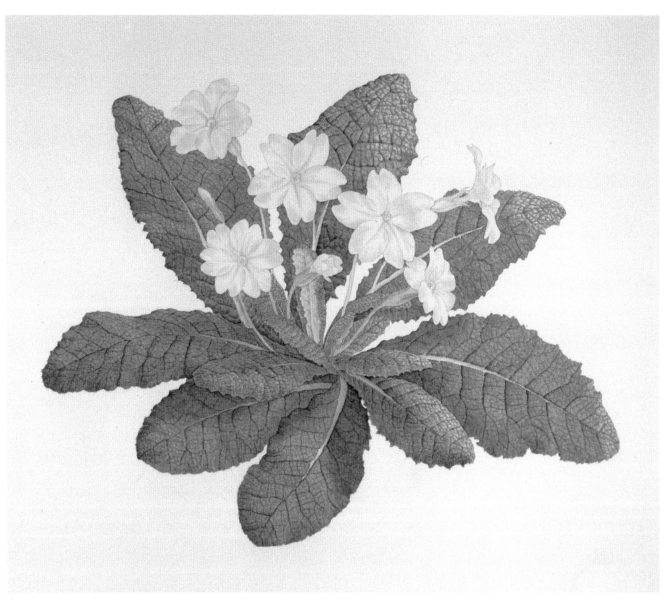

C

3. FURTHER GREEN COATS AND FIRST FLOWER COAT [C]

The second green coat, which was an intensified mix of the first, was washed over the central, younger, leaves. This wash was again modified for the outer leaves by the addition of more Winsor blue and alizarin crimson.

A very dilute wash of Winsor yellow was used on the flowers. I resisted the temptation to make the colour more intense than in life.

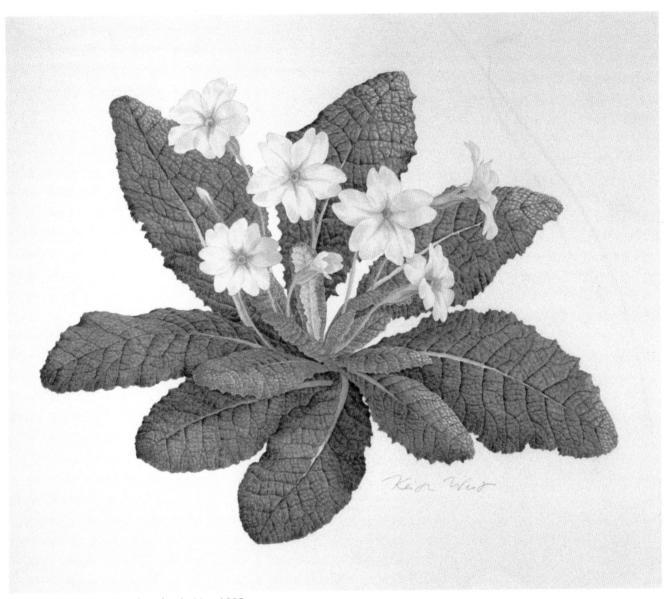

D. PRIMROSE, *Primula vulgaris*, May 1992.

4. FINISHING TOUCHES [D]

The bright tint of the flowers' centres was mixed from permanent yellow and cadmium orange – this was dry-brushed on. The mixture was diluted a little for the newly opened two lower flowers and some of the first green coat was added to capture a slight greenish cast.

Rose madder was dry-brushed into the bases of the leaf midribs.

The second green mix was worked over the leaves, giving emphasis to the sunken lateral veins and shaded areas.

At this point I noticed that a cast shadow was needed for the lower left flower and this was applied using the shadow mix.

The final touch was to add white hairs to the flower stems and calyces, using a number 1 grade brush with Chinese white. The hairs were very fine and they may not show in reproduction.

7 LORDS AND LADIES
Arum maculatum, Family Araceae

The cowl-like *spathes* of lords and ladies, poking through surrounding vegetation, mark the presence of these curious plants. As well as the vernacular name used here, there are several others with sexual overtones, no doubt suggested by the presence of the erect *spadix* within an encircling sheath.

I find the plant attractive: the lovely lines of the spathe, the often deeply pigmented spadix with interesting floral arrangements below, and the sinuous-edged glossy leaves. Later, the flaring red fruits carried on whitish columns are eye-catching well into the autumn. Though the berries look inviting they are highly poisonous.

Lords and ladies may be quite variable in colour within populations, with some individuals bearing spots and blotches on the leaves and spathes, while others lack them. Also, purplish pigmentation may be present or absent on spathes and spadices.

PAPER: stretched Arches 90 lb NOT. IMAGE AREA: 365 × 297 mm.

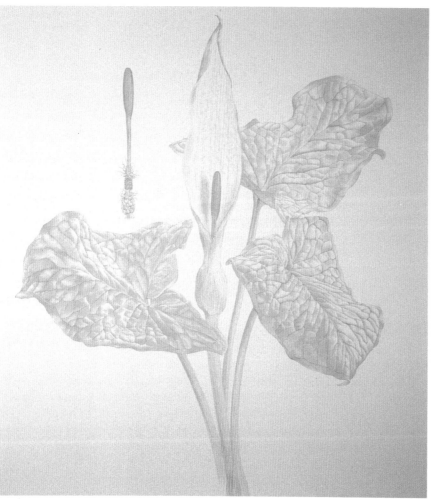

A

1. DRAWING AND SHADING [A]

After measuring and stretching a largish sheet for this painting, I found on picking material from the fringes of nearby woods that a slightly greater width would have been an advantage. Flower heads and leaves were placed in water.

To start, the position of the inflorescence was indicated, but it was not drawn because I felt that the spathe would open more if left overnight. With this in mind, drawing was begun with the lower leaf on the right. The midrib was lightly sketched in and the outline suggested. As the venation pattern was detailed, its establishment allowed the leaf margin to be fined-up.

The next morning, as the spathe had still not fully opened, I drew the base alone so that I could properly position the leaf on the left. By the time this was completed, the spathe had expanded enough for me to draw it. The leaf on the top right was then also drawn.

From another flower, using a scalpel, I removed a complete spadix. This was taped to a small piece of paper which in turn was placed on the drawing board for easy viewing. The parts were examined with my hand-lens before drawing. The function of the various organs in fertilization (including the surrounding spathe) is fascinating, though the story is too lengthy to be detailed here.

Enough space remained to allow the addition of a fruiting head later in the year.

With the shadow mix I began with the top right leaf, progressing by pre-moistening each vein-bounded area and using the blending technique (p. 28).

While adding tone, I noticed that the spadix within the spathe had not been fined-up – the omission was rectified.

In working over the spathe with light touches, I saw that its translucency precluded the presence of an otherwise expected shadow along the curved

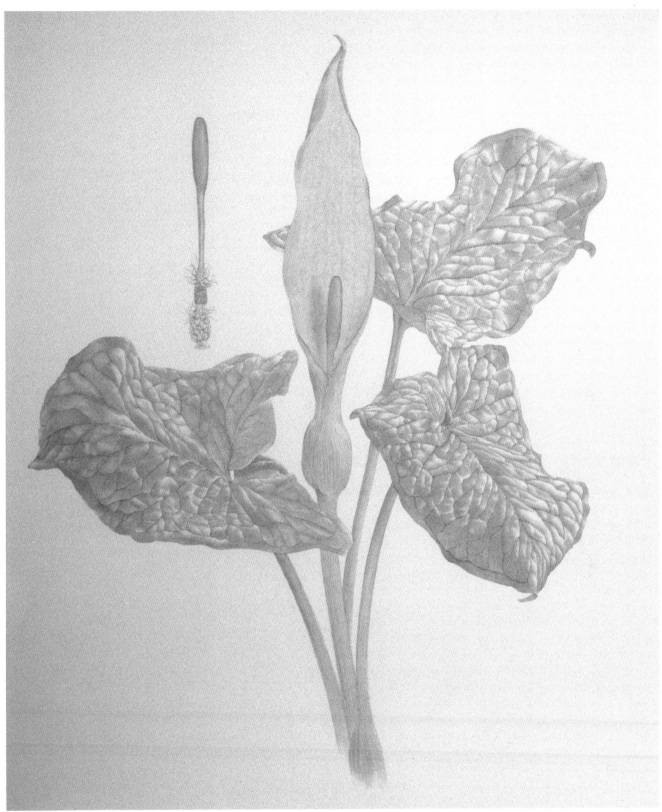

B

inner surface of the right of the spathe. The cast shadow of the spadix was shown.

The excised spadix detail was the last item to be shaded.

2. FIRST GREEN COAT [B]

The underlying green of the plant was made from a much diluted mixture of Winsor yellow, Winsor blue, and a hint of alizarin crimson. This wash was used for all vegetative parts.

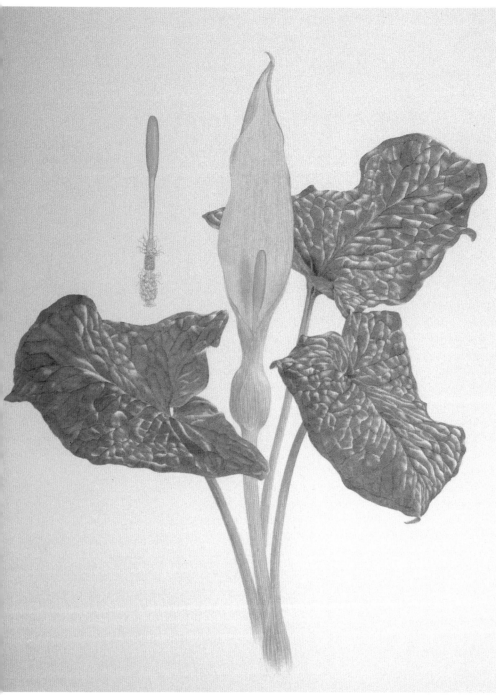

C

D

4. THIRD GREEN COAT [D,E]
The wash from the previous stage was again used, being dry-brushed where needed to give further emphasis.

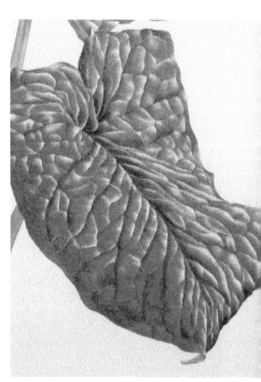

E

3. SECOND GREEN COAT [C]
Fractionally more Winsor blue and alizarin crimson was added to the first green wash for the second green coat. This was carried over the leaves leaving fine traces blank here and there for the light green veins. Some of the mixture was diluted a little and used to strengthen the lines of parallel venation on the stems and spathe.

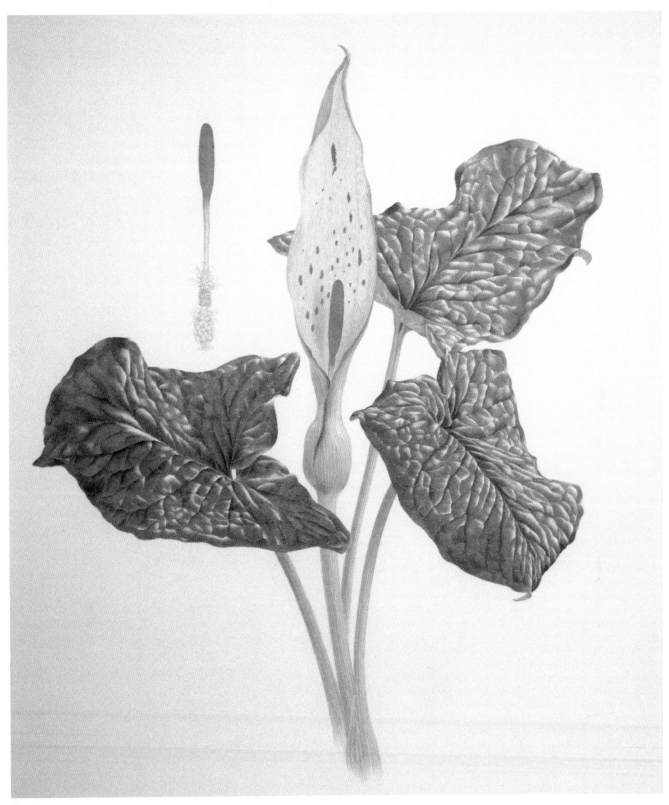

F

5. SPATHE AND SPADIX COLOURS [F]

A small amount of the above wash was left over and Winsor yellow was added to this before it was much diluted and used to enrich the spathe. Dilute permanent magenta was then dry-brushed onto the purplish upper spadices as well as on the margins and splotches of the spathe. (About this time I found that another spadix had to be dissected out as the first had shrivelled somewhat.) The colour of these areas was then made more intense where needed by dry-brushing in a vivid mixture from permanent magenta, alizarin crimson, and Winsor blue.

6. FINISHING TOUCHES [G]

A little of the above purplish mixture was diluted and used for the flushed base of the left leaf stalk which had been missed.

The warm yellow on the lower part of the spadix was derived from permanent yellow with a brush-tip of cadmium orange.

A much watered down Winsor blue was gently brushed over the highlights with the edges being blended in.

Faint translucence on the leaves was suggested here and there by a wash of Winsor yellow.

At this point I discovered that when working on the purple blotches I had neglected to put markings on the leaves – these were added.

7. DETAIL [H]

About three months later, in August, a mature fruiting head was inserted at the upper left of the plate. There was no difficulty in finding suitable fruits because they are conspicuous in season. I chose a head with a modest cluster of berries, anything larger might have appeared too dominant as well as being awkward to accommodate.

I began the fruit detail by drawing the berry at the top of the stem and then working downwards. Not only do the fruiting heads differ in the number of berries that they carry, but also the individual fruits vary in size.

The shadow mix was then used throughout. For this, and all subsequent coats, the pigment had to be applied by dry-brush. The paper had long been removed from the stretching board and wet washes would have made the sheet cockle.

The pale green stem was made from a mixture of permanent yellow and Winsor blue. This was followed by the base of the spadix in a warm gold of mixed permanent yellow and cadmium orange.

The brownish 'collar', the scar left by the caducous spathe, was derived from permanent yellow, alizarin crimson, and a touch of Winsor blue. Then additional Winsor blue darkened the mix for the thin line ringing the base.

Winsor red and permanent yellow were mixed for the bright berries using several coats.

Intense Winsor blue, alizarin crimson and permanent yellow made a virtual black for the scars of the vanished styles on the berries.

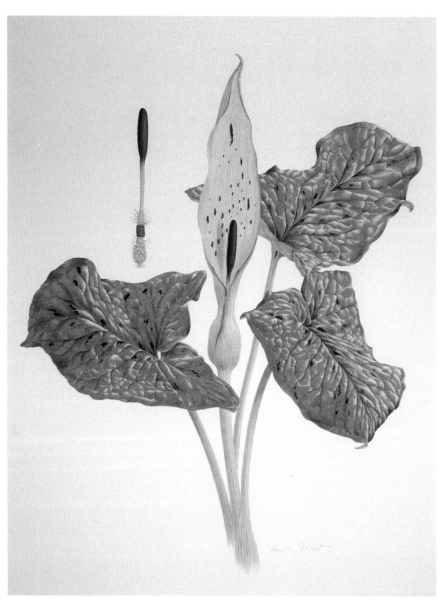

G

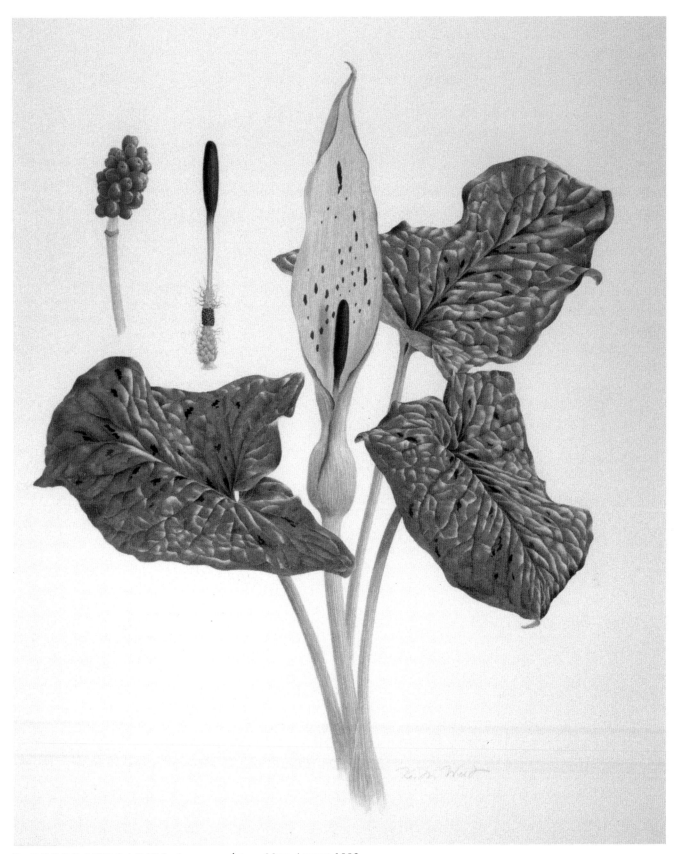

H. LORDS AND LADIES, *Arum maculatum*, May, August 1992.

8 DOG ROSE

Rosa canina, Family Rosaceae

The dog rose has quite a short flowering season in comparison with many cultivated roses, being at its best during June. A large bush in full bloom, sometimes supported by a small tree, is one of the lovely sights of early summer.

The flowers vary in colour from white to an intense pink – ones shown in the painting come from the deeper part of the range.

It is a pity that such a beautiful rose carries the ugly epithet 'dog'. This is believed to come from 'dag', meaning 'dagger', referring to the daunting prickles.

Glowing red hips are a pleasing component of the autumn scene, these are featured on pp. 100–103.

PAPER: stretched Arches 90 lb NOT. IMAGE AREA: 190 × 133 mm.

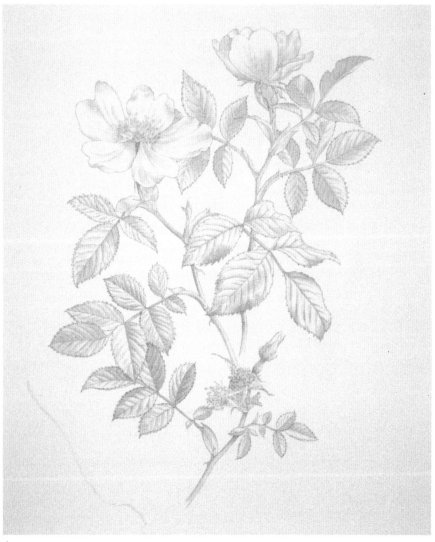

A

1. DRAWING AND SHADING
[A]

When I was ready to do this subject the dog roses had finished flowering in the valley, so I had to go higher to find some. Flowers were collected on a sunny warm afternoon and placed in plastic bags; most had wilted by the time home was reached and some petals had dropped. The stems were crushed to improve water take-up, and put into water to recover overnight.

I began drawing at the top left with a fully opened flower. Perhaps as a result of their exposed ridge-top site, all the flowers showed some malformed petals – I decided slightly to amend these to match some of better form.

A start was made with the stigmas at the flower's centre; then the stamens were lightly indicated and the petals drawn.

In drawing the leaves, starting with those to the left and below the flower, the serrations were followed with care. The stem was trailed off at the base as I wanted to leave a spot for a flower bud.

The opening flower at the top right was then drawn followed by the stem and leaves.

Next came the twig at the bottom carrying a flower bud and two flower bases.

The shadow mix was used throughout, beginning with the leaves and stems. I then shaded the flowers making sure not to make the petals too dark. Further emphasis was added to the stems and leaves.

2 : FLOWER COLOUR AND FIRST GREEN COAT [B,C]

The emphemeral flowers were painted promptly because I wanted to be sure of catching them before they passed the phases already drawn.

I used dilute permanent rose for the bud. This was further diluted for the opening flower and yet again watered for the fully opened flower on the left.

The few visible stamens of the flower at the top right were painted from a mixture of permanent yellow and cadmium orange. This colour was dulled by a dab of the shadow mix, and used for the older anthers of the left flower as well as for the anthers on the left at the bottom of the plate. More shadow colour was introduced to make a brown for the older anthers at the bottom right.

A dilute green was used for the central stigma-bearing boss of the flower on the left, and for those at the base.

The same green was mixed again in rather more intense form for the underlying green coat on all vegetative parts. Small areas were left blank for highlights where appropriate. The mature leaves at the centre showed the most highlights, none were seen on the leaves of the upper twig because only matt undersides were shown.

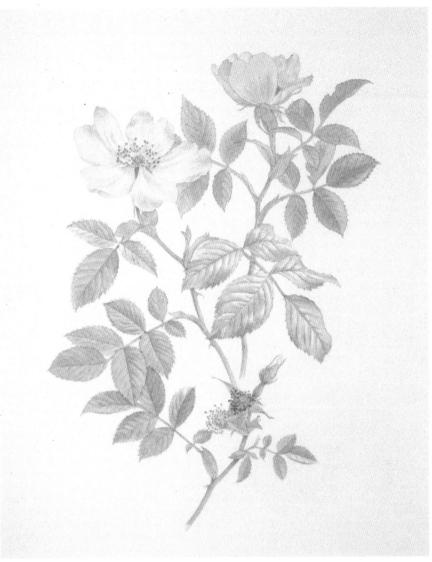

B

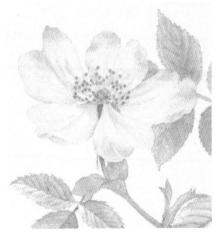

C

61

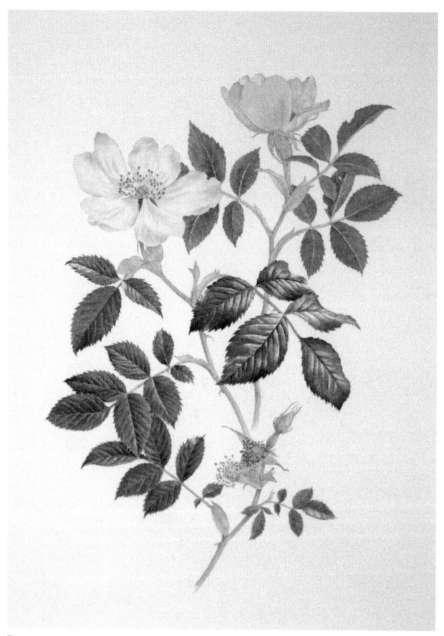

D

3. FURTHER GREEN COATS [D]

The basic leaf colour for the main twig was mixed from Winsor yellow, Winsor blue and a touch of alizarin crimson. On applying this colour by dry-brush, fine traces were left blank to allow the underlying bright green to show through as veins. Another coat was added for emphasis on the darker areas as required.

For the smaller leaves at the bottom right, more Winsor yellow was added to some of the above wash. The same hue was used for the leaf undersides at the top right.

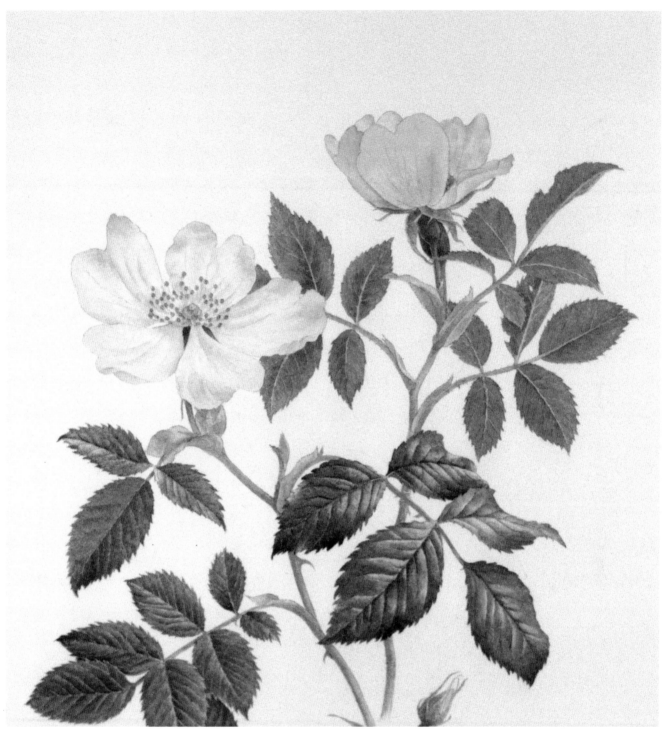

E

4. FINISHING TOUCHES [E,F]

The ovaries at the top and bottom right were coloured by adding a little more Winsor blue to the preceding wash.

Very dilute Winsor blue was washed over all the areas of highlights.

The wash used for the initial green coat was used to enrich the stems and stipules.

The prickles were painted with dilute alizarin crimson.

Finally, the shadow mix was used to give further depth here and there.

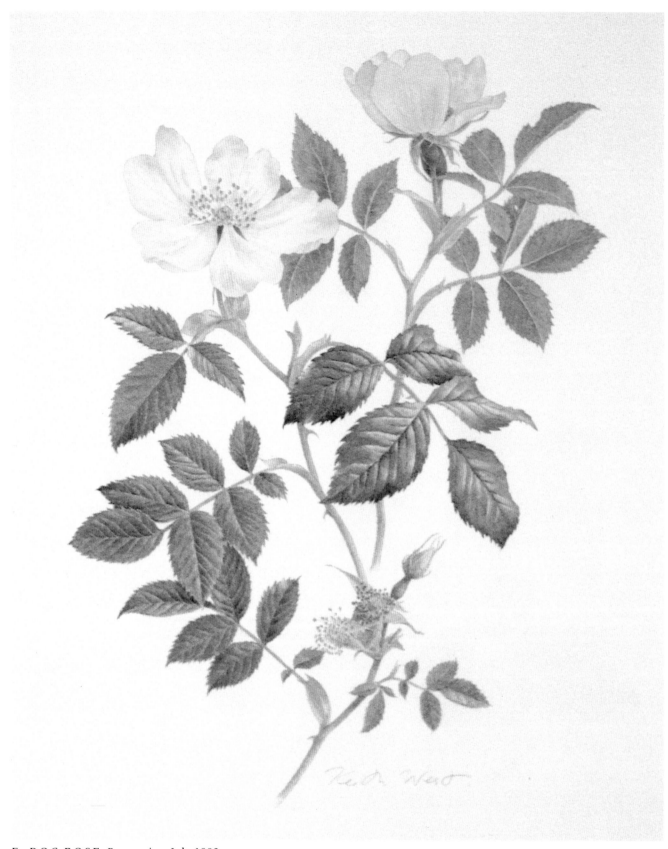

F. D O G R O S E, *Rosa canina*, July 1992.

9 ROSEBAY WILLOW-HERB
Epilobium angustifolium, Family Onagraceae

Rosebay willow-herb is a remarkable colonizer, appearing quickly on cleared land. It is often mentioned in connection with the bomb sites of London in World War II. In the United States and Canada it is known as 'fireweed' because land razed by fire is ideal for its establishment.

The anthers *dehisce* soon after the flowers open, while the styles are reflexed holding the closed four-fid stigmas away from the pollen. Bees and other insects in search of nectar brush against the anthers acquiring pollen grains in their progress from flower to flower. In more mature blooms that have shed all or most of their pollen, the styles straighten and the stigmas become fully presented in the form of a cross receptive to insect-borne pollen. It is said that if the lower flowers of an inflorescence are not cross-pollinated, the later opening upper flowers are self-pollinated – for this to occur the stigmas would have to become receptive and correctly placed at the same time as the pollen is shed.

The intensity of the flower colour varies from one group of plants to another. Many flowers are deeper in hue than the ones portrayed – even to the point of being somewhat jarring. At the other extreme, white inflorescences do occur, if rarely.

In season the ripe capsules release hundreds of seeds as the *valves* steadily curve back. Each seed hangs below a *coma*, or parachute of hairs, as it drifts in the wind. The fruiting heads may eventually form an unsightly tangle of opened pods and trapped cottony seeds. At the same phase, especially after the first frosts, the lower leaves may become brilliant in ambers, reds and crimsons.

The bizarre caterpillars of the elephant hawk-moth may be found on the leaves later in the season.

A

PAPER: stretched Arches 90 lb NOT. IMAGE AREA: 321 × 198 mm.

1. DRAWING AND SHADING
[A]
Some tallish specimens were collected from roadside plants in the hills. The stems were cut to give upper- and mid-sections, and placed in water to recover overnight.

I started by working down from the top of the inflorescence noticing the irregular spacing of the *pedicels*, the subtly shaped buds, and the unusual disposition of the four petals of the flowers.

The stem was carried down to the zone where the withering flowers had just been shed.

Next, a section of mid-stem was drawn to the right of the flowers. This portion held some fully developed and ripening capsules. The axis was inclined so that some of the lower leaves extended behind the first stem. This united the two main elements and gave a more pleasing composition than if they had been arranged in parallel.

The shadow mix was used throughout. I worked on the left stem first, leaving the flower petals until shading for both stems was otherwise complete.

For the right section I shaded the capsules and stem before the leaves. The venous system was highly translucent and I tried to suggest this by leaving blank traces in the tone.

Lastly, the flower petals were lightly shaded to keep an appropriate tonal balance with the rest of the plate.

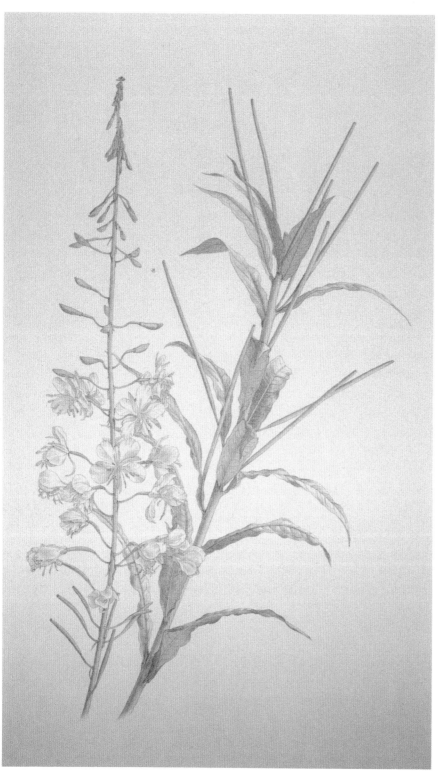

B

2 . FIRST GREEN COAT [B]
A wash mixture of permanent yellow
and Winsor blue was used throughout
all vegetative parts. A few highlights
were left on the leaves.

3 . FIRST FLOWER COAT [C]
The closest I could approximate the
flower colour was by using a mix of
permanent rose and Winsor blue. This
was near the hue but it lacked some of
the vivid quality of the living tissue.

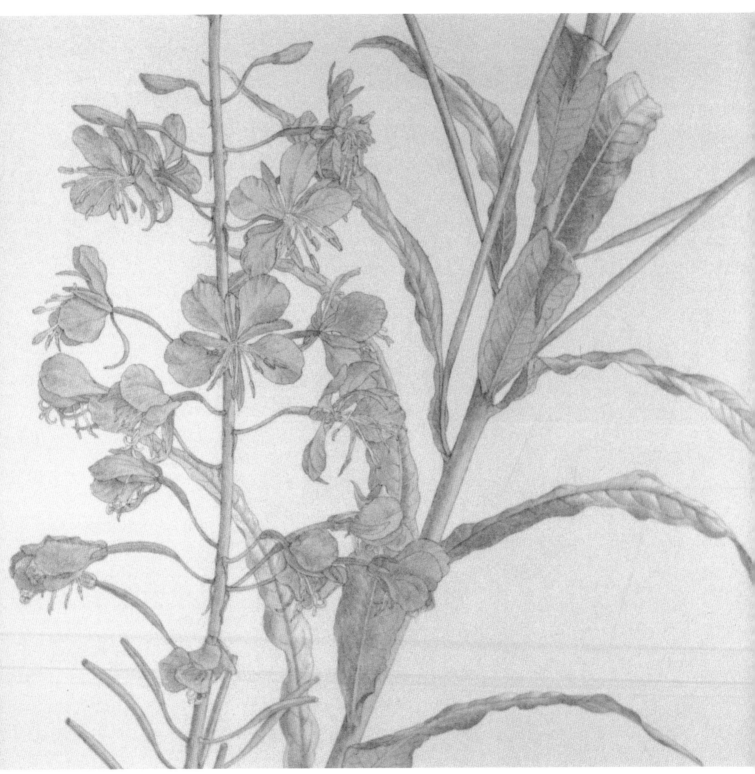

C

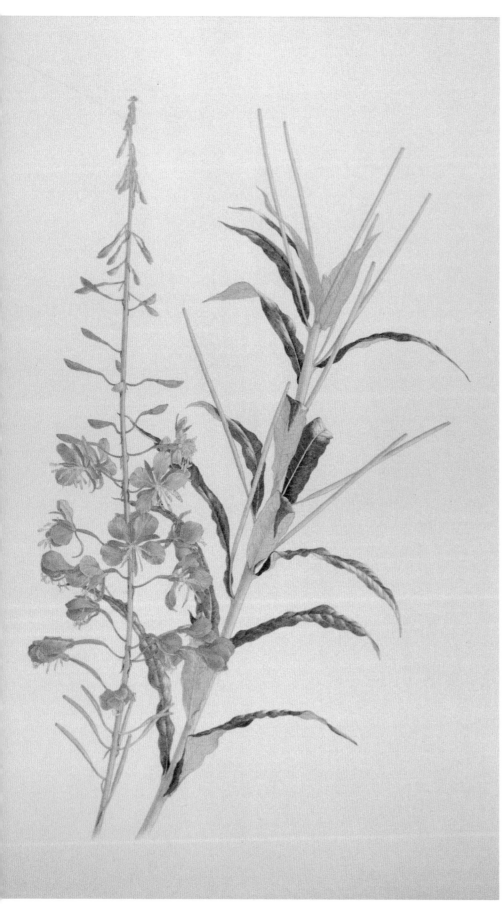

4. FURTHER INFLORESCENCE COLOURS AND SECOND GREEN COAT [D]

The upper left stem showed a rich glow. This was attained by using two coats of a permanent yellow wash.

The petal colour was then added to buds and ovaries.

A light wash of Winsor red was used for the left side of the upper inflorescence stem and for the pedicels on both stems.

Then a second coat of the flower colour was given to the petals and calyces.

The strap-shaped sepals were next further enriched by a more or less equal mix of permanent rose and Winsor red.

The main green for the upper surfaces of the leaves was mixed from Winsor yellow, Winsor blue, and a little alizarin crimson. Where appropriate, gaps were left to allow the undercoat to show through as venation. The tiny bracts subtending the pedicels on the left stem were also of this colour.

5. FURTHER GREEN COATS AND FINISHING TOUCHES [E]

For the section on the right, a slightly more intense version of the first green wash was mixed as above and used on the capsules and stem. This mixture was then amended by the addition of more Winsor blue to make a quite bright green for the leaf undersides.

The wash of the second green coat was dry-brushed where required for final emphases on the leaf uppersides.

Next, a wash of very dilute Winsor blue was brushed over the highlights.

The unopened anthers of the upper flowers were coloured with rose madder. The dehisced anthers were a neutral grey – this was derived from more or less equal amounts of Winsor blue, Winsor yellow and alizarin crimson.

Permanent magenta was used for the undersides of the stigmas.

The dying crumpling lower flowers had a bluish tinge and this was added from a mix of permanent rose and violet.

Finally, further emphasis was given here and there using the shadow mix.

D

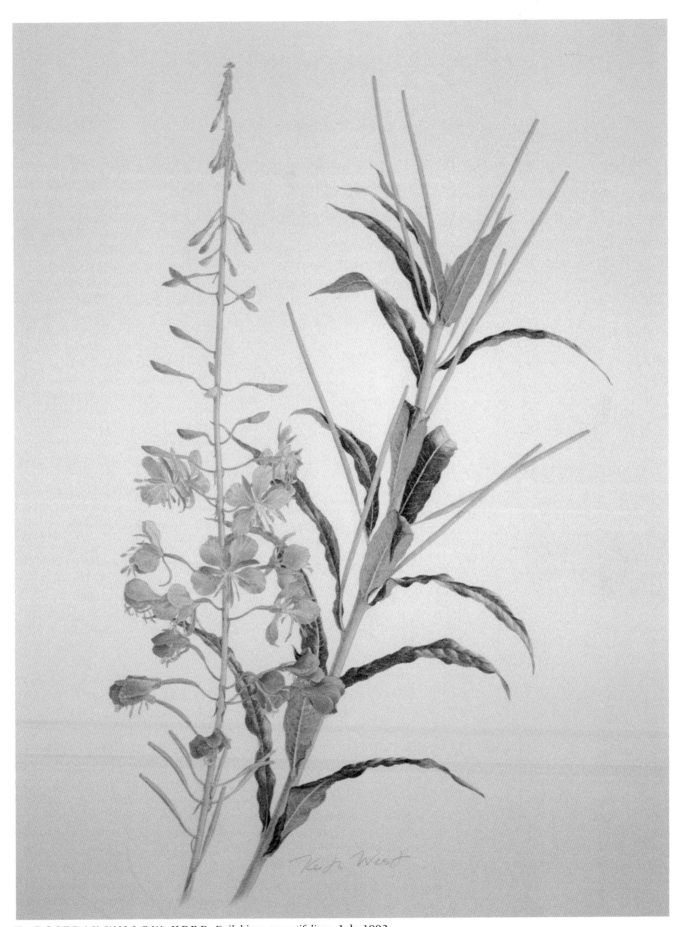

E. ROSEBAY WILLOW-HERB, *Epilobium angustifolium*, July 1992.

10 KNAPWEED

Centaurea nigra, Family Compositae

Knapweeds in bloom are abundant in late summer; they flourish along roadsides, railway embankments and similar places.

The colour of the flower heads is fairly unusual; I find it a little harsh, but this reservation is countered by the interest of the curiously fringed *involucral phyllaries*.

The flower buds are almost globular; they are also very hard. These qualities are expressed in the common name, 'knapweed'. It derives from 'knap', an archaic form of 'knob', and there also seems to be an etymological link with 'knapping' – the hitting or hammering of flints, which were used for road mending in the past.

PAPER: stretched Arches 90 lb NOT. IMAGE AREA: 246 × 142 mm.

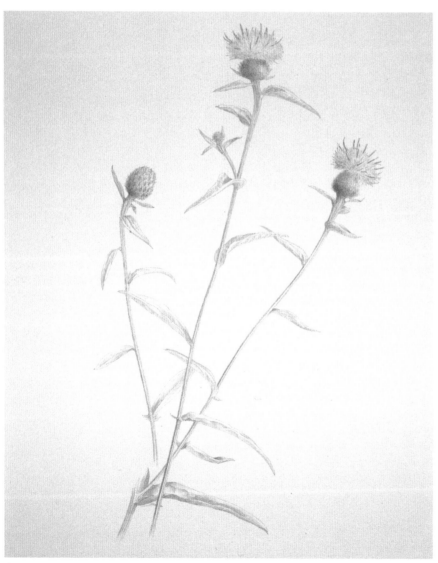

A

1. DRAWING AND SHADING [A]

Specimens were collected from a roadside verge in late afternoon. They were held overnight in water to settle.

The drawing was begun with the upper flower head or capitulum. I took care to differentiate the darkish tubular structures, bearing the sexual parts, from the lighter hued petals. An overall impression of the mass was aimed for, since the lines of every floret were far too complex to follow in precise detail. The same impressionistic treatment was necessary for the massed fringed dark brown phyllaries below the florets.

The stem was continued down, taking in the side branch and bud as well as the leaves. Marked stem features were the thickened portions immediately below the involucres and the strong ribs.

I then selected another stem, also with a mature flower head, to place on the right. This was drawn to include its origin from a main stem with a subtending leaf.

The bud on the left was drawn next: I attempted to show the spiral arrangement of the phyllaries though this was slightly obscured by the fringed margins. The stem below the bud was then completed together with the leaves.

Ample room was left on the right for the later addition of details of a floret and a phyllary.

The shadow mix was used throughout. I used shading to reveal the modelling of the semi-spherical flower head bud and flask-shaped involucres.

2. FIRST GREEN COAT [B]

A wash mixed from permanent yellow and Winsor blue was used for all the vegetative parts. No allowance was made for highlights because all surfaces were matt.

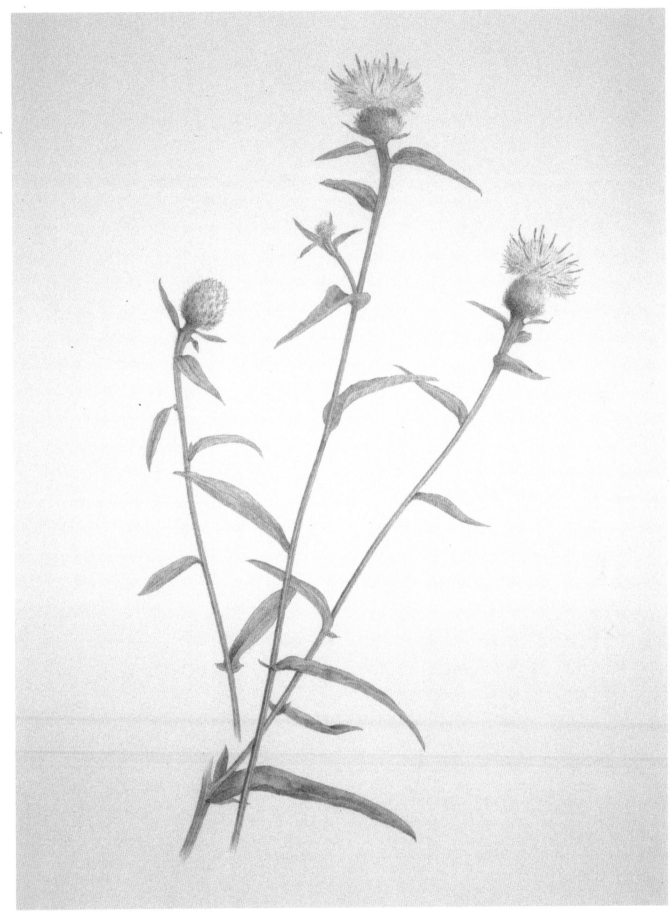

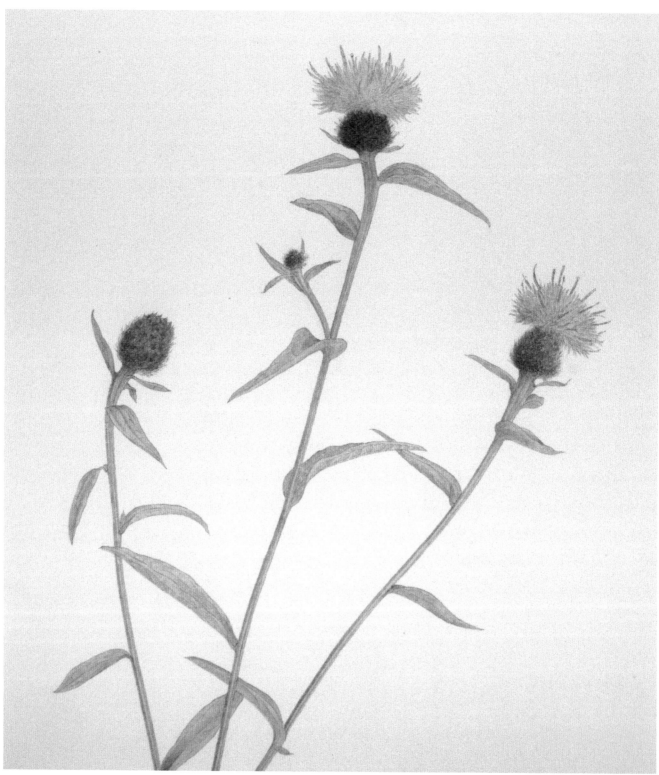

C

3. FIRST FLOWER COLOURS [C,D]

A mixture of alizarin crimson, Winsor blue, and a little Winsor yellow, was used for an undercoat of brown for the buds as well as the involucres.

The colour of the florets came from a dilute mix of violet and permanent rose.

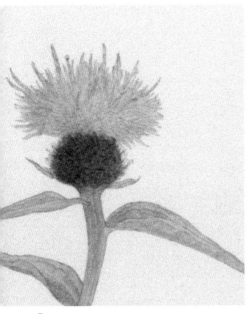

D

4. FURTHER GREENS AND FLOWER COATS ETC. [E]

Another layer of the first green wash was used to heighten the stem colour where required.

The main leaf hue was arrived at by adding to the above wash more Winsor blue and alizarin crimson. Where appropriate, traces were left blank to allow the underlying pale green to show through as venation.

The raised columns of stamens (enclosing pistils) were painted in a dark tone mixed from violet and Winsor blue, dulled by a touch of Winsor yellow. (At this stage it was irritating to notice that the flowers which had opened prior to picking looked a little battered in comparison with those few that had just unfolded. The latter were more symmetrical and neat in the arrangement of the florets and the columnar stamens. Ideally, one should take this into account in picking specimens, but timing is difficult to gauge.)

The flower wash noted above was added to parts of the flower heads to deepen the hue.

The mix for the brown of the phyllaries needed a brush-tip more of Winsor blue for accuracy – this was dry-brushed on.

Further emphasis was given to the deeper tones throughout by using the shadow mix.

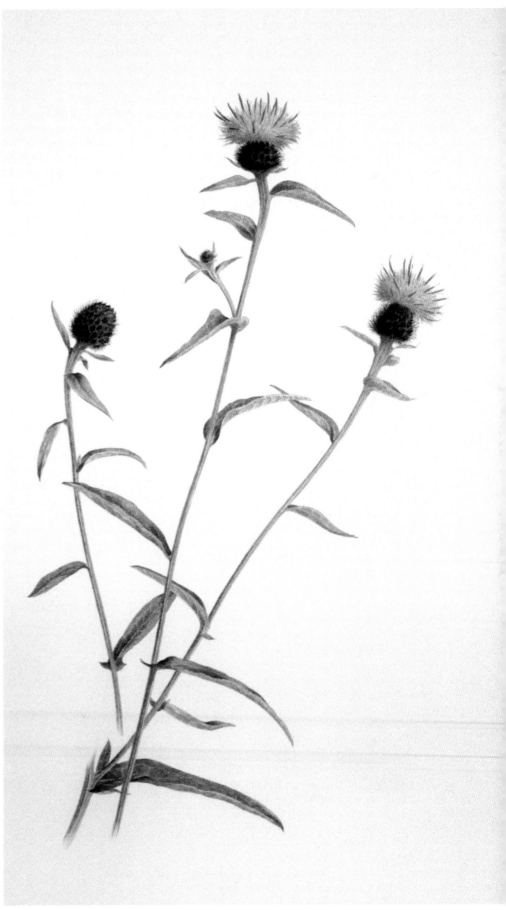

E

73

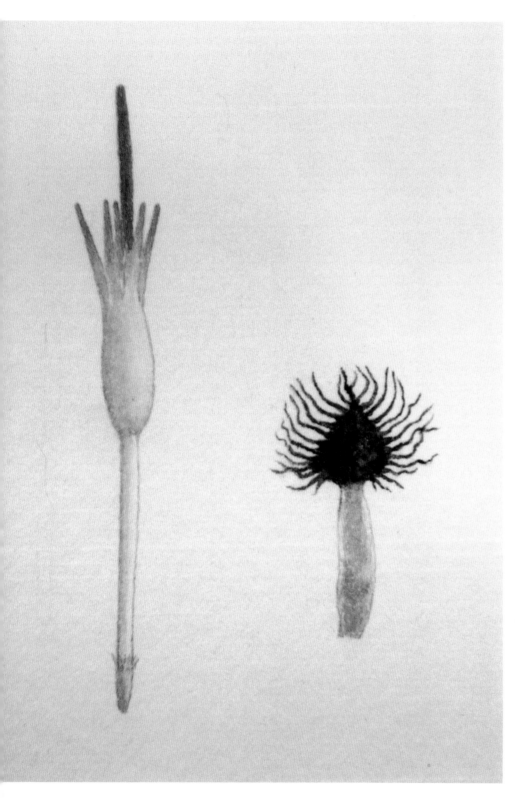

5. DETAILS [F]

I thought that more interest would be added by the inclusion of floret and phyllary details.

A flower head was bisected with a scalpel and then the tip of the blade was used to tease out a number of florets. One was chosen and placed on a pad of paper pre-dampened to slow desiccation.

I used a hand-lens to examine the floret, then 'stepped' a ×2 magnification with dividers onto the right of the plate.

After completing the drawing, a number 1 brush (needed throughout for the details) was used with the shadow mix.

The colours for the corolla and staminal column were applied from the earlier mixes. The hue of the ovary at the base was derived from alizarin crimson with Winsor yellow plus a dot of Winsor blue.

Phyllaries were then tweaked by hand from the mid-section of the involucre where they were the most developed in form. One was placed on the damp pad, then the height was transferred as before with the dividers – again with a magnification of ×2.

Constantly using the hand-lens, the phyllary drawing was completed. Following the shadow mix, the green base was painted using some of the main leaf colour wash plush a little more permanent yellow. The upper, *fimbriate*, portion was coloured using the original brown mix.

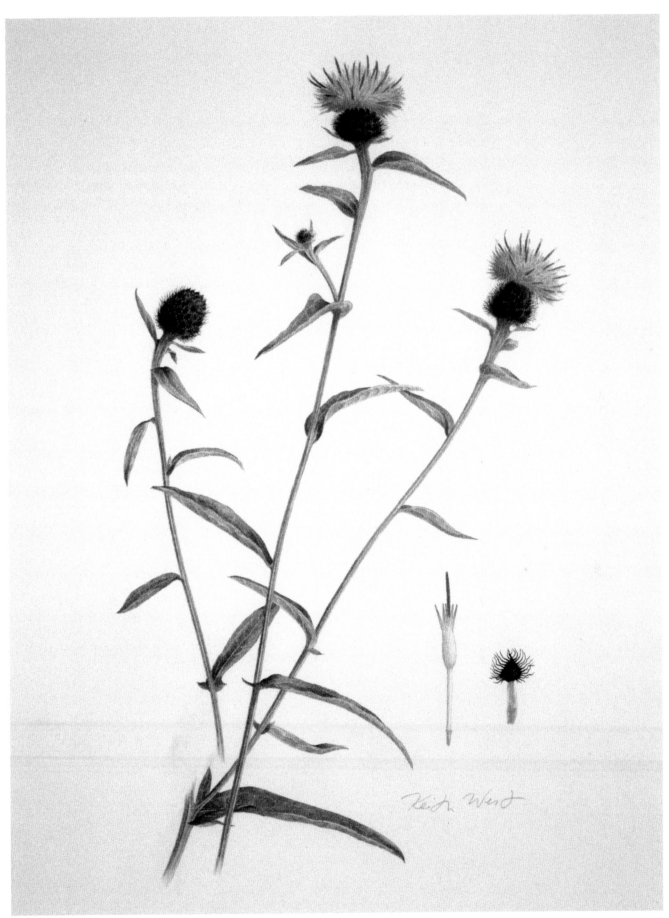

G. KNAPWEED, *Centaurea nigra*, August 1992.

11 MONKEY FLOWER
Mimulus guttatus, Family Scrophulariaceae

The monkey flower is a successfully established garden escapee. It was introduced to horticulture from the Aleutian Islands in 1812. Since then it has become widespread as a wild flower in damp sites, such as beside streams, in much of Britain and elsewhere.

The common name is derived from a fancied resemblance of the flower to a monkey-type face.

PAPER: stretched Arches 90 lb NOT. IMAGE AREA: 243 × 156 mm.

1. DRAWING AND SHADING [A]

Specimens were collected from the edge of a swift-flowing stream.

I began drawing with the upper right petal lobe of the flower on the left. The form was followed clockwise, with care being taken to keep each part aligned and in proportion to the others. Irregular (zygomorphic) flowers, such as the monkey flower, are more difficult in general to draw than regular (actinomorphic) flowers, such as daisies etc.

It was noticed that the minute leaf-like stigma was just visible at the upper lip of the mouth of the flower. The stamens remained hidden. The positions of the red blotches were shown – some were blurred by yellow hairs.

The buds behind the top flower were then drawn, and succeeded by the flower on the right. The leafy stem below was then portrayed, with attention being paid to the unusual and characteristic venation.

To balance the composition, a flowering stem was added to the right with the flower in side view.

The shadow mix was used throughout, beginning with the flowers. The soft edges of the shadows required pre-dampening and blurring (p. 28). Further emphasis was given to some areas with a second layer.

A

2. FIRST YELLOW AND GREEN COATS [B]

A fairly intense coat of permanent yellow was used for the flowers. I worked on these before turning to the vegetative parts because there were few available and I wanted to be sure to capture them before they deteriorated.

The underlying green of the vegetative parts was mixed from permanent yellow and Winsor blue. This was used throughout while skirting numerous highlights.

3. SECOND YELLOW AND GREEN COATS [C]

Additional permanent yellow was dry-brushed on more intensely pigmented parts of the flower, as well as into the calyces where the bright floral tubes showed through the thin green tissue.

A touch of the above yellow mix was added to the first green wash – this yielded a yellow-green for the interior throat of the left flower.

The wash of the first green coat was almost used up, so the same hue had to be mixed again to intensify the colour of the vegetative parts as needed.

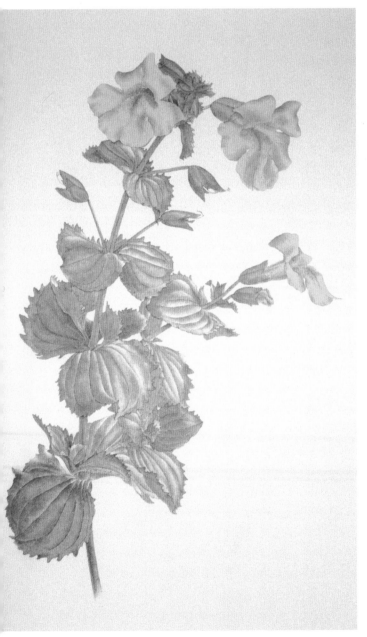

B

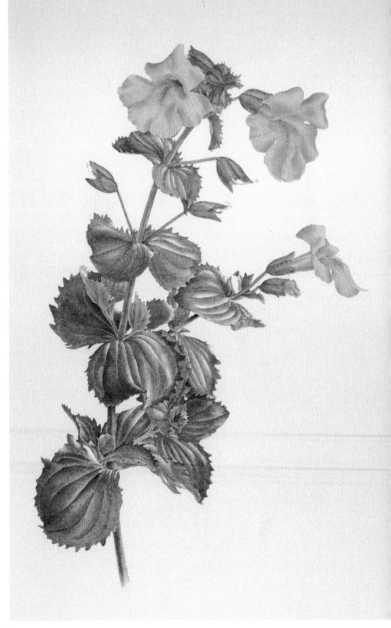

C

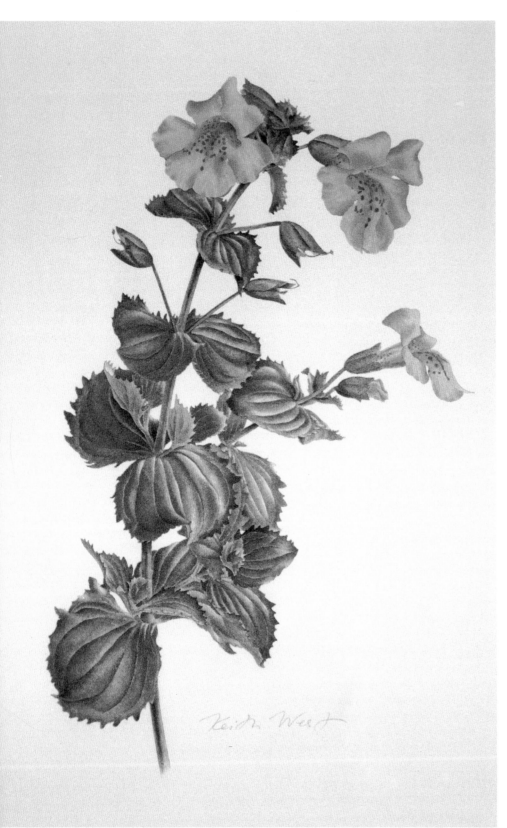

4. FINISHING TOUCHES [D,E]

A dilute mix from cadmium orange and permanent yellow was used on the throat of each flower.

The rich reddish hue of the flower markings was derived from permanent yellow, cadmium orange, alizarin crimson, and a hint of Winsor blue. This was applied with a number 1 brush.

A darker colour from alizarin crimson and Winsor blue was used for the minute speckles on the calyces; this was added to some of the branchlets after dilution.

The green of the vegetative parts was again applied to deepen further some shaded areas.

Winsor blue was added to the orange-reddish mix of the blotches to colour the withering stigmas and styles of the three upper calyces from which the corollas had fallen.

A final task was to add more of the shadow mix to yet further deepen darker areas.

D

E. MONKEY FLOWER, *Mimulus guttatus*, August 1992.

12 HONEYSUCKLE

Lonicera periclymenum, Family Caprifoliaceae

The name, 'honeysuckle', refers to the availability of the nectar-rich flowers for long-tongued hawkmoths, and perhaps more often in the past, for children.

Honeysuckle is a vigorous climber, producing leaves and making rapid growth well before the woodland canopy closes in to reduce light in late spring.

It is also a characteristic hedgerow plant. The graceful flowers appear in two waves – the first in June, the second climaxing in September when ripe fruits accompany the blooms.

The flowers on first opening are white with a light blush of pink. Later they become suffused with yellow which becomes more intense until the flowers' senescence and collapse.

PAPER: stretched Arches 90 lb NOT. IMAGE AREA: 293 × 167 mm.

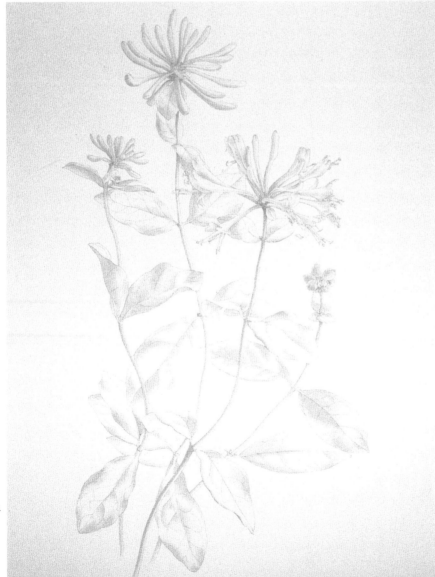

A

1. DRAWING AND SHADING [A]

Flowering and fruiting stems were collected from the hedges of a nearby green lane and placed in 'oasis'.

I began by working on the head in bud at the top because I wanted to catch it at this short-lived stage. Drawing started with the central boss from which each bud originated. The buds were elegantly shaped; some of the more mature ones showed signs of beginning to open with the lower petal lifting slightly along the margins. Though I noticed that the whole inflorescence and the upper part of the stem were covered with a fine pubescence, this was too minute to show without distortion. The stem and leaves for this head were left until later, when the rest of the composition had taken shape.

After completing the budding head I turned to the inflorescence which carried some opened flowers – again starting from the central boss. The twisting stem of this head was then drawn, together with the rather contorted leaves.

The tightly budded inflorescence on the left was then drawn with its stem and leaves. The lower pair of leaves were too damaged to use, so these were replaced by two others from a similar position on another stem.

Next I filled in the stem of the first head, now standing in the rear, carefully carrying the leaves behind those of the other two specimens. Given the regular spacing of the paired leaves, a slightly uncomfortable juxtaposition near the base of the plate seemed inevitable.

Finally, a fruiting stem was inserted on the right. I chose one bearing an average number of fruits for this particular population. Fertilization appears chancy and uneven.

Using the shadow mix I first shaded the rear stem, keeping the tone light with the thought that more might be added later if needed.

In shading the rest of the plate I
found that it seemed best to keep the
tone fairly even overall at this stage,
though a few areas – centres of
inflorescences and some sections of
stem – were deepened a little.

2. FIRST GREEN COAT AND FIRST FLOWER COAT [B]

A first green wash was mixed from
permanent yellow and Winsor blue –
this was carried over all the vegetative
parts. Additionally, the colour was used
for the bases and apices of the flowers,
the minute calyces, and the stigmas
of the opened flowers. Several areas on
the leaves were left blank for low-level
highlights on the semi-matt surfaces.

Then a dilute wash of permanent rose
was brushed into the flower buds and
the floral tubes of opened flowers.

A warm light yellow, mixed from
permanent yellow and cadmium
orange, was used on the flowers: first
on those open for some time, and then
diluted for the paler newly opened
flowers.

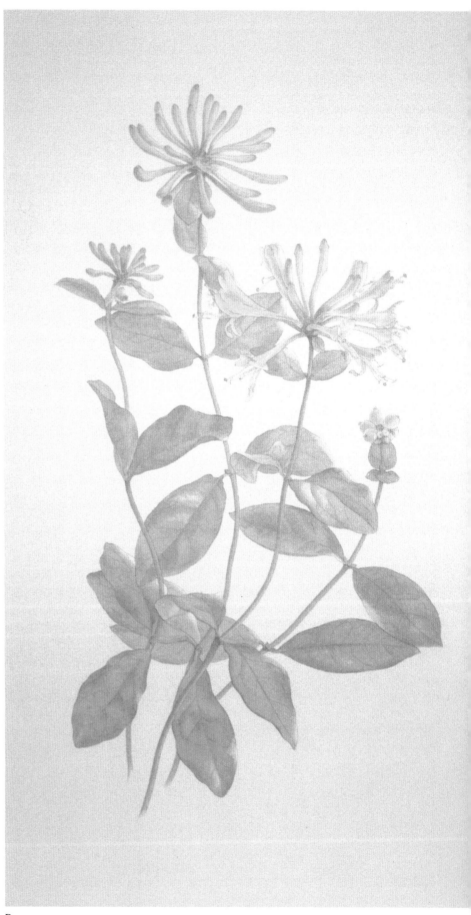

B

80

3. SECOND GREEN COATS [C]

The basic leaf green was derived from permanent yellow, Winsor blue, and a touch of alizarin crimson. The wash was applied in almost dry-brush form to allow me enough control to avoid the midribs and the fine lateral veins. In putting on the leaf green I found that the fairly intense colour tended to obscure the underlying light shading. To avoid losing the pattern of light and shade for each leaf, I returned to the faintly discernible shaded sections and added pigment as soon as the first coat was completed. Fortunately this was feasible due to the unusually dry summer air which left washes ready to be worked over virtually immediately. In this instance, given the darkish tone of the leaves, I ought to have had the foresight to make the original shading deeper.

The undersides of the leaves were slightly glaucous and lighter coloured than the uppersides. To reach this hue I used a dilute wash of Winsor blue drifted over the underlying first green. The same blue was used for the highlights.

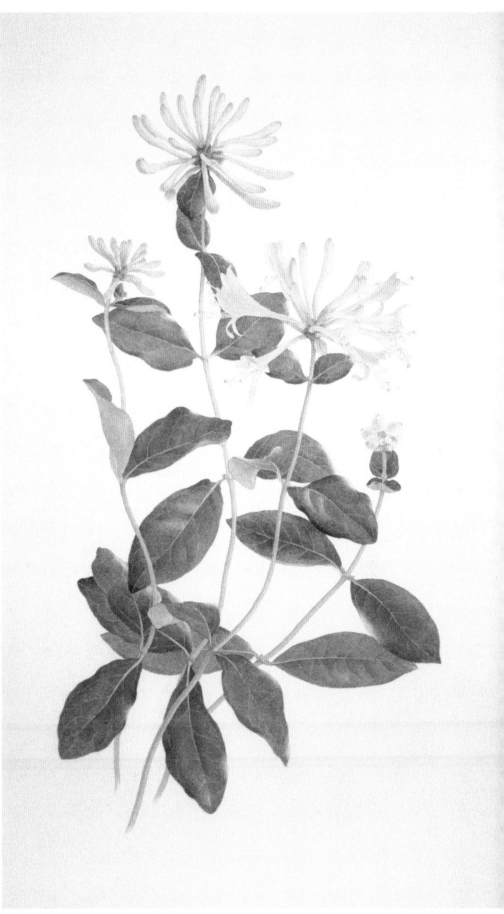

C

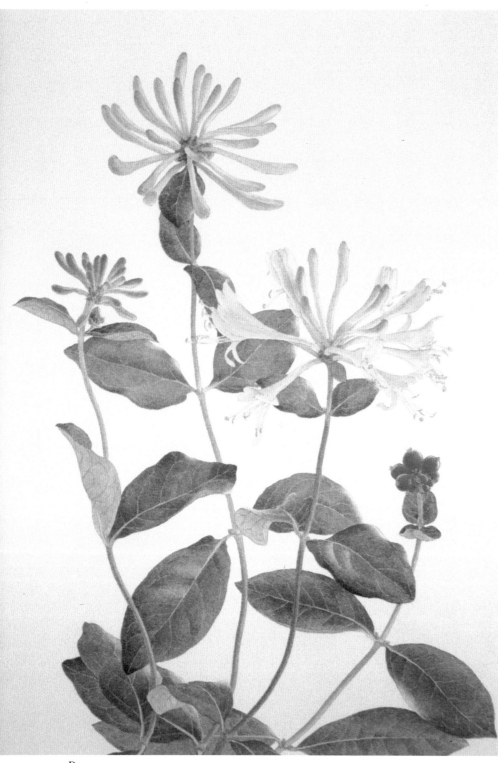

D

4. FINISHING TOUCHES [D,E]

The venation of the leaf undersides was emphasized with the basic leaf green used on the tip of the brush.

For the lower of the two leaves awkwardly angled together on the fruiting stem a cast shadow had been omitted – this was dry-brushed on, again using the basic leaf colour. (In retrospect I am puzzled that I did not make a minor adjustment to this leaf in drawing.)

A mix of Winsor red and alizarin crimson served for the berries, this was dry-brushed using several coats. The minute bracts below the fruits and the remains of the calyces on their apices were first coloured with the yellowish-green of the first green coat; in places this was tinted to a light brown by adding some dilute berry red.

The colour of the flower buds on the left was derived from a mixture of permanent magenta, permanent rose, and a dulling touch of Winsor yellow. The inner buds of the upper and right flower heads were enriched with the same mix.

The permanent rose used for the first flower coat was again applied here and there, to deepen the colour of some buds and opened flowers.

Pollen-coated anthers were coloured with a dilute blend of permanent yellow and cadmium orange.

The stems were, in part, highly pigmented. This colour was matched by a mixture of permanent rose and alizarin crimson, modified by the underlying green.

More touches of the leaf green were added for emphasis where required to complete the painting.

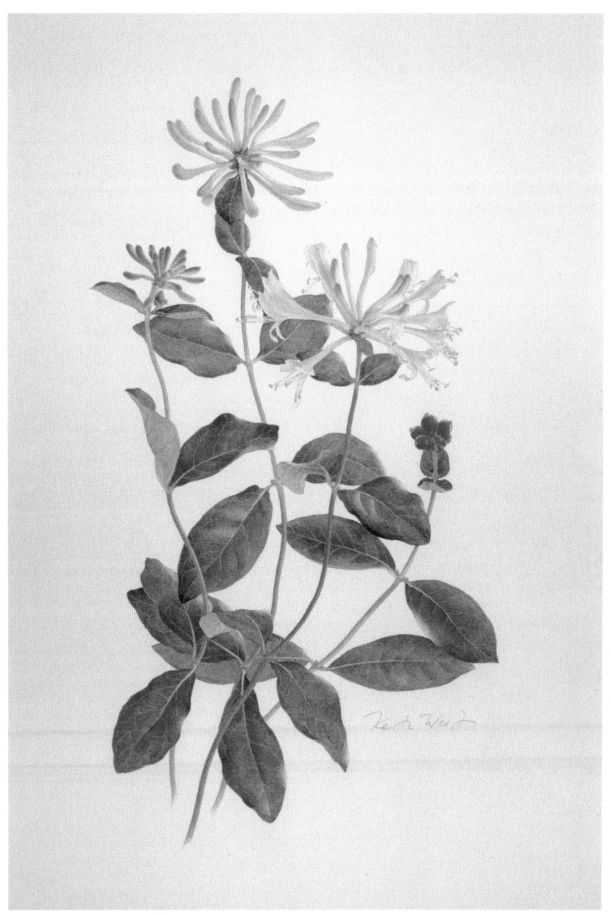

E. HONEYSUCKLE, *Lonicera periclymenum*, August 1992.

13 FIELD SCABIOUS
Knautia arvensis, Family Dipsacaceae

In late summer the choice of wild-flower subjects narrows abruptly – apart from yellow-flowered composites which are not particularly inviting. In this circumstance, pale mauve flower heads are welcome and distinctive.

The unfortunate common name, 'scabious', refers to a past use in treating itches. A botanist of seventeenth-century Saxony is honoured by the generic name.

PAPER: stretched Arches 90 lb NOT. IMAGE AREA: 302 × 195 mm.

A

1. DRAWING AND SHADING
[A]
Specimens were collected from drying south-facing banks along a climbing country lane. After picking, the flowers rapidly wilted, but following a night in water they completely recovered.

I began by lightly roughing in a composition with just a few lines. Material was chosen to show each stage of floral development. (Though each scabious 'flower' is properly a capitulum, for ease of reference I have used the more familiar 'flower' or 'flower head' throughout.)

The opening flower on the left was drawn first as I recognized that this phase would pass quickly. Drawing started with florets at the centre of the flower, with a gradual movement outwards to the more expanded outer florets. The stalk of this flower was followed to its junction with the main stem, including leafy bracts on the way. A larger dissected leafy bract subtended the axil.

In working on the upper flower, I found it appropriate to begin with the topmost floral petal and then to move around the head to the left and right, while also suggesting the amorpous mass of the inner florets. To help in working on this inner detail, I first put in the raised anthers as position markers. On finishing the flower head, I carried the peduncle down to its meeting with the stalk of the left flower.

Another flower was drawn on the right, this time the head was angled to reveal the radiating involucral phyllaries. Drawing began from the point of origin of the upper phyllary. The surrounding ring of floret petals followed, and this was succeeded by the *exserted* stamens and styles. The stem of this head, like the others, was taken to its junction with the main axis. The subtending bract was included.

A flower head in bud, just beginning to unfold, was established on the right. The stem with paired bracts was taken

down towards the bottom of the plate.

Though it was difficult to find a suitable position, I wanted to show a representative leaf from about the plant base. In placing the leaf behind the lower stems, I felt that if the tone were to be kept light, the placement would be effective.

Tone was added throughout with the shadow mix. Though the rear leaf was left with one coat, a second layer was used for emphasis elsewhere as required.

2. FIRST GREEN COAT AND FIRST FLOWER COATS [B]

The underlying pale green of the plant was mixed from permanent yellow and Winsor blue – the wash was used for all vegetative parts. No blank areas were needed for highlights because all the surfaces were matt. The only part left unpigmented was the broadened base of the midrib of the large leaf.

A dilute wash of violet was used for the first coat of the two upper flower heads; the colour was further watered for the lighter central portions.

The flower head on the left, typical of those just opening, showed more red in its colouring than the others on the plate. For this hue, permanent rose with just a brush-tip of violet was used. The difference was subtle and it may not be visible in reproduction.

B

C

3. FURTHER FLOWER COATS AND SECOND GREEN COATS [C,D]

The rose-violet wash was used again to enrich the colour of the left flower. Then the same wash was applied in touches to modify the petal colour of the upper right flower.

Dilute Winsor blue was dry-brushed into some parts of both upper flower heads.

The anthers were then coloured with pale permanent rose.

The bright green of the initial coat was used to deepen the shaded sides of the various stems.

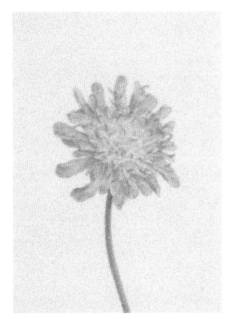

D

4. FINISHING TOUCHES [E]

I felt that more tonal contrast was needed in the flowers, but further use of the shadow mix would have tended to dull the colour. To avoid this, a new shadow mix of Winsor blue and alizarin crimson (omitting the usual yellow) was used judiciously.

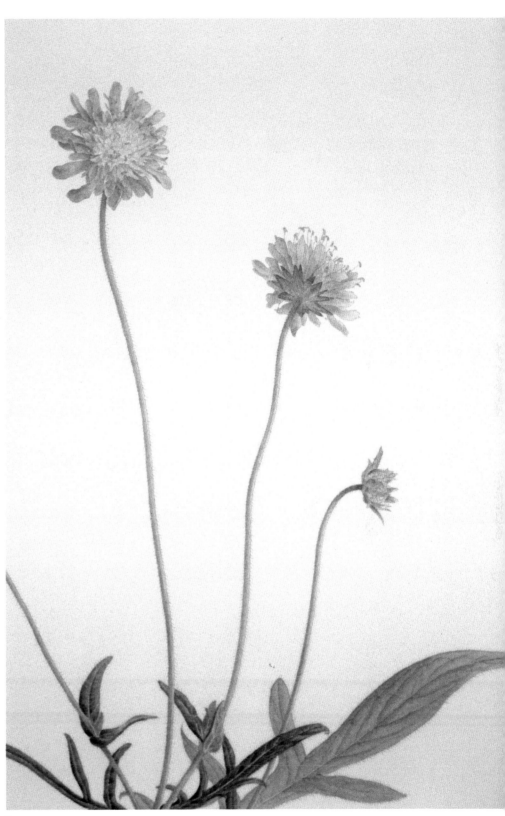

E

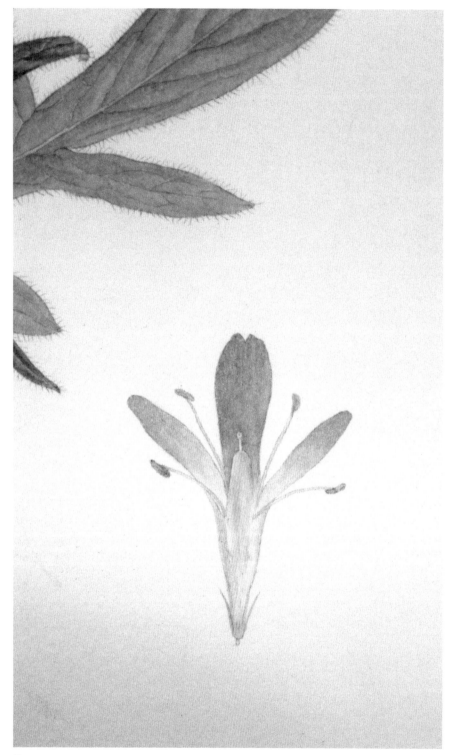

F

5. DETAIL [F]

In the flower heads the forms of the individual florets were lost, so it appeared appropriate to add a floret detail. First a flower head was bisected using a scalpel, so exposing a cross section of florets. A number of the more developed outer florets were prised free with the tip of the blade. These were arranged on a piece of watercolour paper pre-dampened to slow their shrivelling.

Dividers were used to transfer to the plate the height, width, and other main dimensions of the best displayed floret. These were stepped off to give a ×2 scale.

The floret was drawn rapidly, using the hand-lens to check details.

Light shading was added with the new shadow mix (above).

The main rose-violet flower mix was used for the corolla lobes and in dilution on the stamen filaments.

Pale permanent rose coloured the pollen covered anthers, and the first coat green was applied to the floret base.

The last task in completing the plate was to add hairs to the margins of all the vegetative parts. By using the hand-lens I saw that two layers of hairs were present throughout, but at life-size scale it was feasible to show only the longer ones.

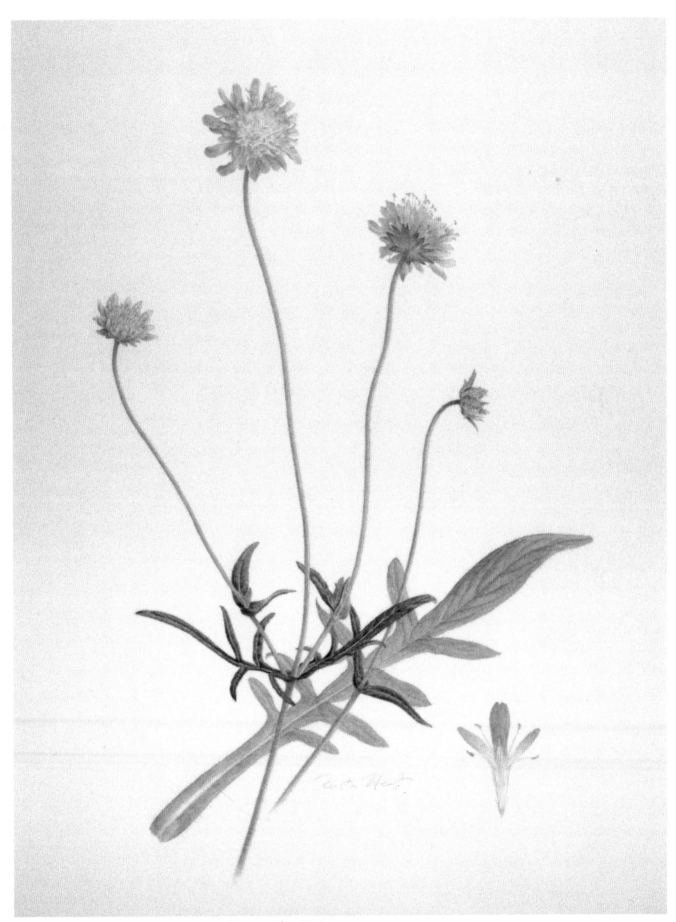

G. FIELD SCABIOUS, *Knautia arvensis*, September 1992.

14 HOP

Humulus lupulus, Family Cannabinaceae

The hop plant genus *Humulus* has a curious taxonomic history, having been variously placed by authors in the families Urticaceae and Moraceae, as well as in Cannabinaceae. The origin of the generic name seems uncertain. Additionally, the specific epithet, *lupulus* (from the Latin *lupus*, a wolf) refers to a supposed wolf-like characteristic of behaving as a strangler – not an obvious trait of wolves. In contrast, the vernacular, 'hop', derives sensibly from the Old English, *hoppan* – to climb.

Though hops have spread from cultivation through much of Britain, the species is probably native only in parts of southern England. It is *dioecious*: the male and female flowers are borne on separate plants.

Female plants, as portrayed here, bear flowers that produce *cones*. If you break one open, you will find the minute yellow resinous granules that add flavour to beer. When sampled by tongue-tip, the grains leave a persistent bitter taste.

The plant is familiar in hedgerows sprawling in dense tangles over other species. Its climbing is accomplished partly by twining around supporting vegetation. This process is assisted by the presence of *retrorse* minute *barbed* hairs – these rub off or are shed from older stems, but they are easily seen on parts actively expanding the plant's coverage. Unexpectedly, leaf undersides are virtually glabrous, but the upper surfaces are coated with similar hairs. These are difficult to pick out without a hand-lens, though they give an odd *scabrous* texture if you stroke against their retrorse formation towards a leaf's apex.

Apart from the use of hops in brewing, in the past the plant has also been a source of food. The Romans treated the young shoots in spring much as we would asparagus. My wife has cooked apparently tender growing tips in early summer, but they were gritty, tough, and tasteless.

PAPER: Arches 90 lb NOT. IMAGE AREA: 296 × 203 mm.

1. DRAWING AND SHADING [A]

Hops were plentiful in the hedges of a nearby lane and I picked ample material. A woody stem was first positioned in 'oasis', and other sections were held in jars.

I decided to make a composition from the woody stems with ripening fruits, a twining stalk, and a detail with mature fruits.

Drawing was started with the largest leaf towards the base of the plate. The midrib of each lobe was placed, the outline was then roughed in and fined-up with the lateral veins carried to the margin. Unfortunately the work was complicated by a steady and quite large change in the leaf's position. I think that in this instance the movement was missed through the detail of the margin serration needing very close attention. In trying unsuccessfully to reconcile the drawn image with reality I amended the positions of some of the lobe midribs as the work progressed. This led to considerable distortion which was obvious when focus was changed from the immediate detail to the leaf as a whole (see p. 12).

The solution was to place a wedge of card in the leaf axil, preventing further movement, and then to erase all but the last two lobes drawn. The other midribs were again positioned and the same sequence followed as before.

In irritation at being held back, and perhaps because I had failed to pick up the movement, I began the redrawing without checking that the leaf's orientation was as I had originally intended. Consequently, the main axis of the leaf is more towards the horizontal than is ideal. The cause of this flaw is mentioned at length because it illustrates how easy it is to overlook the motility which is common enough in plant organs.

The line of the branch was sketched in and then the facing leaves were placed singly, one above the other. Once these were established I returned to put in at the nodes the paired leaves that were turned away exposing their undersides. The developing fruits were also added. The scales of the cones represented different layers of the floral envelopes, these were distinguished by being *acute* or *obtuse* at the tips.

After the branch was completed, I returned to its base to draw the woody stem and the base of the twin branch on the right, together with its much foreshortened subtending leaf.

Minute retrorse barbs, visible on the upper stem etc., were shown where appropriate.

The composition was rounded out by the addition of a twining stem on the left with leaves and one exposed fruit.

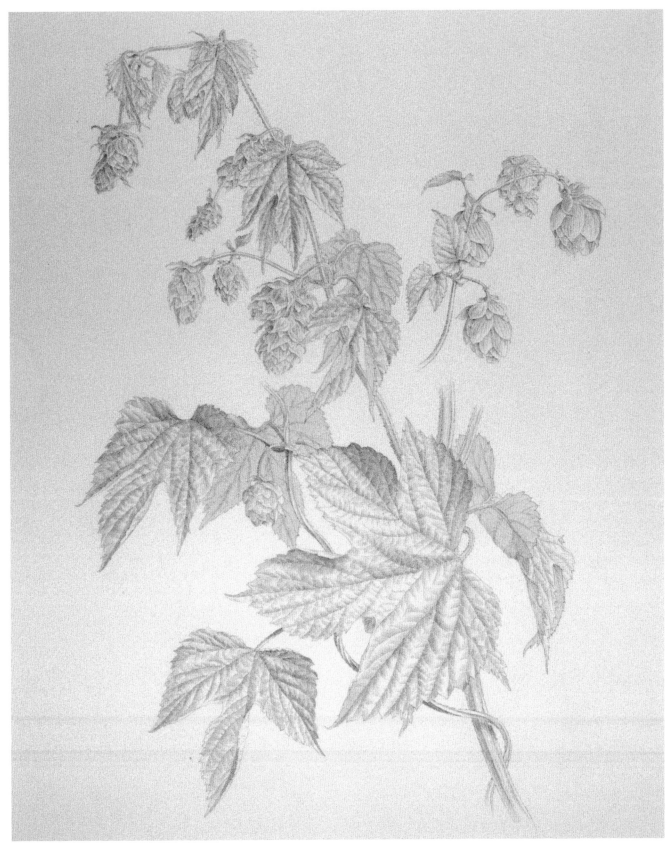

A

The shadow mix was used, starting with the branchlet on the right. I then moved to the fully presented lower leaf knowing that it would take some time to capture the texture. Each tiny shaded portion between the minor veins had to be painted separately with the outer edge being softly blended. The rest of the plate was relatively straightforward.

2. FIRST GREEN COAT [B,C]

A dilute mix of permanent yellow and Winsor blue was used for the first green coat. Both in hue and tone it happened to match the mature hop fruits. On the leaves a few areas were left to indicate the positions of low-key highlights.

C

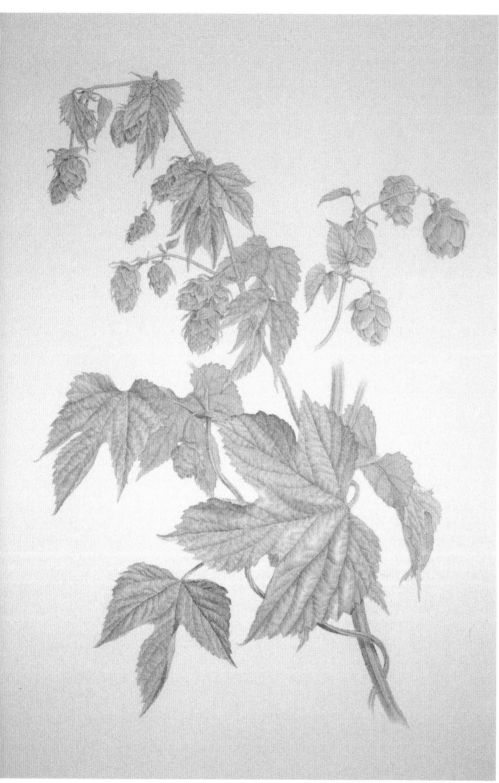

B

3. SECOND GREEN COATS [D]

The basic colour for the leaf uppersides was mixed from permanent yellow, Winsor blue, and a little alizarin crimson. The hue was carried over the leaves between the main veins, section by section. The underlying pale green was allowed to show as veins through breaks left where necessary.

A very dilute wash of Winsor blue was used for the leaf undersides modifying the original green to give a faintly bluish tinge. The main veins were skirted.

I then returned to the first green wash to enrich the shadowed areas on the fruits.

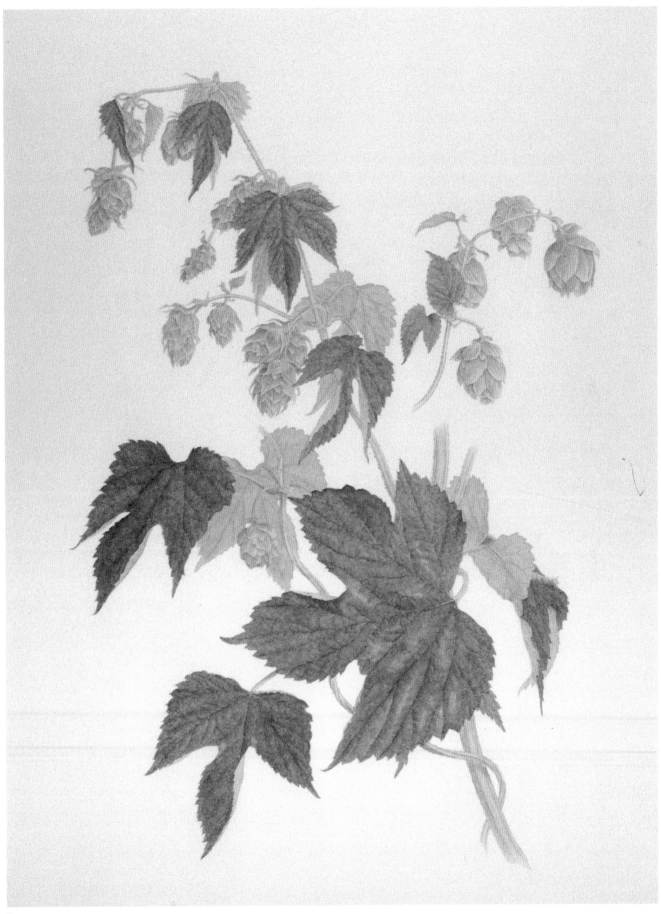

D

4. REDS AND BROWNS [E]

A dilute reddish hue, for the markings on the fruit scales and stems, was mixed from rose madder and a hint of alizarin crimson.

F

5. FURTHER GREEN COATS AND FINISHING TOUCHES [F,G,H]

With the basic coat for the leaf uppersides, the darker parts of the leaves were slowly worked over.

The first green was dry-brushed into the stems.

The reddish mix (above) was deepened by the addition of a brush-tip of Winsor blue and used for the more intensely coloured parts of the fruits and stems.

Very dilute Winsor blue was drifted over the low-key highlights on the leaves (this may not show in reproduction).

Translucence on parts of the leaves was suggested by a wash of permanent yellow.

The brown of the woody lower stem was made from alizarin crimson, permanent yellow and Winsor blue.

Finally, extra shadow colour was added where needed for further emphasis.

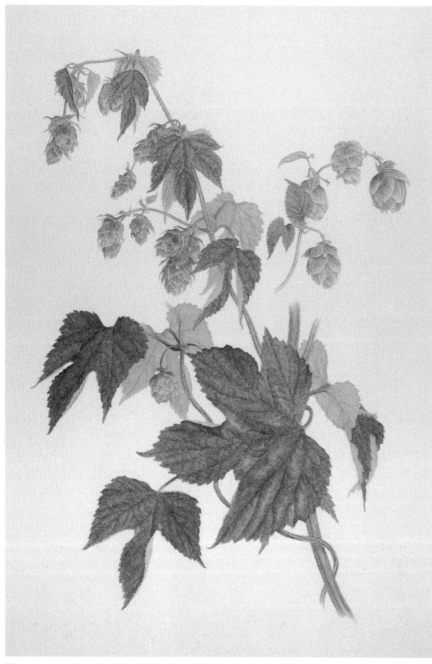

E

94

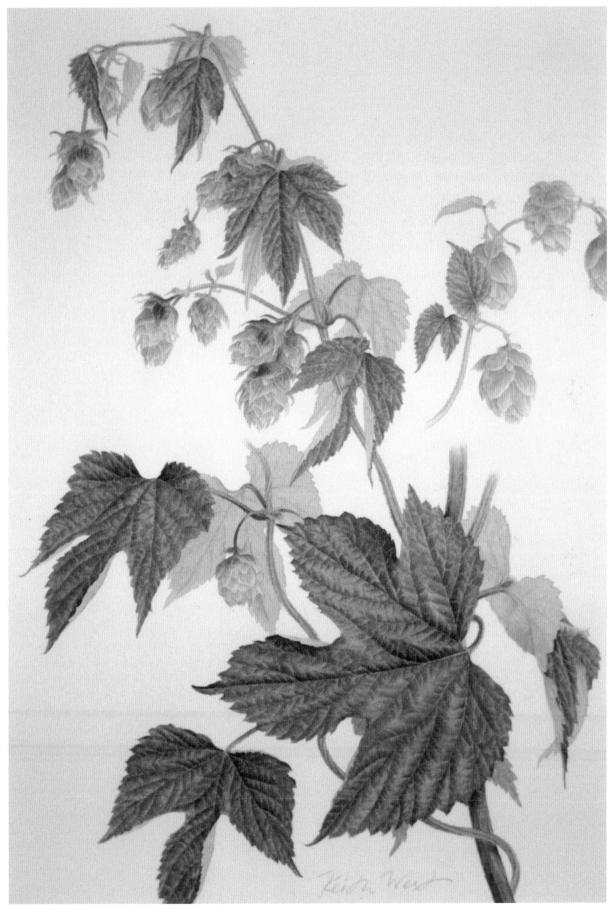

G

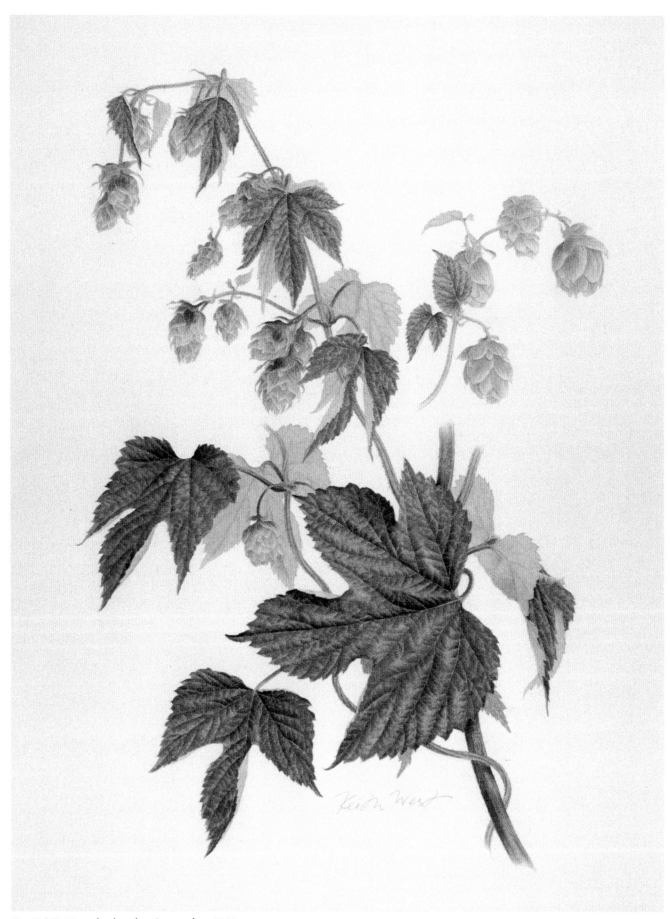

H. H O P, *Humulus lupulus*, September 1992.

96

15 BLACKBERRY LEAF
Rubus sp., Family Rosaceae

There are said to be some 400 species of *Rubus* in Britain and it takes an expert to identify them with any confidence. In this instance I feel comfortable in using only the common and generic names.

During a Sunday afternoon walk I found a blackberry leaf showing the most wonderful combination of colours – yellows, ambers, reds and greens. This spurred me to look several days later for a similar compound leaf. Unfortunately, I had not recognized that the earlier seemingly perfect model was the only one to catch my eye over quite a long stroll. So in looking for more specimens in a frost-free early October, I had walked about five miles before I had gathered enough to give a reasonable choice. None appeared as spectacular as the original. Should you be tempted to paint such a leaf, I suggest that a wider selection might be available after the onset of colder weather later in the season.

Other species offer equally attractive autumn tints, but few have such an interesting form.

PAPER: Whatman 90 lb NOT.
IMAGE AREA: 155 × 145 mm.

A note about the paper used for this painting: while working on *Painting Plant Portraits* I used the last sheet of an inherited batch of Whatman paper watermarked 1946. This paper had the finest handling qualities of any that I had tried. Recently, the remains of three partly used blocks of Whatman paper, watermarked 1935, from the same source were given to me. Again its quality was excellent and more was used for further paintings in this present book. Paper of the same name made today is not of comparable quality.

1. DRAWING AND SHADING [A]

The picked leaves were kept fresh for reference in a vasculum lined with dampened paper towel. The selected leaf was also bedded on damp paper towel in the shallow lid of a similar container. The lid was taped to one side of the drawing board.

I first sketched in the main stem omitting the many prickles for the time being.

The midrib of the upper right leaflet was then established and the generalized outline lightly indicated. The lateral veins were entered before the complex serrate margin was fined-up. Moving clockwise the other leaflets were drawn using the same sequence. To complete the drawing, prickles were added.

The shadow mix was applied throughout. Largish cast shadows were washed in. Dry-brush recorded the delicate pattern of minute shadows between the lateral veins. This was taxing but a necessary phase in capturing the characteristic texture.

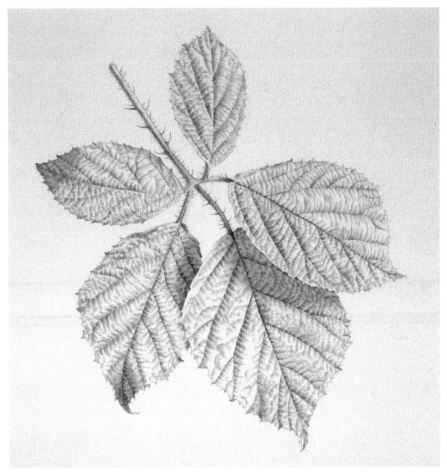

A

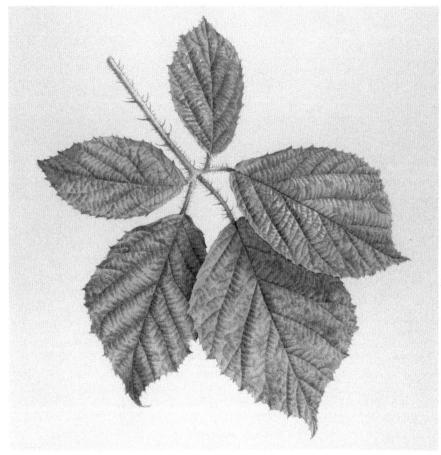

B

2. FIRST COLOUR COATS [B]

The usual underlying green being inappropriate for this painting, a warmish yellow was mixed from permanent yellow plus a tiny amount of Winsor red. This was used for part of the upper leaflet and for the base of the one on the right. The other three leaflets were given a complete yellow wash.

Dilute Winsor blue signposted the positions of low-key highlights on the upper and right leaflets.

Yellow-green was mixed from permanent yellow and Winsor blue. This colour was dry-brushed, working section by section between the lateral veins, where needed on all the leaflets.

3. REDDISH COAT [C]

Alizarin crimson and permanent yellow were mixed to produce a reddish wash. This was used for the main stalk (petiole) and the leaflet stalks (*petiolules*). It was also used with dry-brush to position markings on the leaflets.

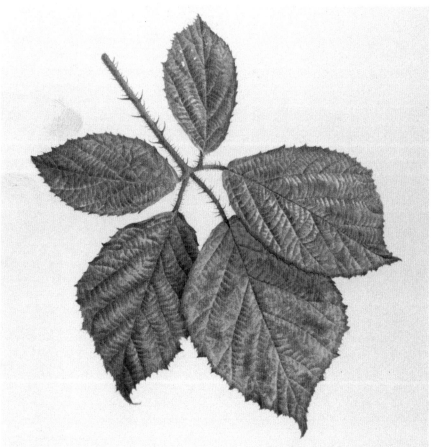

4. FINISHING TOUCHES [D]

The yellow-green above was used to enrich green areas; and the reddish mix intensified the colour of the stalks and the leaflet markings.

Some of the shadow mix was added to the reddish colour to make a dull deep purple. This was dry-brushed to some of the darker markings on the leaflets. Finally, it was applied to give a crisp finish to the margins.

C

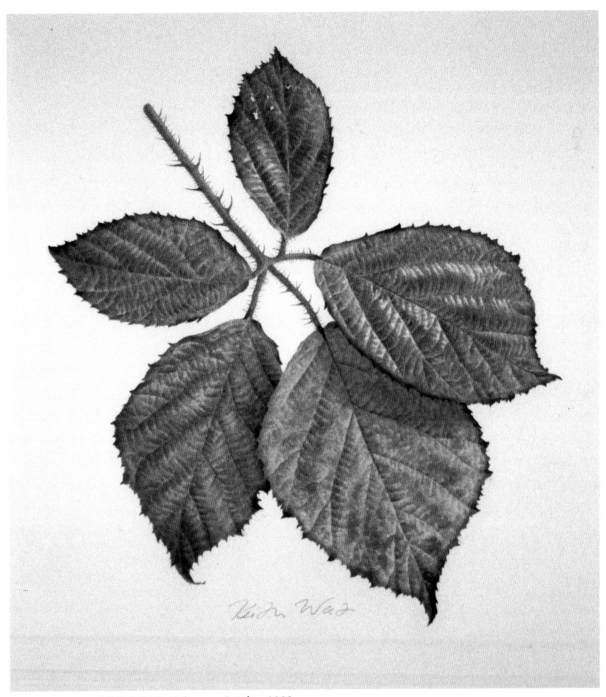

D. BLACKBERRY LEAF, *Rubus* sp., October 1992.

16 DOG ROSE, HIPS
Rosa canina, Family Rosaceae

This painting is a companion-piece to the dog-rose flowers.

It was a balmy summer afternoon when the flowers were collected; in contrast, as the hips were taken from the same bushes there was a buffeting chill north wind and the skies were grey. The fruits gave a welcome warm note to an otherwise bleak scene.

I had no difficulty in finding a robin's pincushion to include. These curious excrescences are caused by a gall wasp, *Diplolepis rosea*. This tiny insect inserts her eggs into a leaf bud, whose tissues then follow a new pattern to form a ball of crimson threads. At the heart of the mass there is a woody structure containing many chambers in which the larvae develop.

An alternative name is 'bedeguar': this originated from the Persian, 'bād-āwar' – wind brought.

PAPER: Whatman 90 lb NOT (1935 – *see* p. 97).
IMAGE AREA: 190 × 133 mm.

1. DRAWING AND SHADING [A]
To match the dog-rose flower painting, the outer dimensions of the earlier work were lightly marked on the sheet (as the drawing progressed, the elements were easily spaced to fit this framework).

The twigs were placed in 'oasis' and drawing began with the tuft of withered filaments at the apex of the top hip. Other hips had shed their filaments – these included the one on the left of the cluster as well as the pair drawn later on the separate twig. Following the upper hip, the two on the left were entered together with their subtending leafy bracts. The hips on the right completed the group.

The stem was carried down, putting in the branchlet to the front and then the one to the left.

The right of the plate was developed using a twig with two hips. Several leaves were tattered in keeping with the season.

Room was found for the robin's pincushion on the left. It was impossible to show each thready outgrowth in detail – the mass was suggested, but care was taken with the strands that showed clearly about the perimeter.

The shadow mix was used through-out. I changed to a finely pointed new number 3 brush to be able to cover details such as the pincushion threads and the leaf serrations. Many areas were pre-moistened to help in blending edges.

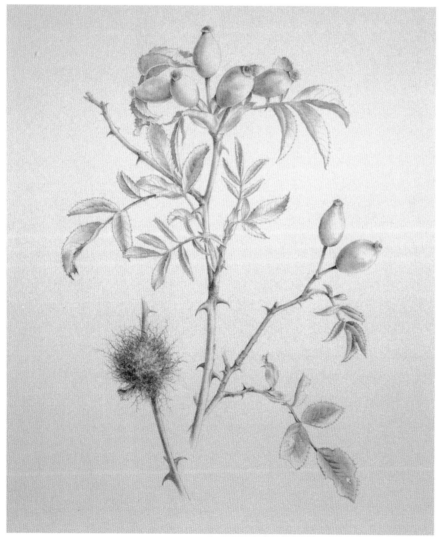

A

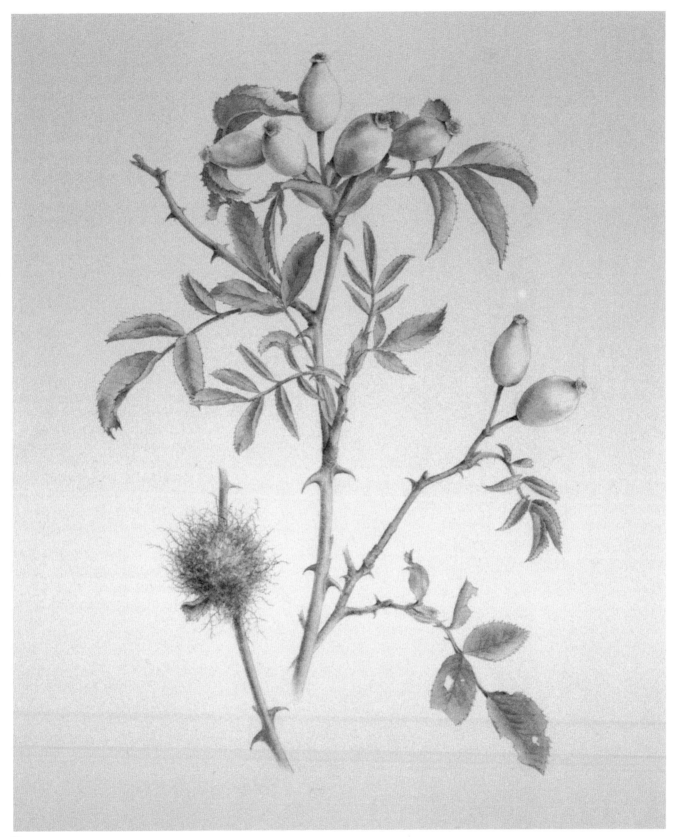

B

2. YELLOW AND GREEN COATS [B]

A wash of permanent yellow was given to leaflets, in whole or part, that showed autumn colouring. Some of the same wash was used on a portion of the robin's pincushion.

For the rest of the vegetative parts, an underlying dilute green wash was mixed from permanent yellow and Winsor blue.

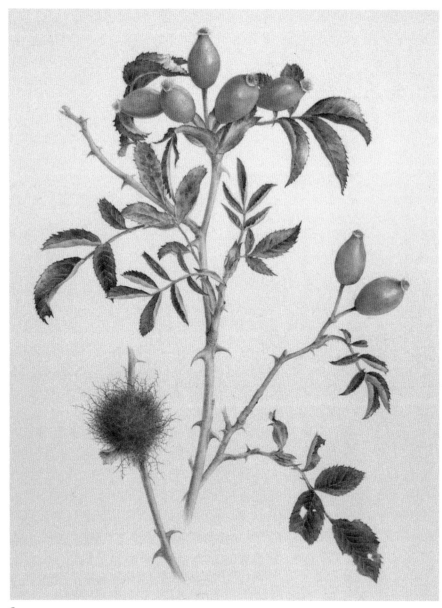

C

3. SECOND GREEN AND FIRST RED COATS [C,D]

The main leaf green was derived from permanent yellow, Winsor blue, and a hint of alizarin crimson. This was used as a semi-wash on the leaflets, leaving minute traces for the underlying green to show through as veins (these may not be visible in reproduction). A few leaflets carried highlights, pigment was stopped short of these areas and blended in.

The hips were coloured using a wash from Winsor red and permanent yellow. I moistened patches of highlights, blurring their edges as pigment was carried around them.

Bright crimson edged the serrated leaf margins: for this the brush-point was lightly loaded with intense alizarin crimson. This colour was diluted slightly for the pincushion.

4. FINISHING TOUCHES [E]

The hip colour was used again, this time with dry-brush to give more control over variations in the depth of tone; in some places several coats were given.

The brownish-red flush on the stems was mixed from alizarin crimson, Winsor blue and permanent yellow. A second coat for the lower main stem was darkened by adding more Winsor blue.

The robin's pincushion colour was enriched with more alizarin crimson.

Dilute Winsor blue was washed over the leaflets' few highlights. It was also used to give a faintly bluish cast to the undersides of the leaflets.

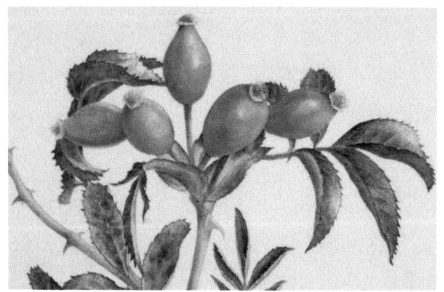

D

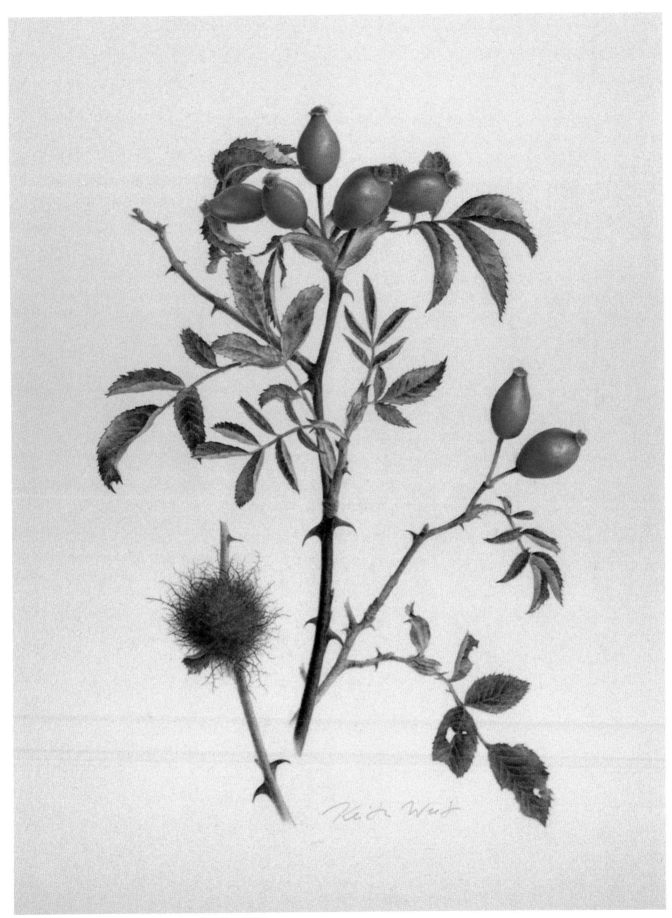

E. DOG ROSE, hips, *Rosa canina*, October 1992.

17 HORSE CHESTNUT, CONKERS
Aesculus hippocastanum, Family Hippocastanaceae

The horse chestnut, said to be native to northern Greece, is now found in much of the temperate world. The tree was first grown in Britain in the mid sixteenth century and it has since become a familiar part of the landscape.

There is some debate about the origin of the prefix, 'horse'. It may have been suggested by the horseshoe-shaped leaf scars on the twigs: these marks are curiously like the real thing in miniature, even the vein traces appear to mimic nail heads. 'Chestnut' derives, through several forms, from the Greek, *kastanea*, which is also reflected in the generic combination. And the nuts, the 'conkers', were once 'conquerors', as used in the children's game.

Throughout the seasons the horse chestnut presents attractive aspects to the botanical artist – sticky buds in winter (*see* winter buds), unfurling tender leaves, orchid-like flowers, and the fruiting phase used here.

PAPER: Whatman 90 lb NOT (1935 – *see* p. 97).
IMAGE AREA: 223 × 97 mm.

1. DRAWING AND SHADING [A]

During a bright morning following a hard frost, my wife and I gathered conkers. Amber and golden-yellow horse chestnut trees fringed a nearby lake-shore path. From the many scattered empty *husks* it was clear that children had taken the bulk of the crop, but there were still plenty, including a few newly fallen and pristine.

Nuts, husks, and leaves (strictly, leaflets) were put into a vasculum lined with damp paper towelling to retard deterioration.

On returning home, I examined the collection and then made a rapid sketch of a feasible composition. A white card was placed to one side of the drawing board, and the components were arranged on this to more or less follow the rough. Time was taken in making small adjustments to create a pleasing balance.

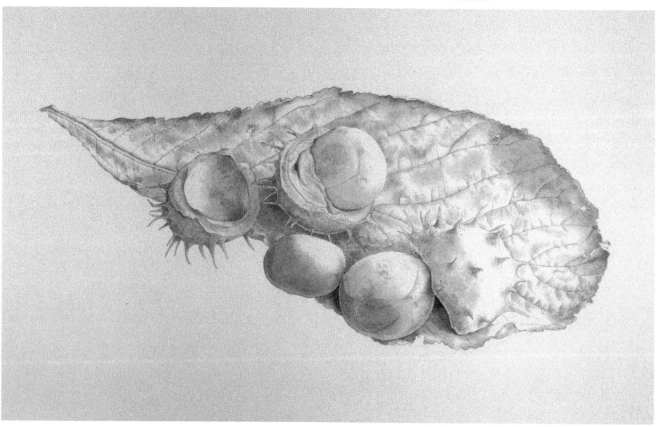

A

As I was working out the composition it became obvious that the main axis should be horizontal rather than vertical. This does contrast with the rest of the plates in the book – other than the primrose which is more square shaped – but the material dictated the format. This might serve as a reminder that unless a work is intended for a specific format, dimensions should be largely determined by the form of the plant material.

I began with the upper conker emerging from a section of the tri-valved enfolding husk. The nut below was then drawn, followed by the larger one on the right plus a husk. These elements were balanced by the spiny husk on the left, placed to expose its moulded concave interior.

At this point the drawing was left overnight. The next morning I found that the final component, the leaf, had dried and distorted beyond use – it was replaced by a similar one from the vasculum. First the midrib was entered, and the outline lightly indicated. As the lateral veins were placed the toothed margin was fined-up. (In my dry room the leaf had an annoying tendency to curl in on itself – it was necessary to damp it down every so often using wet paper towels.)

I used the shadow mix throughout. The leaf was quite challenging: wash was used for the large main shadows, then semi-wash and dry-brush were applied to the smaller areas with much blending. The conkers and husks were completed with semi-wash and dry-brush. I decided to ignore the shadows extending to the underlying card since these might have detracted from the overall form. For other arrangements such shadows might well have been appropriate.

2. FIRST COLOUR COATS [B]

Using dilute Winsor blue I swiftly indicated the positions of the conker highlights because I was aware that their sheen was rapidly diminishing.

The leaf amber was mixed from permanent yellow and alizarin crimson with a touch of Winsor blue. The initial coat was dilute to give a light tone which would allow later adjustment. The mix was applied as a semi-wash working section by section between the lateral veins.

Some of the amber wash was further diluted and tinted with a little more permanent yellow. This mix was used on the husks as the underlying colour.

A first coat for the conkers was made from alizarin crimson, Winsor blue and permanent yellow; dry-brush was used for close control.

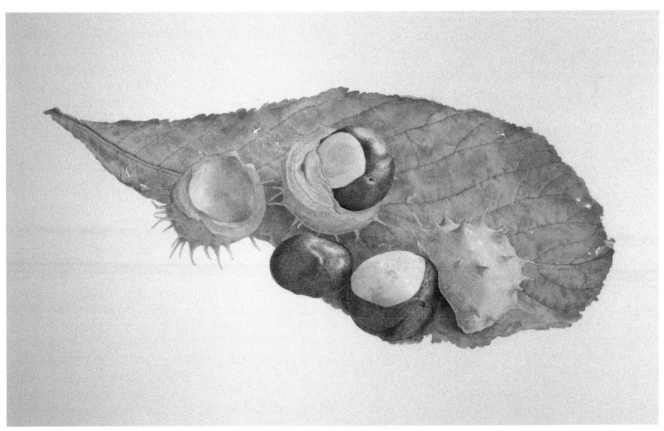

B

105

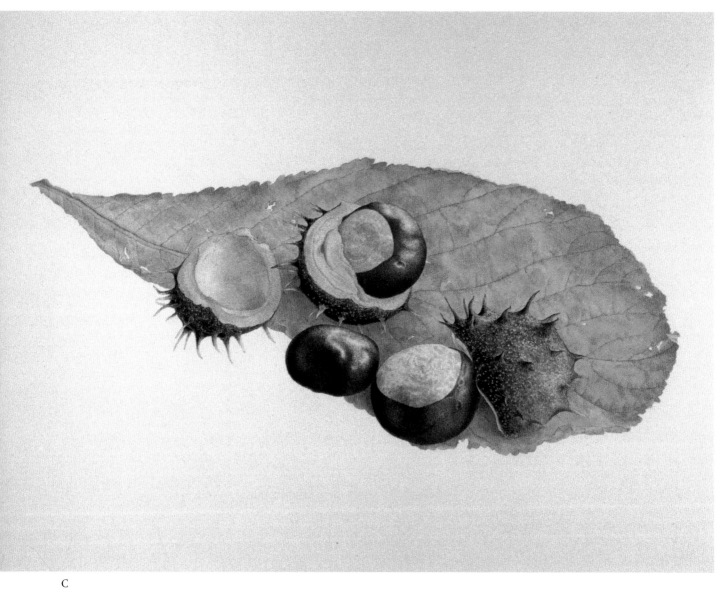

C

3. SECOND COLOUR COATS [C]

Though many of the fruits were still green as they fell from the tree, the husks soon turned to the rich brown shown in the plate. This colour was mixed from alizarin crimson, Winsor blue and permanent yellow. It was dry-brushed using just the tip of the brush in order to imitate the speckling by leaving tiny gaps.

The lower portion of the right husk was lighter than the rest – this hue was derived from some of the first conker mix by adding more permanent yellow. After dilution this was washed on before the darker husk brown was blended in.

I found that the conkers had slightly more red in their make up than was present in the first coat. This lack was corrected by the addition of a little extra alizarin crimson to the mix, which was then dry-brushed as a second coat.

The central discs of the conkers were a mottled pale brown. This colour was mixed from dilute alizarin crimson, permanent yellow, and Winsor blue, and then dry-brushed.

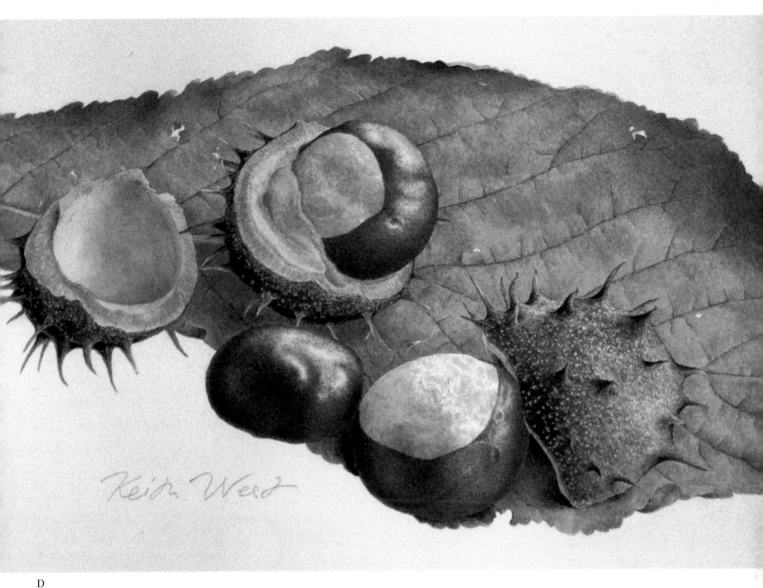

D

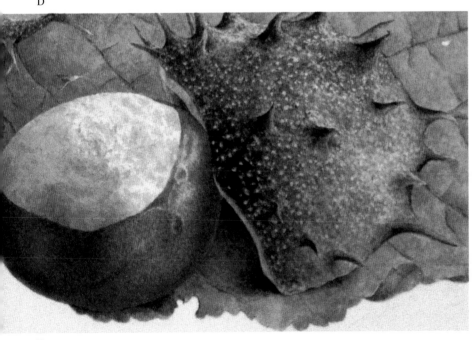

E

4. FINISHING TOUCHES [D,E,F]

The effect of the shading of the conkers in suggesting their roundness had been somewhat diminished by the addition of colour. Another application of the shadow mix restored the tonal balance.

The leaf was dry-brushed with the original amber, intensifying the colour as necessary. The same mix was used on the faintly *striated* thick edges of the husks.

Dark husk colour was used on the brush tip to strengthen the venation which had been rather submerged by the heightened colour. The lines were gently blended in.

Finally, the shadow mix was used to deepen some of the darker areas.

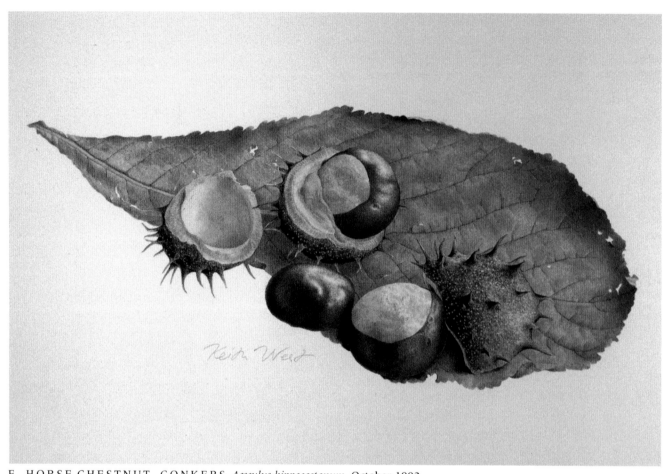

F. HORSE CHESTNUT, CONKERS, *Aesculus hippocastanum*, October 1992.

18 POLYPODY

Polypodium vulgare, Family Polypodiaceae

In a book about portraying wild flowers it might seem odd to include a representative of a non-flowering group. Yet hardy ferns are worthwhile and attractive subjects, also, they have the added appeal of being available when few plants are in flower. The polypody is relatively straightforward to draw in comparison with many other fern species – though care is needed to capture the characteristic outline of the fronds and their individual lobes. I have avoided using any of the technical terms applicable to ferns since only one species is treated here.

In the polypody, microscopic spores are borne in specialized organs forming circular pads on the undersides of some of the fronds (*see* detail). On reaching suitable conditions, spores germinate to produce minute green structures that bear the sexual parts. From this intermediate phase fern plantlets develop which eventually grow into the mature spore-bearing form.

The number of fern species in Britain is small. Some, like the polypody, are locally abundant and in such situations they are suitable for portrayal. Rarer species should not be collected.

PAPER: stretched Arches 90 lb NOT. IMAGE AREA: 257 × 182 mm.

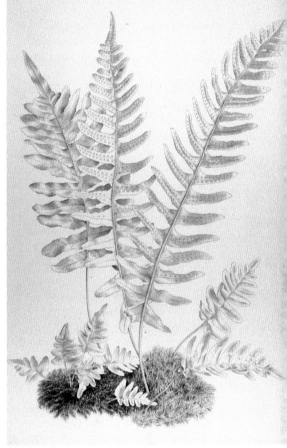

A

1. DRAWING AND SHADING [A]

In collecting polypody fronds from an upland stone wall, I also took some mosses and lichen because originally a full background was planned. I was concerned that the warm dry atmosphere of my room would quickly dessicate the vulnerable material. To avoid this the smaller components were held in a plastic box lined with damp paper towelling; the larger fern fronds were steeped in water in a jar – later to be positioned in 'oasis' as they were being portrayed (they were returned to the water after each stage).

On a separate sheet I made a very rough and rapid trial composition. In sketching this loose guide it quickly became clear that the planned full background would not be appropriate and the mosses would best be restricted to form a foundation for the ferns.

Then, on the watercolour paper, I began by lightly indicating the course of the midrib of the tall frond on the right. The midrib was fined-up as I worked from the apex adding the lobes on the right side before turning to the left half. Care was taken to record the minute teeth on the margins as well as progressive changes in the lengths of the lobes. It was noticed that each cleft between the lobes did not quite reach the midrib, though sometimes the differentiated tissue was less than 0.5 mm wide.

In following such a regular pattern it is easy to lose your place because elements closely resemble their immediate neighbours. For the polypody it helped to check occasionally by counting lobes from the apex as well as by using particular features as markers – scars, flaws etc. The shapes of the spaces between the lobes were also recognized as aids to accuracy.

The central frond was next drawn using the same procedure. Then the third frond was positioned slightly to the rear on the left – this, in contrast to the others, was sterile (non-spore-bearing). I found it easier in this instance first to draw the left lobes after the line of the midrib was established. The lobes on the right were harder to place as they were partially obscured.

To complete drawing the fertile fronds I indicated the slightly raised traces of the pads of the spores as they appeared on the uppersides of the lobes.

I then turned to work on the base of the plate by first entering the small fronds on the right. Others, emerging from moss to the left, were used to balance the composition.

The mosses were nicely complementary, one being deep in tone and

the other light in bright green. They were used simply to link the fern components and to provide a pleasing base – there seemed little point in trying to identify the species. I made no attempt to do more than give a general impression of their structure. The left moss had tiny leaves that were difficult to distinguish separately; the clump on the right had larger leaves tending to curve in one direction. An unexpected bonus was the discovery of a false scorpion, less than 5 mm long, clambering over the leaves. The little creature held a menacing stance with pincers held wide when confronted by a teasing pencil point.

For the shading phase, the shadow mix was used first on the longest frond on the right. Small dabs of pigment were applied to register the positions of the underlying spore pads – this was done before adding the bulk of the shading because otherwise the light markings might have been submerged. The other two large fronds followed, then I worked on the small group on the left together with the deep-toned moss. The light-toned moss was shaded judiciously – I tried to ensure that lines passing behind the stalk of the lower fern were made to appear to be continuous. The small ferns on the right were the last elements to be shaded.

2. FIRST GREEN COATS [B]
A very dilute yellow-green was used as an undercoat throughout on both ferns and mosses: this was mixed from Winsor yellow and Winsor blue. In painting fern fronds I found it helpful to turn the drawing board so that the lobes were placed vertically with the apices uppermost.

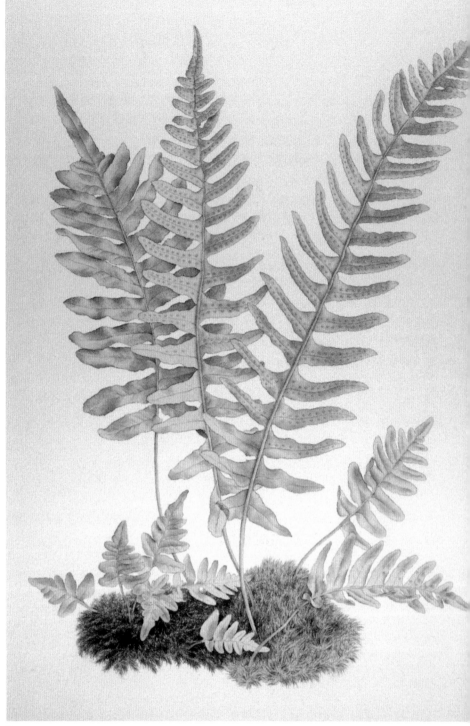

B

3. FURTHER GREEN COATS [C]
The hues of the three large fronds differed from each other. The lightest was the frond at the centre, its mid-green was mixed from permanent yellow, Winsor blue, and a touch of alizarin crimson. This wash was labelled and retained to use for later coats – in their turn, washes for the other two

fronds (below) were also labelled.

The colour for the frond on the right was mixed from the same ingredients, though it was fractionally more intense and it carried a little more Winsor blue.

The wash for the left frond was yet deeper in tone: again the same pigments were used, though with extra alizarin crimson and Winsor blue. The

same wash was dry-brushed into the moss on the left; I allowed the underlying green to gleam through in parts.

For the small fronds at the base of the plate it was appropriate to use some of the wash for the right frond.

The vivid green of the other moss clump was derived from Winsor yellow and Winsor blue.

110

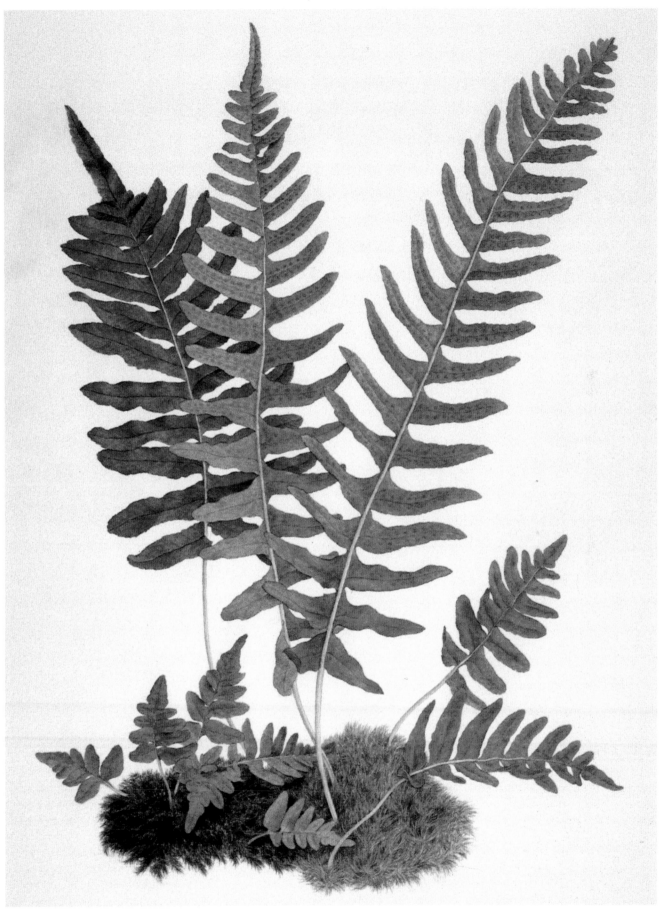

C

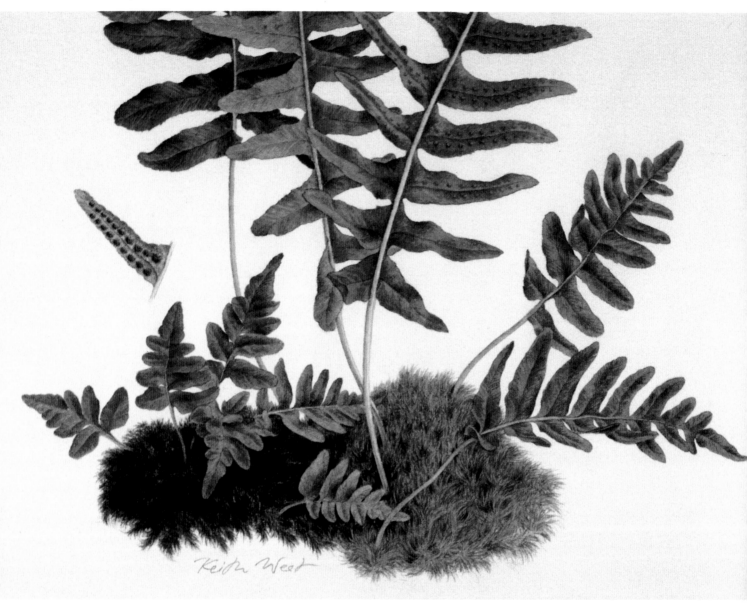

D

4. DETAIL AND FINISHING TOUCHES [D,E]

Using the labelled washes, the colours of all the fern fronds were intensified as required.

The stem of the sterile frond on the left was tinted with a warm reddish-brown. This was mixed from alizarin crimson, Winsor blue and permanent yellow.

Both mosses were enriched by the use of more of the original mixes.

A detail of a lobe underside was needed to show the clusters of spore-bearing organs. From the large frond used on the right of the plate, a lobe was detached and positioned on the right of the drawing board. The specimen was held in place by a tab of 'magic' tape.

After completing the simple drawing of the lobe it was painted. The colour was mixed from a combination of the washes used for the right frond and for the sterile left frond. The central vein and other portions were strengthened by a second coat.

The stout midrib to the right was coloured by using some of the wash of the first green coat (above).

The russet spore cases were painted using a mixture of Winsor yellow, alizarin crimson, and a brush-tip of Winsor blue.

Finally, emphasis was given by again using the shadow mix in a few areas throughout the plate.

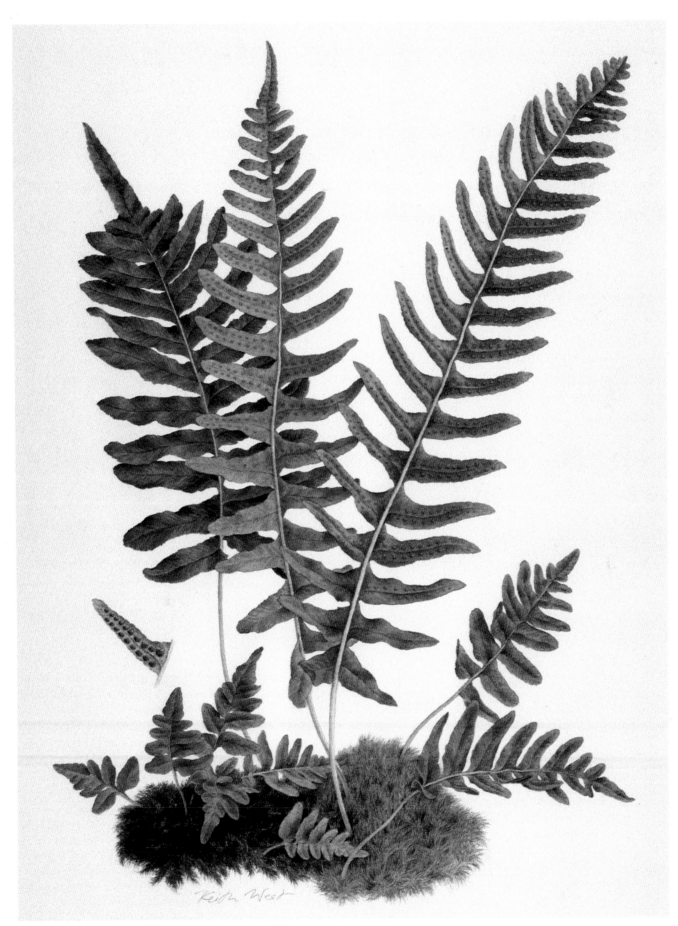

E. POLYPODY, *Polypodium vulgare*, December 1992.

19 WINTER BUDS

a, HORSE CHESTNUT, *Aesculus hippocastanum*, Family Hippocastanaceae; b, ASH, *Fraxinus excelsior*, Family Oleaceae; c, SESSILE OAK, *Quercus petraea*, Family Fagaceae; d, HAZEL, *Corylus avellana*, Family Corylaceae; e, SYCAMORE, *Acer pseudoplatanus*, Family Aceraceae.

In considering a painting of winter buds my first impulse was to use only those of the horse chestnut. Though these are conspicuous and handsome, while collecting specimens I looked also at the buds of other species and realized that a selection would be more interesting. Buds have inevitably been present in many past works, but this is the first time that I have used them as a main theme.

I was tempted to introduce twigs of several more species into the composition because bud, bark and stem characters are distinctive and absorbing. Unfortunately, with the type of arrangement chosen, additional elements would have made a confusing picture.

In realistically portraying plants attention to accuracy is a constant concern, but with less obviously attractive components such as the twigs it is necessary to maintain interest by trying for an especially fine level of detail.

While working on the winter buds the natural light was so dim throughout that I had to rely entirely upon a 'daylight' bulb. The required placement of the lamp in relation to the drawing board meant that the light fell on the model from the top left to give a shaded right side – the sole instance for this book.

By portraying winter buds I wanted to suggest a worthwhile topic in the season when choices are inevitably diminished. A plate of bud-burst for the same species in spring might provide an excellent match.

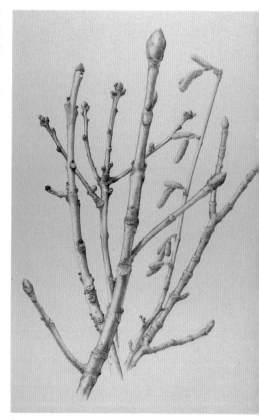

A

PAPER: stretched Arches 90 lb NOT. IMAGE AREA: 250 × 174 mm.

1. DRAWING AND SHADING [A]

Through habit I placed the collected stems in water. One horse chestnut twig was overlooked and remained dry. None of the specimens, wet or dry, appeared to deteriorate during the work – presumably because liquid transport in winter would in any case be minimal.

Each twig in turn was taped alongside the drawing board. This was done in preference to the usual course of positioning plant models in water or 'oasis' since I needed to bring them close to the limited light source.

For all the subjects, I recorded the characteristic shapes of the buds and the ways in which the bud scales overlapped. Stem features included small lateral buds, lenticels, leaf scars, and the tight corrugations of terminal bud scale scars – spaced at intervals corresponding to yearly growth.

I began with the horse chestnut twig, working down from the large terminal bud at the top of the plate. Next came the ash, its stem a quiet grey-green and the buds stark in virtual black. This was followed by a branchlet of hazel with developing male catkins in which I tried to show the spiral structure without overemphasis. The hand-lens revealed graceful outlines to the enfolding scales. (More advanced catkins on another stem opened to shed pollen after a few days in the warmth of my room.)

A sessile oak twig was then placed to the left of the horse chestnut; the angles of the lateral branchlets provided a balancing movement. The last component was the sycamore, chosen for its bright green buds and knobbly stem bearing distinct evidence of past structures.

It became clear at this point that the composition was complete. This was slightly disappointing since I held in reserve some twigs of a willow (species unresolved) bearing purplish buds with a waxy bloom, as well as alder branchlets with pinkish catkins distinct from those of the hazel.

The shadow mix was used throughout the plate, working across from the right.

2. UNDERLYING COLOURS OF TWIGS [B]

The first twig to be given an underlying colour was the sycamore, on the right. The palest hue was the fawn of the lenticels and upper stem leaf scars. This was mixed from permanent yellow, alizarin crimson, and a little Winsor blue. But for the leaf buds, the mixture was washed over the entire stem.

The same colour was an appropriate underlying wash for the hazel twig and it was used for all parts.

For the horse chestnut the wash was modified with a touch more alizarin crimson and then applied overall, but for a highlight on the terminal bud. The leaf scars and the bud-scale scars were enriched by a second coat, bringing them close to their final colour.

The same mixture and the same procedure were used for the oak twig – the second coat this time was added to the buds.

For the ash on the left a slightly different approach was needed. The reddish-brown of the last two stems was here used only for the leaf scars and lenticels, the rest of the twig was painted in a dull greyish-green obtained from permanent yellow, Winsor blue, and alizarin crimson. This was brushed on carefully as a semi-wash in order to skirt the tiny lenticels. The lower portion, just below the lateral branchlet, was greyer. To reach this colour, Winsor blue and a dab of alizarin crimson were added to some of the last mix.

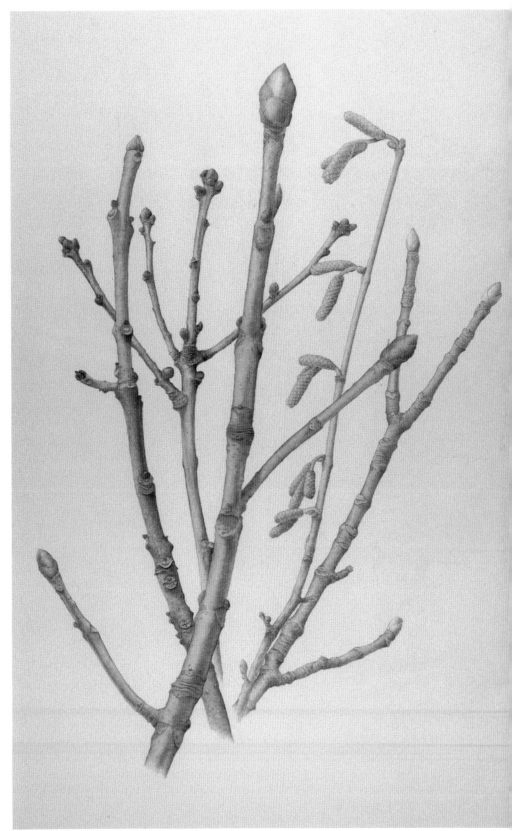

B

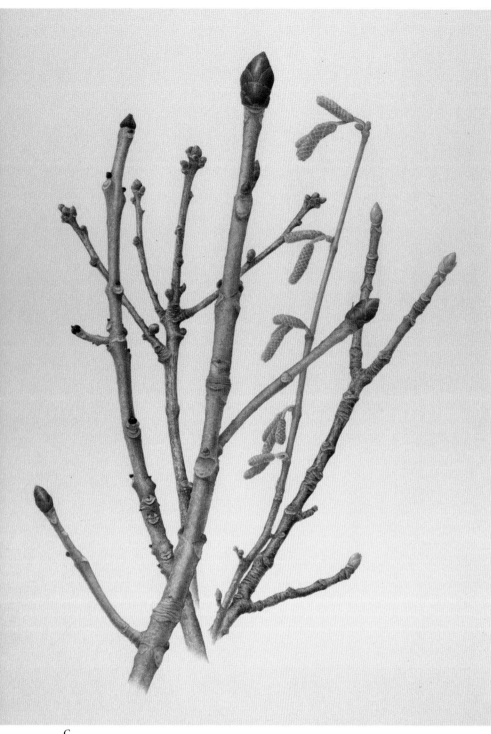

C

3. BUD AND CATKIN COLOURS; FURTHER STEM COATS [C]

The bright yellow-green of the sycamore buds was derived from Winsor yellow and Winsor blue.

This green was modified slightly by a hint of alizarin crimson and used on the hazel catkins. On drying, these parts were next given a coat of dull rose mixed from alizarin crimson, Winsor blue, and a little permanent yellow. On the catkins, by using the brush-tip, I left a light edge to each scale – a fiddly manoeuvre.

The glossy horse chestnut buds were painted with a rich mixture of alizarin crimson, permanent yellow and Winsor blue. This hue was also touched to parts of the oak buds.

For the dark ash buds I mixed alizarin crimson, Winsor blue and a hint of permanent yellow to make a deep sepia approaching black.

After the buds there was further work on the stems. The hazel stem was the least complicated: the upper portion was an even light brown, and this was mixed from permanent yellow, alizarin crimson and some Winsor blue; the lower stem was marginally darker, the same mix was used plus more Winsor blue.

The horse chestnut came next. A dilute dull brown was mixed from alizarin crimson, Winsor blue, and permanent yellow – this was applied as a semi-wash.

For the oak twig I first added some green touches about the apices of the branchlets. The green was derived from permanent yellow, Winsor blue, and a tinge of alizarin crimson. The same components, in close to equal amounts, were then used to make a neutral grey: this was dry-brushed here and there over the twig with tiny strokes to allow the underlying colour to show through.

The other main element was a red-brown mixed from some of the horse chestnut buds mix plus a little more alizarin crimson. For this I used the brush-tip to make minute lines, blobs and specks.

The ash twig was simple in make-up, the original mixes for the upper and lower parts were used again to make the colours more intense.

The last twig, the sycamore, was complex. I began with a dilute bluish-grey overall coat taken from near the apices of the upper branchlets to the base skirting the leaf scars on the way. For this, some of the neutral grey (used on the oak) was cooled by the addition of more Winsor blue and dry-brushed on to modify the original pale fawn. The grey was pierced and in some places replaced by a rich brown derived from alizarin crimson, permanent yellow and some Winsor blue.

4. FINISHING TOUCHES [D, E, F, G]

The dark brown of the sycamore, the last entry above, was also dry-brushed over deeper toned bits of the horse chestnut twig.

116

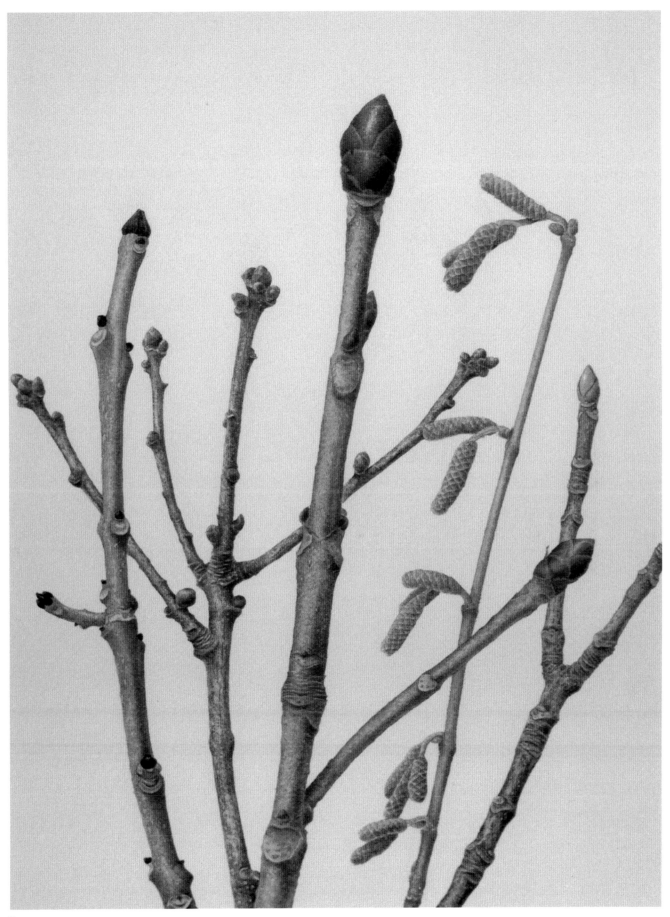

D

Some of this brown was then added to Chinese white to make a pale opaque fawn used on lenticels on all the twigs to give them better definition.

Fine reddish lines edged the margins of the sycamore bud scales: these were realized by mixing alizarin crimson with a spot of Winsor blue.

The shadow mixture gave final touches of emphasis where needed.

The last step was to provide a key notation, the letters used were pencilled first and then heightened with shadow colour.

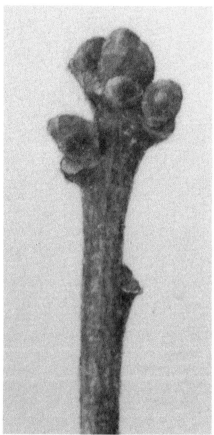

F

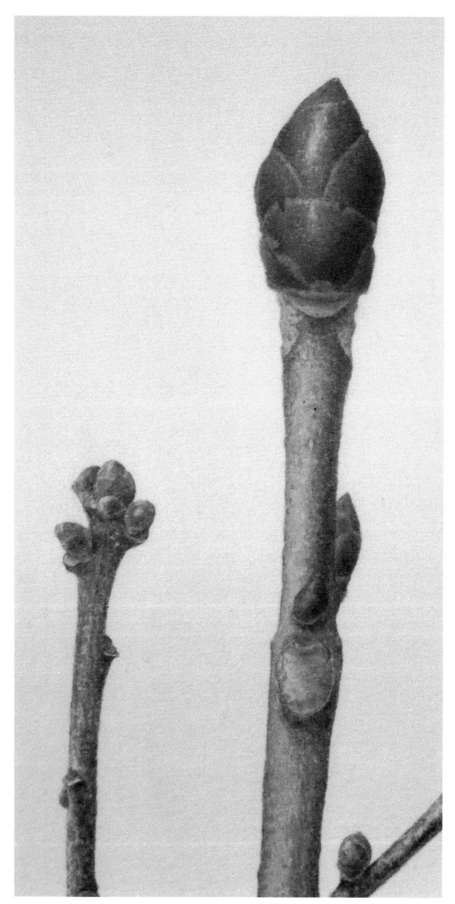

E

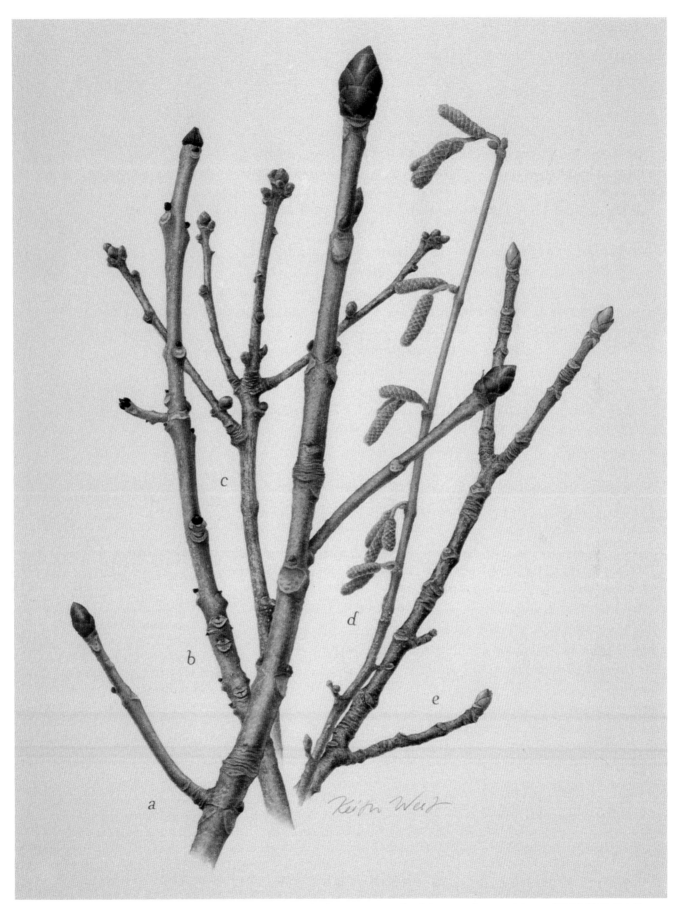

G. WINTER BUDS: a, HORSE CHESTNUT, *Aesculus hippocastanum*; b, ASH, *Fraxinus excelsior*; c, SESSILE OAK, *Quercus petraea*; d, HAZEL, *Corylus avellana*; e, SYCAMORE, *Acer pseudoplatanus*. December 1992.

20 IVY
Hedera helix, Family Araliaceae

Ivy occurs naturally or as an introduction throughout much of the temperate world. It blooms from October until into January, providing copious nectar for insects still flying late in the year. When many other food sources have passed their season, the black fruits of ivy are available. Several birds take them and they are gorged by wood pigeons.

Ivy clings by root-like structures that do not penetrate the tissues of the host plant. The stems grow to a substantial girth, and where a number are present together they may form a braided pillar of great strength. Contrary to popular belief, ivy does not harm the trees it embraces.

As reflected in the painting, ivy has two distinct leaf types: leaves of the mature plant have entire margins, while juveniles have leaves that are variously palmately lobed.

In the golden age Bacchus sported an ivy crown – supposed then to prevent drunkenness. Folklore suggests other past uses, including a cure for whooping cough, but none appear to have persisted to the present. Recent research indicates that ivy absorbs benzine – a suspect in 'sick-building syndrome'.

I chose gouache to paint this species because ivy has several characteristics best suited to work in this medium: these include the dark heaviness of the mature leaves, areas of glossy highlights, and the distinctive intricate venation of the juvenile leaves – for each feature light pigments are painted over dark ones.

The gouache was prepared by using Chinese white mixed with my usual watercolours to gain the necessary opacity. If you prefer to use gouache from a manufacturer's range, less white will be needed in the mixtures described below.

PAPER: stretched Whatman 90 lb NOT (1935 – *see* p. 97).
IMAGE AREA: 252 × 173 mm.

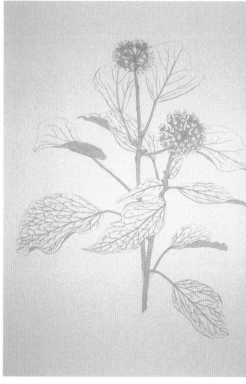

A

1. DRAWING AND FIRST GREEN COATS [A]

Ivy is abundant in the vicinity of my home, so ample specimens were collected. The afternoon was cold with wind driven rain and I was surprised to find numerous flies supping nectar as they held fast to bobbing inflorescences.

The stems were placed in water overnight. Some time was spent in examining the material before I selected two pieces: one carried an inflorescence of opened flowers and a few buds; the other carried developing fruits – ovaries from which surrounding petals and stamens had recently dropped. I decided that these would make up a plate, with the addition of a stem bearing juvenile leaves which would be chosen later to balance the composition.

As a preliminary, I sketched a rough trial layout on scrap paper to serve as a loose guide. After this the stem with flowers and buds was placed in 'oasis' and turned to show its best aspect. Drawing was begun with the complicated inflorescence and it became clear that it would be useful later to include an enlarged flower to reveal detail.

The peduncle was then followed down to the axillary bud on the left, plus the subtending leaf which appeared partly behind the inflorescence allowing the flowers to stand out against the darker leaf surface.

Next I added the two leaves on the right with the upper one also partly behind the inflorescence. The lower leaf was lightly drawn because I thought that the head with developing fruits would be appropriately placed over part of the surface. To complete this component, the lower left leaf was drawn and the stalk carried down.

The stem bearing developing fruits was also carefully sited in 'oasis' and drawing began by entering the circumference of the spherical head over the leaf, as noted above. The covered portion of the leaf was erased but for a faint trace. One of the central disc-like ovaries was drawn and the others followed; I took care to ensure that each disc was placed accurately in relation to the others adjacent.

I then drew the stem and the leaves, which carried veins that were much more evident than in the first specimen. At this point I decided to paint the material so far drawn before placing a juvenile element and a flower detail.

The first green coat was the pale yellow-green of the stems and veins mixed from Chinese white, permanent yellow, and a little Winsor blue. The colour was also used for the leaf undersides, though I was aware that later they would have to be modified. In following the veins the pigment was allowed to overrun their width.

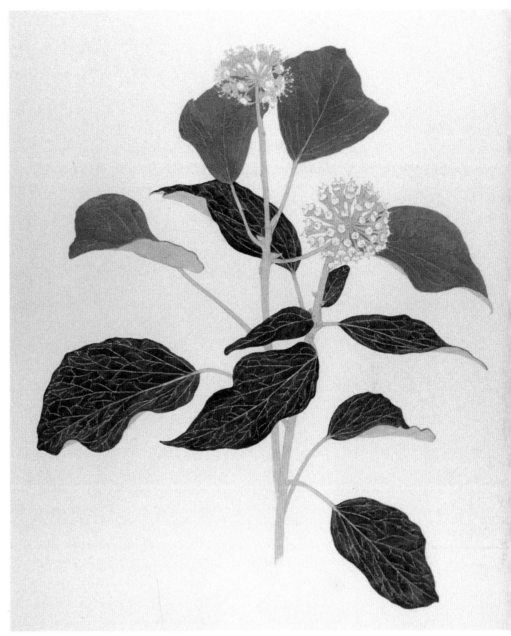

B

2. FURTHER GREEN COATS [B]

A mid-green was mixed from Chinese white, permanent yellow, Winsor blue and a hint of alizarin crimson. This was applied to the leaves of the rear stem in turn, starting with the one at the upper right.

For the leaves of the front stem a darker hue was derived from the same ingredients as before, but this time less Chinese white was used with more of both Winsor blue and alizarin crimson. The colour was tricky to manipulate around the veins. I should mention that the leaves could have been painted before drawing in the venation on the dark ground – I preferred not to do this since the pencil line would have been awkward to establish and irritating to follow, even with a raking light. There are other methods, but from experience it seemed best to use the means chosen.

At this time I noticed a speck on the paper to the left of the lower right leaf. Carelessly I used a brush assumed to be clean to lift off the particle. Unfortunately, pigment remaining in the hairs stained the paper and it could not be removed. The flaw was faint and may not show in reproduction [B]; later I covered the spot with a juvenile leaf.

stem leaves were emphasized by using some of the original colour mix. The starkness of the minor veins was lowered by blurring followed by the addition of a little of the leaf mix much diluted.

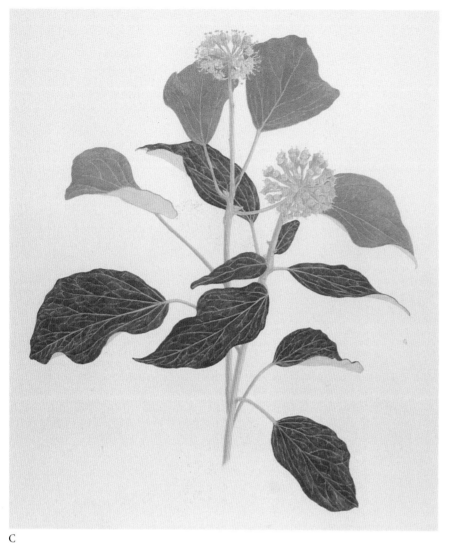

C

4. FURTHER LEAF DETAILS [E]

After working on the dark leaves I found that the hue of the rear stem leaves needed adjustment. More Winsor blue was added to the original colour and the mix was brushed on thinly; for deeper-toned portions extra Winsor blue and alizarin crimson were introduced to the mixture. These colours were also added to the front stem leaf mix for use in the darker parts.

The leaf undersides were modified by brushing in a thin bluish-green derived from Chinese white, Winsor blue, permanent yellow, and alizarin crimson.

3. DETAILS OF FLOWER AND FRUITING HEADS, STEMS AND LEAVES [C,D]

The ovaries of the flowers were painted using some of the pale mix of the stems and veins modified by the addition of more Chinese white and permanent yellow. Still more Chinese white and permanent yellow was added to reach the hue of the discs of the developing fruits.

In the fruiting head, the pedicels and swelling receptacles below the discs were seen to be too light, this was corrected after adding more Winsor blue and alizarin crimson to some of the stem mix. This same green was also brushed into parts of the inflorescence.

The gold of the anthers was mixed from Chinese white, permanent yellow, and a brush-tip of alizarin crimson.

Parts of the major veins of the front

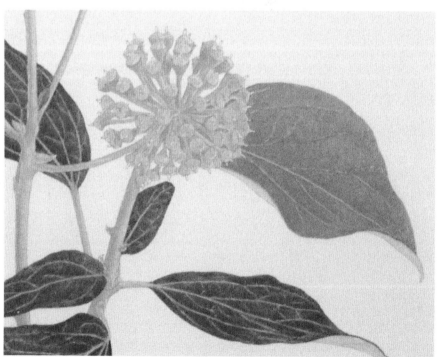

D

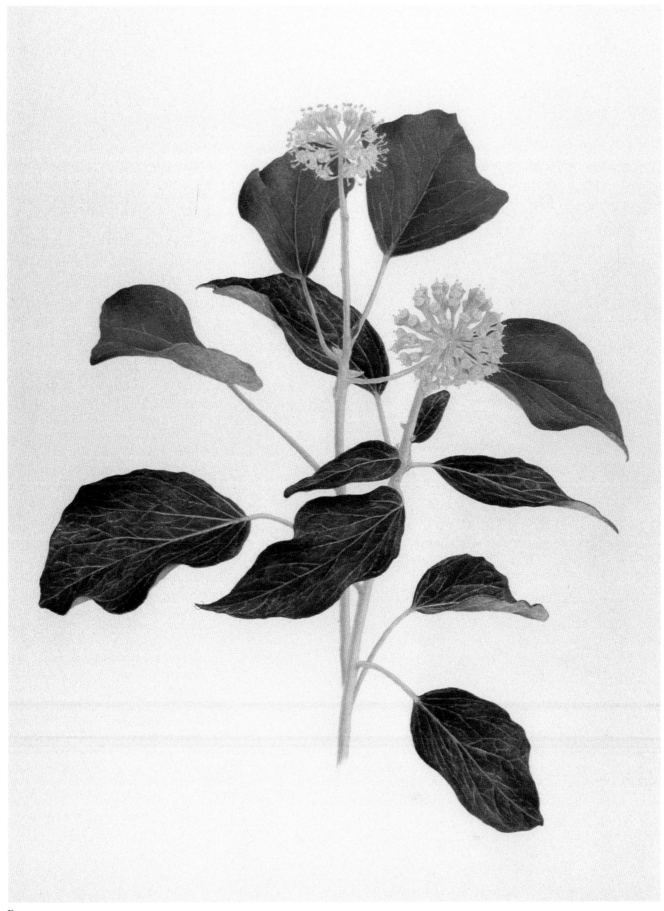

E

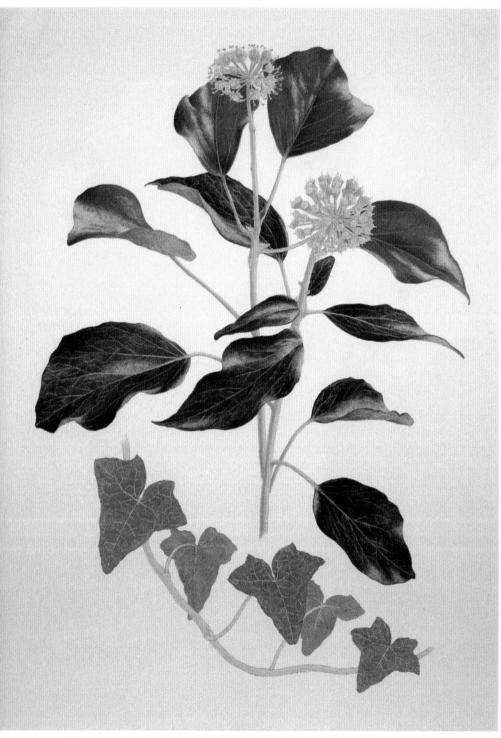

F

5. HIGHLIGHTS AND JUVENILE LEAVES [F]

Chinese white and Winsor blue were mixed for the bright highlights on the leaves. The colour was placed by using minute dabs and the edges of each area were blended in. I had to break off before completing this phase because the natural light had faded.

To finish the day under artificial light I drew a stem bearing juvenile leaves. It was taped to the drawing board because I could not manage a correct alignment in 'oasis'. I felt sure that the leathery leaves would not deteriorate by being out of water for a few hours.

After roughing in the line of the stem, I fined it up and added leaves. By slightly moving one leaf it was possible to cover the small stain on the paper noted above.

The venation network on the leaf uppersides was distinct and decorative – this was drawn in detail. On leaf undersides veins were obscure.

The stem and veins of the juvenile leaves were given a light coat of the original mix used earlier for this purpose.

A mixture of Chinese white, permanent yellow, and Winsor blue, was made for the underlying mid-green of the leaves. Using a pointed brush-tip the tracery of veins was skirted.

The basic dull bluish-green of the leaf undersides was mixed from Chinese white, Winsor blue, permanent yellow, and alizarin crimson.

At this time, shortly after noon, the winter daylight was strong enough to allow me to complete the highlights left unfinished from the previous day.

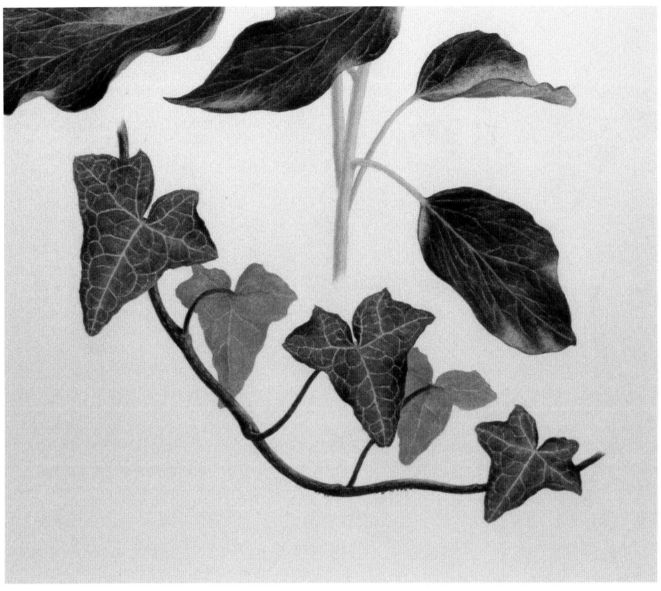

G

6. COMPLETION OF JUVENILE LEAVES [G]

In the juvenile leaves, the contrast was not great enough between the tone of the major veins and that of the mid-green undercolour. This was corrected after adding more Winsor blue to the original mix.

For the purplish-bronze overlying coat a fairly dilute mixture of Chinese white, alizarin crimson, and Winsor blue was used. This was dabbed on with restraint allowing the underlying green to show through. Some of the mix was further diluted as a modifying layer for the leaf undersides.

Touches of the highlight colour were used on the stem. The leaves, contrasting with the adult form, were matt surfaced and so no highlights were needed.

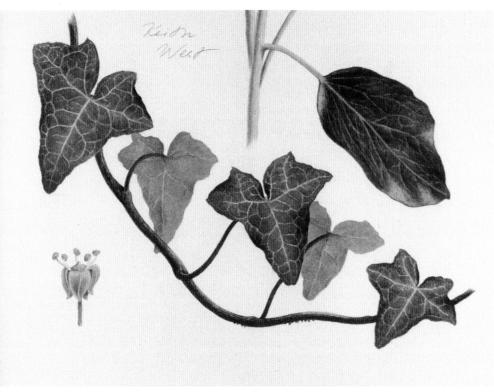

H

7. FLOWER DETAIL AND FINISHING TOUCHES [H, I, J]

As individual flower structure was lost in the inflorescence, a ×2 flower was introduced as planned at the lower left. Several flowers were detached and placed to the side of the drawing board on a piece of dampened paper towel. After examining them with a hand-lens I selected one bloom to draw. To start, the main vertical dimensions were stepped off on to the paper with dividers. The point of a brush absorbed tiny nectar beads that distorted the ovary outline. In making the drawing I lightly indicated stellate hairs on the pedicel – these may not be visible in reproduction. The flower was coloured using the earlier mixes.

Returning to the body of the plate, the upper stems and axillary leaf buds were softly coloured with a light-brown mix made from Chinese white, permanent yellow, alizarin crimson and a touch of Winsor blue.

Winsor red was added to the preceding brown mixture to give a reddish glow to axillary leaf buds and to some of the developing fruits.

The swelling discs were rimmed by darkly pigmented minute scale-like calyces with their connecting tissues. These parts were coloured using the purplish-bronze of the juvenile leaves after adding more Winsor blue.

As a final step, shadow colour from Chinese white, alizarin crimson, Winsor blue, and a hint of permanent yellow was added here and there throughout.

I

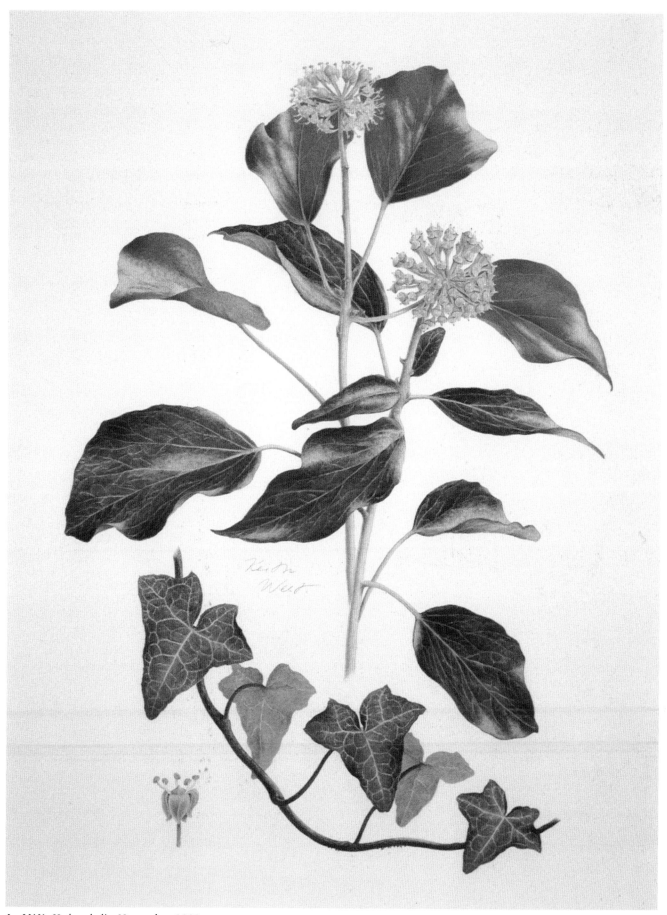

J. IVY, *Hedera helix*, November 1992.

Index

Italic numbers indicate illustrations. Plants are entered by their common names first, except where only scientific names have been used.